THE FINE ART

of

CHINESE BRUSH PAINTING

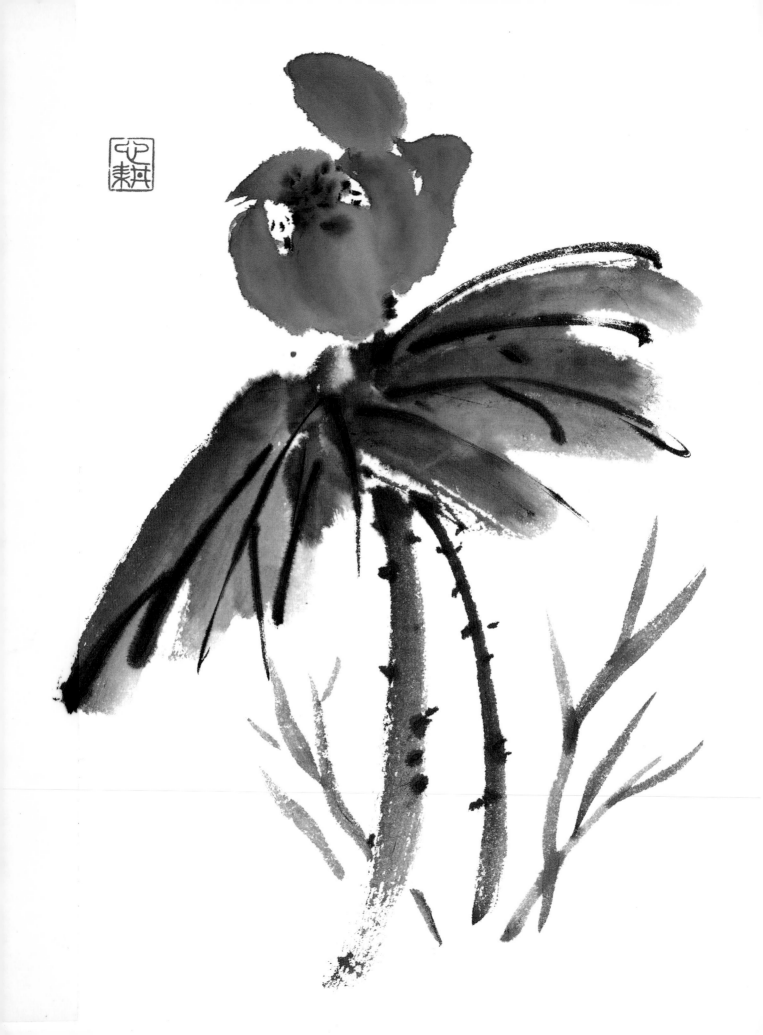

THE FINE ART
of
CHINESE BRUSH PAINTING

Translated by Michael Brunelle and Beatriz Cortabarria

中國書畫

Sterling Publishing Co., Inc.
New York

Text: Walter Chen
Exercises: Walter Chen, Hsiao-lin Liu, Li-chi Tsai, Manuel Díaz
Photographies: Nos & Soto, Walter Chen

© Parramón Ediciones, S.A. - World Rights
Ronda Sant Pere, 5, 4th Floor
08010 Barcelona - Spain
A division of Grupo Editorial Norma

Translated from the Spanish by Michael Brunelle and Beatriz Cortabarria

Library of Congress Cataloging-in-Publication Data Available

10 9 8 7 6 5 4 3 2 1

Published by Sterling Publishing Co., Inc.
387 Park Avenue South, New York, NY 10016
© 2006 by Sterling Publishing Co. Inc.
Distributed in Canada by Sterling Publishing
c/o Canadian Manda Group, 165 Dufferin Street
Toronto, Ontario, Canada M6K 3H6
Distributed in the United Kingdom by GMC Distribution Services
Castle Place, 166 High Street, Lewes, East Sussex, England BN7 1XU
Distributed in Australia by Capricorn Link (Australia) Pty. Ltd.
P.O. Box 704, Windsor, NSW 2756, Australia

Sterling ISBN-13: 978-1-4027-4394-8
 ISBN-10: 1-4027-4394-7

For information about custom editions, special sales, premium and
corporate purchases, please contact Sterling Special Sales
Department at 800-805-5489 or specialsales@sterlingpub.com.

Acknowledgments
We would like to express our gratitude to Carles Codina,Chieh-yi Chen,
Jing-chiuan Chen, Su-iuan Chiang, Mauricio González, Ming-tzong He, Shang-hua Hong, Kuei-jin Iu,
Shu-chuan Lee, Maria Isabel Sallent and Shu-tzy Tzeng for their cooperation in this book.

Page after page brings the reader closer to a very particular universe, immersed in tradition. The East is enigmatic, full of colors, sounds, and aromas that are exotic to the West, inhabited by people accustomed to a dialogue with nature and its creatures.

Through a brief historical introduction, you will come to appreciate the close relationship between calligraphy and painting, the importance of a well-organized work area, and the way to make and use materials and tools according to the artistic requirements.

The essential characteristics of this art form and how to apply them are demonstrated; the importance of the seal is explained—how to make one and use it in the work of art. Also explained are the display of calligraphy and painted work, as well as the different techniques for representing natural elements such as plants, animals, daily life, and human portraits.

And finally, through simple illustrated step-by-step exercises, we show you how start on a path that has endless possibilities, is filled with symbolism, and is thousands of years old.

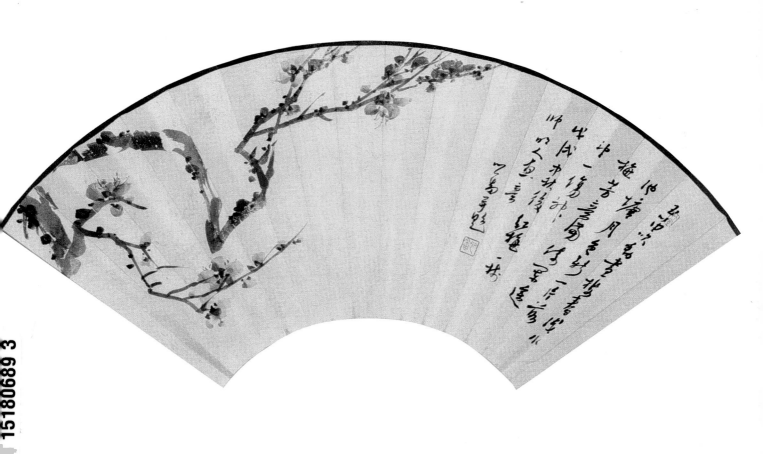

A Brief History of Chinese Painting

The goal of Chinese painting is not to create a faithful copy of real objects, as is sometimes the case in Western cultures, but rather to represent the essence of things, to highlight the most outstanding features of the model, without getting into details. The idea is not to capture the form of things but to subjectively express what is hidden behind the way things look, As the old Chinese saying goes: "the objective of the artist is to reveal the harmony (of the universe) that lies beyond reality and that cannot be perceived by the senses."

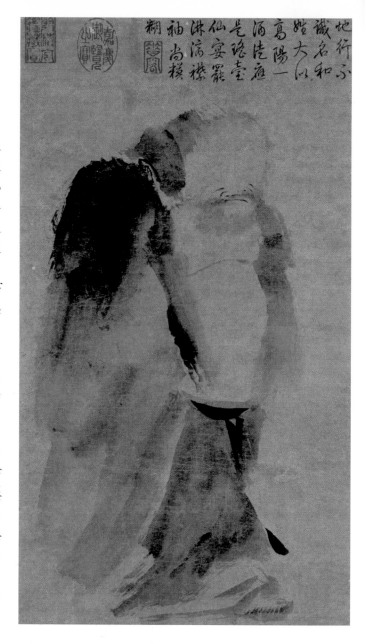

THE PAINTING GENRES

It is impossible to talk about the different genres in Chinese painting without emphasizing the influence of Taoism as an individual religious experience of integration with nature. It is understandable, then, that the two main genres of painting make reference to it.

In Chinese painting, the most important genre by far is the landscape. Although in the beginning, landscapes constituted only the background for the characters, the genre became independent during the Suei, or Sui (581–618), dynasty.

Next in importance are flowers and birds, a genre that made its appearance late and was perfected during the Tang dynasty.

The last genre includes people or characters. This genre is considered to have been at its pinnacle from the beginning of Chinese painting until the Song dynasty. With the arrival of Hindu Buddism, it acquired an Indian influence and became devoted to a generic portrayal of human qualities, without depicting realistic features. This is the oldest genre; it reached its highest peak of splendor during the Period of the Warrior Kingdoms.

Attributed to Liang-kai, The Immortal *or* Chan Monk, *thirteenth century, Southern Song dynasty. Page from an album. Ink on paper. National Palace Museum (Taipei, Taiwan).*

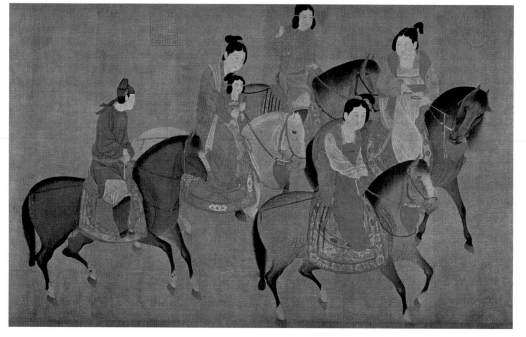

Copy attributed to Li Kong-lin (twelfth century) of a painting by Chang Siuan (eighth century) known as Mrs. Kuo-kuo Going for a Ride on a Horse. *A section of a horizontal scroll. Black ink and colors on silk. National Palace Museum (Taipei, Taiwan).*

LANDSCAPE PAINTING

In the beginning, landscape was not an independent genre. The landscape was painted in color (especially greens, blues, gold, and dark red), and it constituted the background for other scenes. The painting of independent landscapes began during the Tang dynasty. The colors were replaced with monochromatic washes, and this con-stituted a significant departure in the esthetics of Chinese painting. It was during the period before the Song dynasty that this genre was consolidated by the painter and critic Jing Hao, who together with his followers Li Cheng and Fan Kuan defined the typology of a pictorial genre. A painted landscape, unlike those in Western cultures, was created not to be exhibited but to be viewed in private and to be interpreted after long observation.

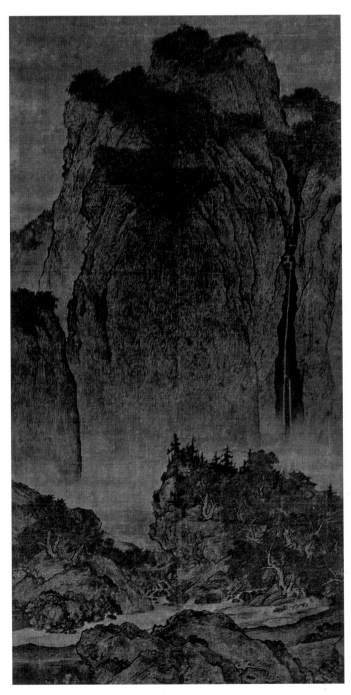

Fan Kuan, Journey Through Springs and Mountains. Vertical scroll. Ink and light color on silk. National Palace Museum (Taipei, Taiwan).

THE DYNASTIES

Until 1912, when the republic was proclaimed, Chinese imperial history was classified by dynasties rather than by the centuries of the Christian calendar. The periods of each dynasty, especially the oldest ones or the periods during which different powers coexisted, can vary depending on the source. In this book we provide the reader with only approximations. The names are written in the traditional writing system with the pinyin (of the People's Republic) system in parenthesis. We must warn the reader that the English pronunciation of certain letters and syllables often does not correspond to the pronunciation in Mandarin Chinese; it sounds more like the traditional system.

Shang 商	(1765-1122 B.C.E.)
Chou (Zhou) 周	[(1121-256 (221) B.C.E.)]
Ch'uen-ch'iu 春秋	(722-481 B.C.E.)
Chan– Kuo 戰國	(403-222 B.C.E.)
Period of the Warrior Kingdoms	
Ch'in (Qin), first imperial dynasty 秦	(221-206 B.C.E)
Early Han or Western Han 前漢	206 B.C.E.-8 C.E.
Later Han or Eastern Han 後漢	25 C.E.-220 C.E.
Period of the Three Kingdoms 三國	220-265 C.E.
Western Tsi (Jin) 西晉	265-316 C.E.
Eastern Tsi (Jin) 東晉	317-420 C.E.
Dynasty of the South and North 南北朝	420-581 C.E.
Suei (Sui) 隋	581-618 C.E.
T'ang (Tang) 唐	618-907 C.E.
Period of the Five Northern Dynasties 五代	907-960 C.E.
Northern Song 北宋	960-1127 C.E.
Southern Song 南宋	1127-1279 C.E.
Yuan 元 (or Mongol)	1280-1368 C.E.
Ming 明	1368-1644 C.E.
Ch'ing (Qing) 清	1644-1911 C.E.

Fan Kuan's passion for the contemplation of valleys and mountains led him to live among them and to make them part of his spirit. For him, nature was the only true painting teacher, even though the technique and the style came from Li Cheng, whom he deeply admired. So, Fan Kuan studied the landscape all day long by observing it: the shapes of the rocks, the varied vegetation, how the mountains change with the atmosphere that surrounds them, and how they are engulfed by the clouds. The artist added miniature figures to his mountains, which highlighted the insignificance of humans before the majesty of nature.

Those painters were surpassed by Guo xi (or Kuo Si), who was perhaps the best landscapist of the Song dynasty. He also observed nature very carefully, paying more attention to the changes produced by the seasons and the weather. In this sense, he was one of the first to create the effect of light on the mountains.

Later, during the Yuan dynasty, technical and compositional details emerged that are reminiscent of the Song painters, but the lines were simpler, longer, and straighter and the black ink gave way to brown and red washes. It was the culmininating moment of landscape painting, coming from the hands of the so-called four masters. And regarding the themes, the landscapes appear to be filled with pavilions and gazebos, which are references to an absent man.

歷史概論

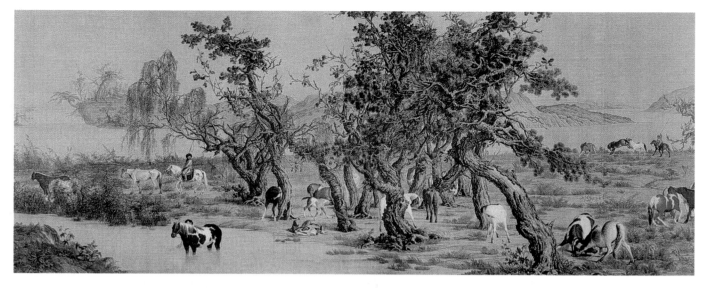

PAINTING BIRDS AND FLOWERS

At the same time that landscapes were at their pinnacle, in the twelfth century, the imperial court began to develop themes with birds and flowers. These motifs constituted an inspiration to express the feelings and aspirations offered by nature, by life itself, a point of convergence with the poetry that is derived from living creatures.

This genre was developed with three basic techniques. The first one, known as *Gongbi*, is a technique used for details, in which the outline of the model is drawn first with very meticulous lines or dots and then the inside is filled with brushstrokes of color. It is the preferred method for working with details and to create great realistic effects.

Another technique, very popular during the Song dynasty, consisted of representing the model with washes, in such a way that the inked area approximated its look without lines that defined its profile.

A third technique, *Mo gu*, the *Shieyi* technique, carried out with very expressive brushstrokes, was based on the direct use of the brush and ink to express the spirit of the birds and the flowers. The brushstrokes flow freely but concisely, in an attempt to capture the model's spirit.

Giuseppe Castiglione, or Lan Shining, One Hundred Horses, *1728. 37 inches (94.5 cm) high. National Palace Museum (Taipei, Taiwan).*

Chu Ta, Two Birds. *Page from an album. Ink on paper. 12.5 × 10.5 inches (31.7 × 26.3 cm). Private collection.*

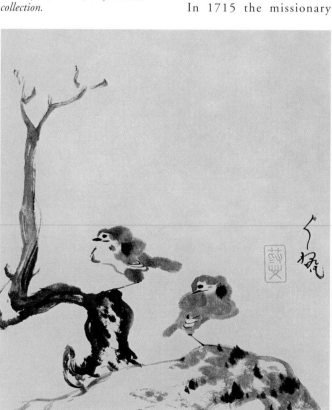

PAINTING DURING THE LAST IMPERIAL DYNASTY

Contacts with Europe took place on a large scale beginning in the sixteenth century, when Portuguese vessels reached the Canton coast. In the seventeenth century the baroque style entered China; and its influence was soon felt: Western perspective began to be applied; themes with female figures became popular; and there was an increasing interest in heavily ornate motifs.

In 1715 the missionary

Giuseppe Castiglione (1688–1766), known in China as Lang Shining, arrived in Peking, becoming the official painter and main portrait artist of the emperor. He introduced certain Western styles, a synthesis that blended the oriental technique with the modeled forms and the chiaroscuro of the West. His paintings were very celebrated but his style did not have continuity, and the local artists of the Imperial Department considered his paintings acceptable pieces of craftsmanship but not works of art due to their heavy shadows and the brushstroke's lack of fluidity.

Beginning in the thirteenth century, at the same time that the courtly painting style was de rigueur, an antiacademy sentiment was developed that followed the *Chan,* or *Zen,* philosophy. One of the most important esthetic consequences was the relevance acquired by the line; the stroke turned into artistic object with its own complete meaning. Chu Ta (1625–1705) was one of the best representatives. He executed his work spontaneously, with a single stroke and no room for mistakes. He did not intend to create a realistic representation

of the model but to emphasize the internal energy and its simplicity.

During the Qing dynasty various schools with very different styles and ideas coexisted. They ranged from orthodox thought, which limited itself to maintaining tradition, to artists who, especially in the southern regions, looked for new clients among the merchants who had become wealthy through commerce. Despite the influence of European culture, Western styles found few followers. The exception was a limited group of artists from Shanghai, who developed a daring style of bright colors, among whom Jen-I (1840–1896) stood out.

In the twentieth century, the influence of Western art was more prominent, although some artists revived traditional painting. Chi Pai-Shih (1863–1957) was among them, but his paintings offer a very expansive feeling, thanks to a semiabstract treatment. He was also a very intuitive and infor-

mal painter due to the clear Chan influence in his work.

Other artists who stood out as well in the twentieth century were Wu Chen Shih (1844–1927), who painted with ink using a vigorous style and developed bird and flower themes, as well as landscapes and bamboo; Chang Ta-Chien (1899–1983), who became prominent for introducing technical innovations, such as a new way of spraying paper with pulverized ink; Pu Hsin-Yu (1896–1963), relative of the last emperor, who transmitted the exquisite education received in the palace in poetry, calligraphy, and painting with a pure and refined style; and finally, Cheng Shan-Hsi (1932), who painted in a more intimate and everyday style.

Chi Pai-Shih, Flower of a Plum Tree. *Private collection (Hong Kong, China).*

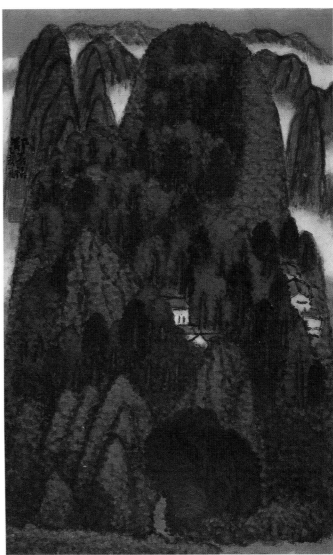

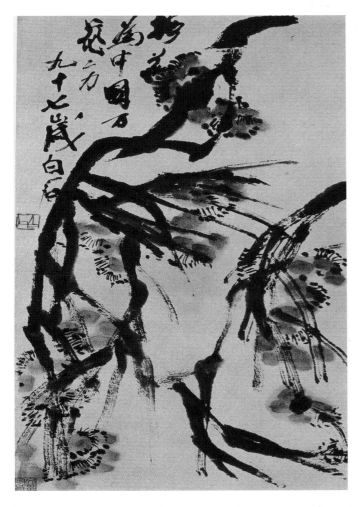

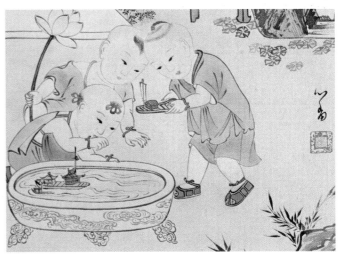

Cheng Shan-Hsi, Mountain Retreat Houses. *His style was a development of the Tang dynasty's landscapes. Several layers of very dense colors can be perceived.*

Pu Hsin-yu, Children Playing *(fragment). Private collection. This work by a famous contemporary painter is a good example of the Gongbi style. A sense of inner peace can be felt through the lines and the exquisite nature of the colors.*

歷史概論

The Styles and Evolution of Calligraphy

Chinese characters have a long history. Many writings date back three thousand years, before the Shang dynasty (1765 B.C.E.). The development and expansion of writing, stimulated by the progress and increasing demands of society, as well as by the instruction of pen and ink techniques, constituted the backdrop for the gradual evolution of the magnificent art of Chinese calligraphy.

THE DIFFERENT STYLES

Brushstrokes are the trademark of the art of calligraphy. Through it and through the centuries, different styles and writings have developed. The first calligraphy was the *Chia Ku wen,* or *Jia-gu wen,* used for inscriptions on bones and tortoise shells during the Shang dynasty. The *Chi wen,* or *Chung Tin wen,* follows the archaic forms of the Chia Ku wen, but it is more stylized. Another writing style, the *Chua wen,* was used on stone or wood seals during the Chou, or Zhou, dynasty. The *Li shu* is a type of administrative writing that was used in official documents during the Hang dynasty. And the *Kai shu,* which emerged at the end of the Han dynasty, was modeled on the administrative writing style. Because it is such a facile style of writing, it became the most common writing style since the Period of the Three Kingdoms, the one normally used for daily needs. In these calligraphy styles all the lines are drawn precisely, cleanly, and separate from one another.

The quick-writing and cursive styles are not as angular as the administrative type. They consist of simplified shapes, with connected strokes and lines drawn spontaneously and freely. This is the case with the *Tsao shu,* or *Cao shu,* quick writing of connected strokes with a great variety of linear forms, and the *Hsing shu,* or *Xing shu,* writing, a treatment in cursive that is a hybrid between normal writing and quick writing. These two styles are the preferred ones for general handwriting, for letters, notes, and the like.

Independently of the style chosen, from the elaborate pictographic style of seals to the flow of cursive writing, pictographs are created to the point of forming complex paintings of abstract beauty. The ink must flow off the pen like musical notes, floating harmoniously in a combination of rhythm and melody. Thus the composition acquires a life of its own and captivates the spectator.

Chia Ku wen *writing on a tortoise shell.*

CALLIGRAPHY STYLES		
	Fish	Bird
Chia Ku wen 甲骨文		
Chin wen 金文		
Chuan wen 篆文		
Li shu 隸書		
Kai shu 楷書		
Hsing shu 行書		
Tsao shu 草書		

Evolution of Chinese calligraphy from the beginning to the present time for the words fish *and* bird. *All the styles were established during the Tang dynasty.*

THE ART OF CALLIGRAPHY THROUGH THE CENTURIES

The main feature of calligraphy is the brushstroke, an element that is shared with painting, as are the tools that are used. For these reasons, the two disciplines have been intimately connected from their beginnings.

The evolution of calligraphy, and of painting, took place as a result of the frequent influence of political and social conditions. The Ch'in, or Qin (221–206 B.C.E.), and Wei (220–265 C.E.) dynasties contributed to the development of metaphysics, and artists made an effort to eliminate the Confucian ethics of the Han dynasty (206 B.C.E..–220 C.E.). There was more room for artistic imagination and audacity in writing, clear examples of which are the graphics developed by the great master Wang Shi-chih (321?–379?). During the Tang dynasty (618–907 C.E.), calligraphy formed part of the imperial exams and was used by famous courtesans.

Through calligraphy, intellectuals materialized their reflections, moral principles, and most intimate feelings. The practice of calligraphy became a way of cultivating oneself. In this way, the personalities of the old masters remained reflected in their graphics.

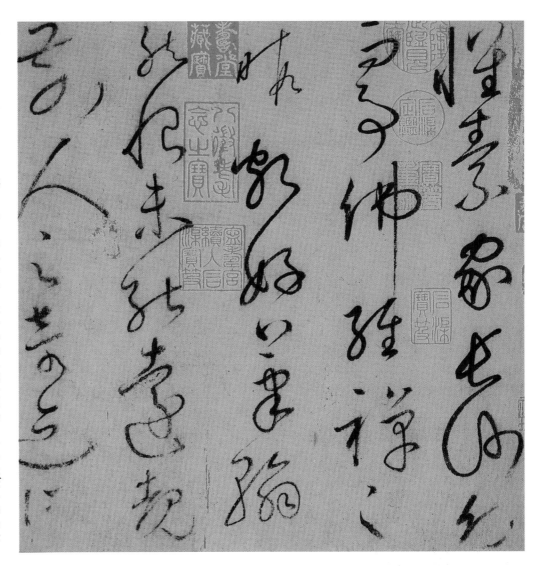

Huai Su (725–785). Fragment of His Autobiography. 11 x 30 inches (28.3 x 75.5 cm).

Copy of Wang Shi-chih's style, created during the Tang dynasty. No original works by the artist survive, but part of one of them can be found inside an emperor's tomb.

Huang Ting-jiang (1045–1105), Title of the text Pavilion Inside the Landscape of Pine and Wind. *This calligrapher from the Southern Song dynasty was a specialist in* Hsing shu *and* Tsao shu *writing.*

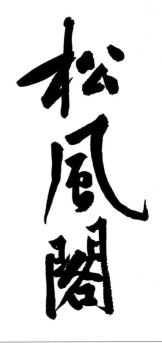

歷史概論

Arranging the Work Area

The landscape genre is known in painting by the name of *Shan Shuei,* 山 which literally means *mountain* and *water.* Artists use this same concept to set up their work area. The writing desk is considered a microcosm of life. Students receive an interdisciplinary education, which means that they work with the technique, the materials, and the spirit in unison with nature. This communion must also be carried out into the workspace, and it is translated into small stone gardens, miniature plants, or other elements from nature, which help the artist concentrate and achieve better results.

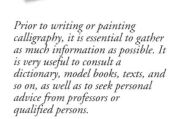

Prior to writing or painting calligraphy, it is essential to gather as much information as possible. It is very useful to consult a dictionary, model books, texts, and so on, as well as to seek personal advice from professors or qualified persons.

THE IMPORTANCE OF THE WRITING DESK

The writing desk is a very personal space whose decoration is planned very carefully to create the ideal environment for working comfortably and with the utmost tranquillity. It must be a refuge, an interior garden, a private workroom with the atmosphere of a studio in which the artist—painter or calligrapher—can store his or her "treasures," cherished paintings and old books, as well as tools for writing and painting. Among them are delicate paper, decorated sticks of ink, the stone to grind the ink, the inkwell, brush holders, and brushes, whose handles may be decorated with plant motifs. Many of the objects are true jewels of craftsmanship made from bronze, porcelain, lacquer, or carved stone.

In this space the artist seeks the peace and the harmony that allows him or her to become one with nature so the artistic spirit can emerge like the air that is exhaled from the lungs, springing out like the seeds that germinate in the earth.

The position of the artist, who must also have the required tools within reach, as well as a peaceful environment and adequate lighting.

THE WORK AREA

A good position and proper posture for working are essential for painting comfortably and achieving good results. The back should be upright but without tension, and the left elbow should rest lightly on the desk. The shoulders and the neck should remain relaxed, while the right arm should be suspended in the air to allow the wrist and the hand to carry out circular motions as if they were performing a dance.

The lighting is also a very important factor because Chinese painting incorporates very subtle tones. For you to appreciate them accurately and precisely, the desk must be evenly lighted.

A PROPERLY ARRANGED DESK

One of the requirements for working comfortably is a large desk, where the paper can be centered on a piece of flat felt that is not water absorbent. At the top, to the right, the brush rest is placed near the inkwell, the stick of black ink, a cloth to absorb excess moisture, a cup for washing the brush, a "chrysanthemum palette" or porcelain palette to mix different ink colors, and finally a piece of rice paper to test whether the tone of the wash is correct before it is permanently applied to paper. At the top, to the left, sits a pot in which to store brushes when they are dry, and a vase with flowers as a model. On the side, red paste ink is placed to seal the work when it is finished.

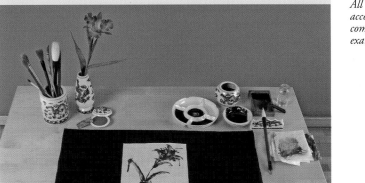

All the tools must be arranged according to the artist's needs and comfort, as can be seen in the example.

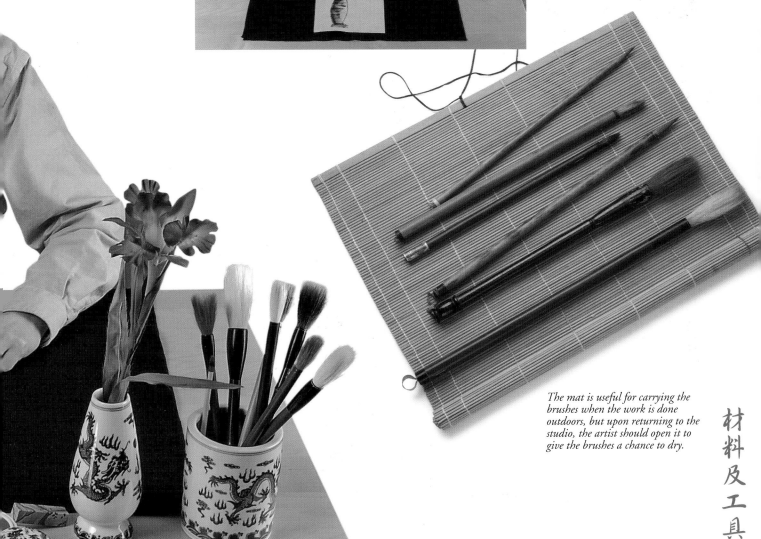

The mat is useful for carrying the brushes when the work is done outdoors, but upon returning to the studio, the artist should open it to give the brushes a chance to dry.

材料及工具

The Four Treasures of the Studio: The Brush 筆

The brush, the ink, the paper, and the ink stone, or inkwell, are the four essential elements of a Chinese writing desk. Each one represents an aspect of daily life, and all are necessary for their interrelation. They are the tools for developing creativity, but at the same time they become greatly venerated objects that are worth collecting. The treasures for painting and calligraphy are the same; with them the artist is able to project the spiritual and intellectual feelings that any work contains in Chinese culture and in the Far East in general.

THE BRUSH

The brush is one of the four treasures of the master's desk. There are many varieties of brush, which is the result of many centuries of experience. They are made with hair from different animals, even from human hair, to create different lines and textures. The evolution of the brush has been coupled with that of the ink, the ink stone, and the paper.

ORIGINS OF THE BRUSH

The birth of the brush coincided with that of the ink and the ink stone, since these tools are related to one another, influencing and stimulating one another. They made their appearance at the end of the Neolithic era, but they did not acquire their characteristic forms until the fourteenth to tenth centuries B.C.E. They began to have widespread use in the second century B.C.E., and they became prominent and were perfected between the seventh and twelfth centuries, reaching their greatest splendor during the fourteenth to seventeenth centuries. The way they are used has hardly changed since then.

Brushes are made from different materials according to the quality desired and how they are to be used: the feathers of chicken, geese, and other birds; the hair of goats, deer, pigs, leopards, and tigers; and even human hair from newborn babies and adult men's beards. Despite the variety, experience has shown that rabbit hair is the best and most ideal material, especially when it is cut in the fall or winter, because it is coarser during these seasons.

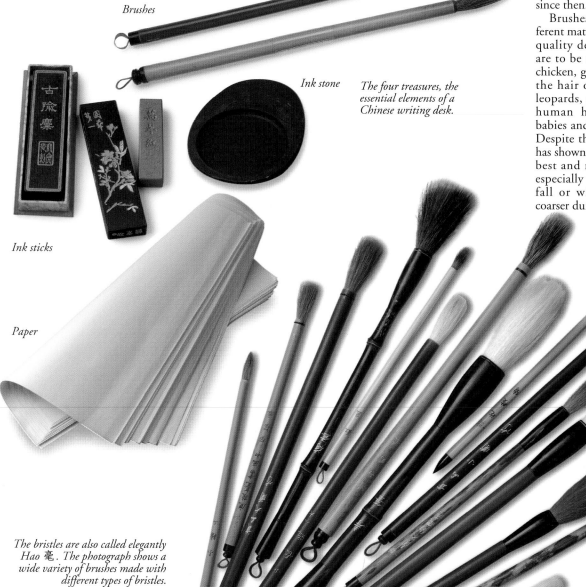

Brushes

Ink stone

The four treasures, the essential elements of a Chinese writing desk.

Ink sticks

Paper

The bristles are also called elegantly Hao 毫. The photograph shows a wide variety of brushes made with different types of bristles.

TYPES OF BRUSHES

Chinese brushes (Japanese are also good) should be used to paint or to write Chinese calligraphy; watercolor brushes used for Western-style painting are not acceptable. Chinese brushes are classified into three different varieties, depending on the material they are made of and the stiffness of the hair: soft-hair, coarse-hair, and mixed-hair brushes.

SOFT-HAIR BRUSHES

Soft-hair brushes are generally made from goat's hair, chicken feathers, or the hair of newborn babies. The hair is very soft and can hold a large amount of water. The brushes are easy to handle, and their tips open like fans when pressed gently on the surface of the paper. Because of this, the characters written with them create wide, thick, heavy lines. Depending on their uses, soft brushes can be subdivided into other varieties.

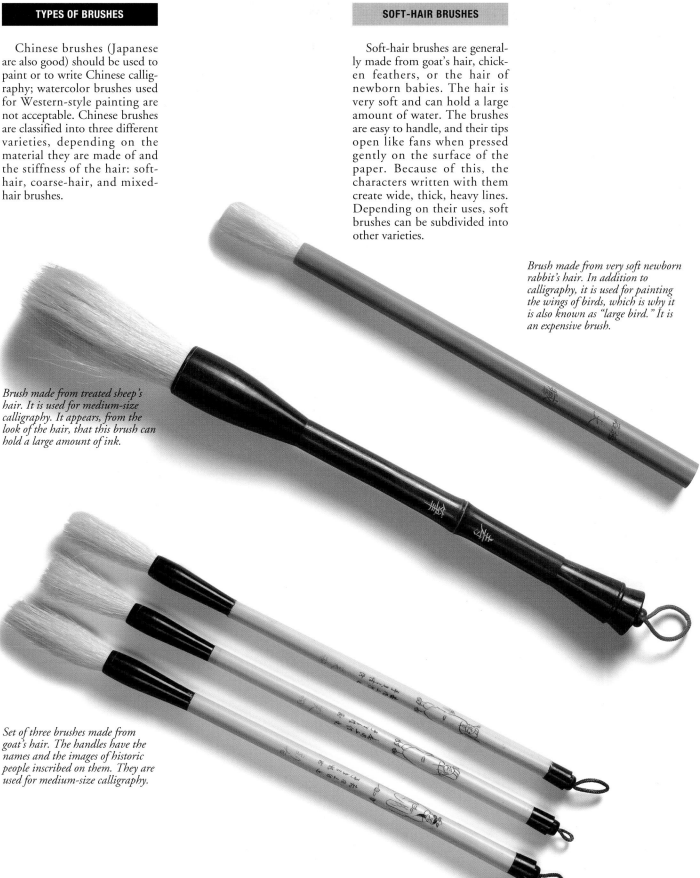

Brush made from very soft newborn rabbit's hair. In addition to calligraphy, it is used for painting the wings of birds, which is why it is also known as "large bird." It is an expensive brush.

Brush made from treated sheep's hair. It is used for medium-size calligraphy. It appears, from the look of the hair, that this brush can hold a large amount of ink.

Set of three brushes made from goat's hair. The handles have the names and the images of historic people inscribed on them. They are used for medium-size calligraphy.

材料及工具

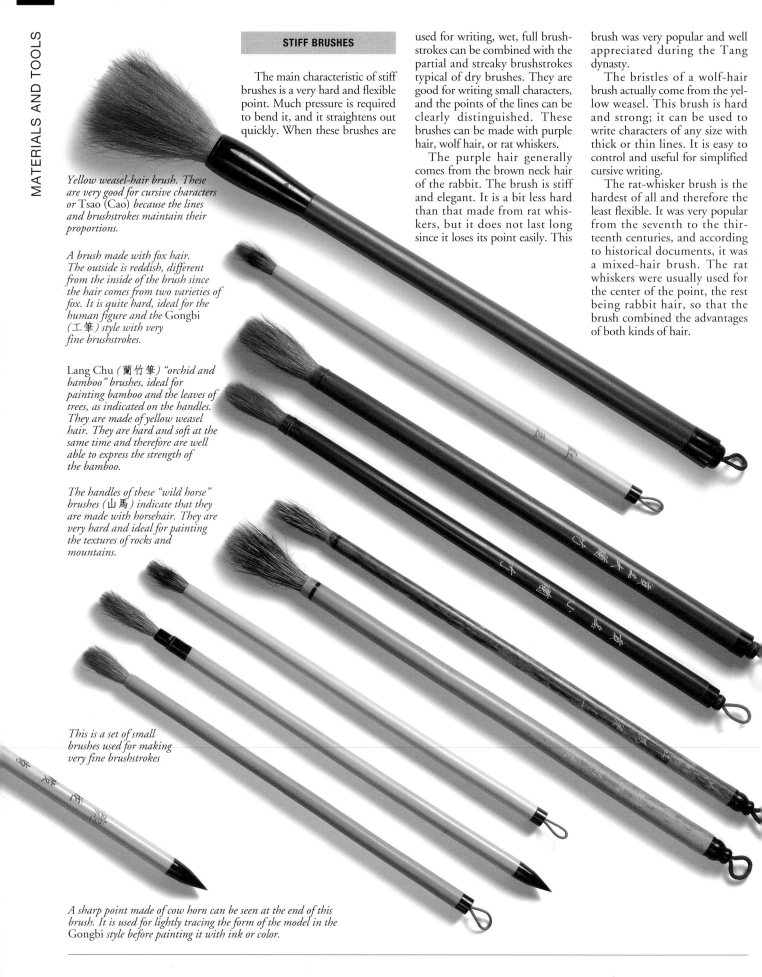

STIFF BRUSHES

The main characteristic of stiff brushes is a very hard and flexible point. Much pressure is required to bend it, and it straightens out quickly. When these brushes are used for writing, wet, full brushstrokes can be combined with the partial and streaky brushstrokes typical of dry brushes. They are good for writing small characters, and the points of the lines can be clearly distinguished. These brushes can be made with purple hair, wolf hair, or rat whiskers.

The purple hair generally comes from the brown neck hair of the rabbit. The brush is stiff and elegant. It is a bit less hard than that made from rat whiskers, but it does not last long since it loses its point easily. This brush was very popular and well appreciated during the Tang dynasty.

The bristles of a wolf-hair brush actually come from the yellow weasel. This brush is hard and strong; it can be used to write characters of any size with thick or thin lines. It is easy to control and useful for simplified cursive writing.

The rat-whisker brush is the hardest of all and therefore the least flexible. It was very popular from the seventh to the thirteenth centuries, and according to historical documents, it was a mixed-hair brush. The rat whiskers were usually used for the center of the point, the rest being rabbit hair, so that the brush combined the advantages of both kinds of hair.

Yellow weasel-hair brush. These are very good for cursive characters or Tsao (Cao) because the lines and brushstrokes maintain their proportions.

A brush made with fox hair. The outside is reddish, different from the inside of the brush since the hair comes from two varieties of fox. It is quite hard, ideal for the human figure and the Gongbi (工筆) style with very fine brushstrokes.

Lang Chu (蘭竹筆) "orchid and bamboo" brushes, ideal for painting bamboo and the leaves of trees, as indicated on the handles. They are made of yellow weasel hair. They are hard and soft at the same time and therefore are well able to express the strength of the bamboo.

The handles of these "wild horse" brushes (山馬) indicate that they are made with horsehair. They are very hard and ideal for painting the textures of rocks and mountains.

This is a set of small brushes used for making very fine brushstrokes

A sharp point made of cow horn can be seen at the end of this brush. It is used for lightly tracing the form of the model in the Gongbi style before painting it with ink or color.

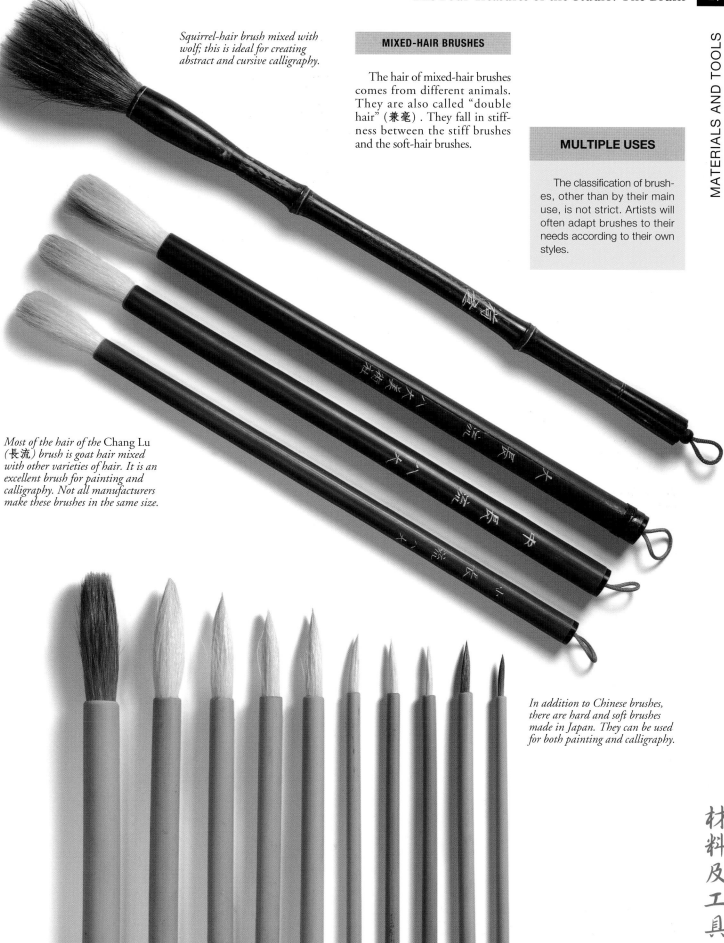

Squirrel-hair brush mixed with wolf; this is ideal for creating abstract and cursive calligraphy.

MIXED-HAIR BRUSHES

The hair of mixed-hair brushes comes from different animals. They are also called "double hair" (兼毫) . They fall in stiffness between the stiff brushes and the soft-hair brushes.

MULTIPLE USES

The classification of brushes, other than by their main use, is not strict. Artists will often adapt brushes to their needs according to their own styles.

Most of the hair of the Chang Lu *(長流) brush is goat hair mixed with other varieties of hair. It is an excellent brush for painting and calligraphy. Not all manufacturers make these brushes in the same size.*

In addition to Chinese brushes, there are hard and soft brushes made in Japan. They can be used for both painting and calligraphy.

材料及工具

Chinese Ink and 墨 Its Forms

In Chinese the pictogram for writing is based on *mo*, referring to the black color of the ink, which is used in most works of painting and calligraphy. This is related to the Chinese nation's predilection for the use of black pigment, as seen in many historical pieces. The adoration of black forms is an important part of the esthetic criteria of past generations.

Sticks of black ink from various makers. The name of the manufacturer or of well-known mountains, or a landscape can be seen on each stick.

According to some historical documents, the most ancient inks derived from vegetable and mineral compounds. Artificial ink appeared during the Chou, or Western Zhou, dynasty (1122 B.C.E.–771 B.C.E.). It is believed to have been an extract of carbonized pine ashes. According to tradition, one day Xing Yi, its inventor, was washing his hands at the river when he saw a piece of floating pine charcoal. When he pulled it from the water his hand was stained black. He was very surprised by his discovery. He took the blackened fragment home, where he ground it into powder. He attempted to agglutinate it with water but failed, so he tried rice soup and was successful. He created a malleable ink paste, which he could form by hand. This is how the first artificial ink sticks were formed. Artificial ink is much better than natural ink in quality, ease of use, and esthetic effects.

In the third century, two precious medicinal products, the pearl and musk, were employed in the production of ink. During this period, one way of valuing ink was to check whether it had sufficient glue and whether it was a very dark black. The use of glue in the process of making ink had important consequences, since it hardened the ink during the drying process and allowed it to be shaped into sticks. When it was used, it needed only to be ground in the ink stone; it did not have to be pressed.

Colors are traditionally available in cakes. In the center of the palette can be seen the color yellow, which is the dry lacquer of the Garcinia cambogia. *It is very toxic.*

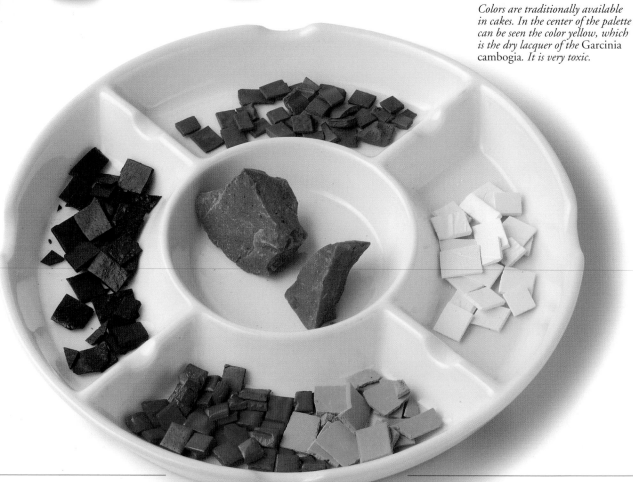

英國 WINSOR & NEWTON 公司精選最常
用的 10 個國畫顏色，組成攜帶型盒裝，精
巧美觀，使用方便。

042（**006**）朱標		317（**023**）赭紅	
074（**008**）赭石		322（**025**）花青	
150（**011**）中國白		707（**053**）石青	
205（**017**）洋紅		544（**038**）葡萄紫	
267（**020**）藤黃		708（**054**）石綠	

MADE IN ENGLAND BY W & N

THE VALUE OF INK

In the tenth century, writers and painters customarily made ink for their own use or as a gift for their friends. They would sometimes even make it to keep it like a jewel, a valuable possession. It is no surprise that, given such interest, books were written in those days about the fabrication and evaluation of ink.

Today matte and glossy inks are available at different prices and qualities. They should be selected based on the work that is to be done, always opting for quality, since good ink highlights the work and gives it more value.

Nowadays there are several companies that manufacture the basic colors for Chinese painting, available in tubes. The colors are bright red, burnt sienna, Chinese white, crimson lake, new gamboge, Indian red, indigo blue, Winsor blue (green shade), purple lake, and Winsor emerald.

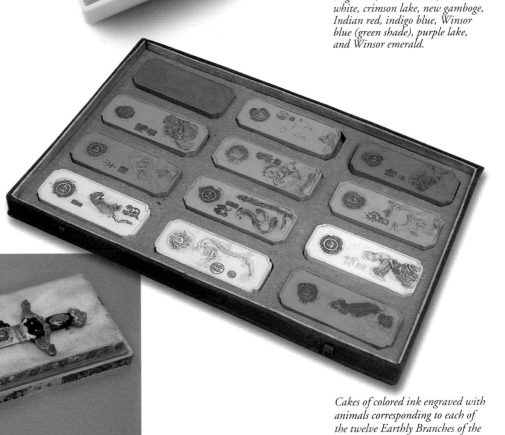

A black ink stick in the shape of a sword. This is a high-priced, collectable ink.

Cakes of colored ink engraved with animals corresponding to each of the twelve Earthly Branches of the Chinese horoscope that symbolize a person's birth year.

材料及工具

The Ink Stone or Ink Stand 硯

The ink stone is the tool used for preparing the ink, although it also is used as an inkwell and for smoothing the point of the brush. One of the four treasures of the studio, the ink stone has a long history that reaches back to the end of the Neolithic era, about six thousand years ago.

Throughout history, humans have experimented with different materials for making an ink stone that would combine several objectives: achieve the finest possible ink from the process of grinding and the later scraping of the stick; have a practical tool that works as an inkwell; and, finally, be ornamental on the desktop. This last objective is why many ink stones have sculpted forms or decorative relief.

PARTS OF THE INK STONE

Once the relevance of the ink stone to the artistic process is recognized, its use will be better understood by a description of its parts and each of their functions. They are as follows:

The **"salon of the ink stone,"** also called the "salon of the ink" and the "heart of the ink stone," is the central area where the ink is prepared. The value of the ink stone is based on this part and the material of which it is made, since the quality of the ink depends on it.

The **"well of the ink stone,"** also called the "sea of the ink stone," is the most concave part, which contains the water and later the liquid ink.

The **"front of the ink stone,"** or "head of the ink stone," is the largest part, since the other three sides contain sculpture and other ornamentation.

The **"hill of the ink stone"** radiates from the center of the ink stone; it slopes upward on all sides so the ink will flow to the bottom.

The **"edge of the ink stone"** refers to the border around the salon. It acts as a dike to contain the water and prepared ink.

In addition to the parts mentioned above are the "side of the ink stone" and the "lid of the ink stone." They act as a surface for inscriptions, or for engraving a name, some verses, or a seal, which also may be added to the bottom of the ink stone. Because of this the Chinese ink stone can be an authentic jewel.

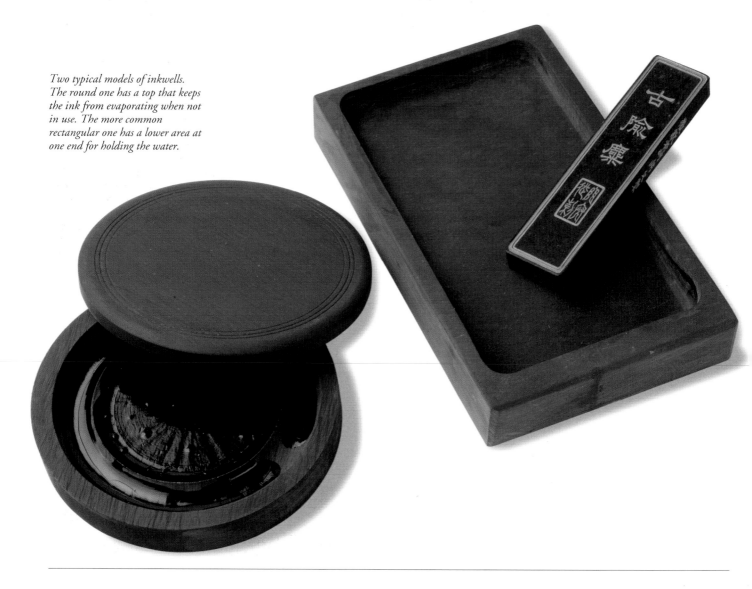

Two typical models of inkwells. The round one has a top that keeps the ink from evaporating when not in use. The more common rectangular one has a lower area at one end for holding the water.

FORMS OF THE INK STONE

In every era, changes in the form of the ink stone were made based on convenience and the way the ink stone was used at that time. In actuality there are four varieties.

Flat ink stone. The flat ink stone is the most ancient and also the most popular. The flat shape is stable when the artist is grinding the ink stick and can be subdivided into the following models: geometric figures, generally round, oval, rectangular, and octagonal; natural figures with outlines of animals or plants, such as a fish or a lotus leaf; figures in the shape of everyday objects, such as tea tables, hatchets, musical instruments, or traditional three-legged jars; and capricious figures with special shapes that make use of the veins and forms of the materials from which the ink stone is made.

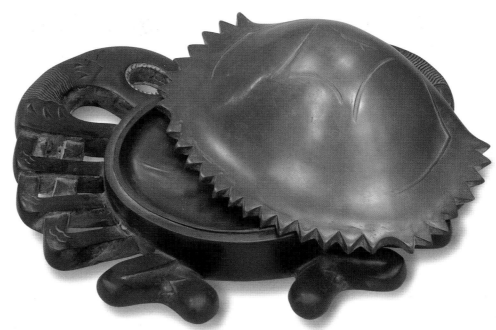

A black stone ink stone carved in the form of a crab with a shell carved from brown stone. It is from the Ch'ing, or Qing, dynasty (1644–1911), twentieth century. All the pieces on this page belong to the collection of the Museum of the Shie Jy Institute (Min Shiong City, Taiwan) and were donated by the director, Ming-tzong He. Photograph: Chieh-yi Chen.

Ink stones with feet. Ink stones with feet were widely used before the seventh century. They have ornamental shapes and nowadays are found only in the world of collectors.

Nonfreezing ink stones. In the coldest regions of China, ink froze easily. Two forms of ink stone were developed as a solution. One has space underneath the salon that is filled with hot water to keep the ink at a usable temperature. The other system consists of putting a metallic base under the ink stone so the ink can be heated with embers.

Portable ink stones. The top of a portable ink stone has two levels. The base is hollow, so it can easily be carried by hand.

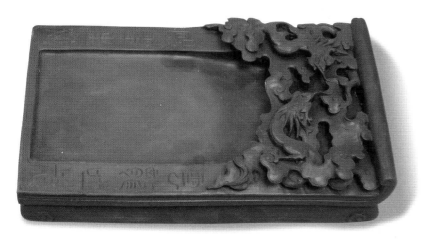

An ink stone carved in the shape of two dragons on a cloud (right side). On the upper and lower edges are inscribed poems related to the carving. Twentieth century.

Ink stone with four carved feet, in the shape of three lions playing with a ball. Twentieth century.

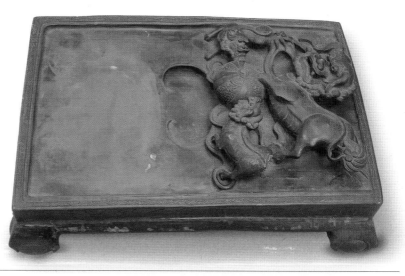

材料及工具

Paper 紙, a Chinese Invention

Before the discovery of paper, the most common surfaces used for writing were bones, bamboo stalks, wood tablets, and woven silk. However, silk was very expensive and bamboo was heavy. All this led to the invention of paper, a new material that was light and easier to handle.

Rice paper is sold in rolls and sheets.

Three varieties of Shiuan *paper. The first sheet is raw, the second is mature, and the third is a raw* Shiuan *of very long fibers. It is especially appropriate for landscapes that use many overlaid washes because it is very durable.*

The oldest paper still preserved dates from between 100 and 200 B.C.E. It was made from linen rags. Around the sixth century the Chinese paper industry experienced great growth. This was when the famous *Shiuan* paper appeared, which took its name from Shiuan Chou, its main place of manufacture. A legend relates that a disciple of the inventor of paper, Tsai Lun, lived in this city and worked in the paper industry. His greatest desire was to produce the perfect paper, which was white enough to be used to draw a portrait of his master and to make a book. However, despite multiple experiments he failed time and again. One day, in the valley he spotted some fallen trees next to a stream. They were decomposed and had a whitish color from the great amount of time that had passed since they had fallen. It occurred to him to use this tree to produce white paper, and finally he was able to achieve his goal. Based on this legend, we can deduce that during the Tang dynasty (618–907) it was fairly common to make paper from tree bark. Ever since then this paper has been prized and indispensable for calligraphy and painting. Since the fourteenth century it has been used only for this purpose.

The traditional process for making Shiuan *paper.*

KINDS OF *SHIUAN* 宣紙 PAPER

This traditional paper, *Shiuan* paper, is flexible, white, and compact and has a wonderful texture. It favors clear distinction between shades of ink, and it is naturally absorbent and resistant to aging, moths, heat, and light. It can easily be preserved for a long time. There is a saying that calls it "a precious thousand-year paper."

Based on its traditional manufacture, *Shiuan* paper comes in three varieties: raw, sized, and intermediate.

Raw *Shiuan* 生宣, or raw paper, is called this because it can be used as soon as it is made. It is very absorbent and is used for paintings with ink washes and drawings with large strokes.

Sized *Shiuan* 熟宣 used to be made by soaking the paper in alum; later it went through a process of polishing, gumming, powdering, and coloring; and finally it was soaked in a bath with gold dust, waxed, and glued. This paper was also known as "*Shiuan* alum paper." It was used for painting *Gongbi* with minute details or for *Kai shu* and *Li shu* calligraphy, done with very fine brushes. Its greatest flaw was that over time it deteriorated easily.

Intermediate *Shiuan* is made by submerging raw paper in the liquids of different plants. It is somewhat water resistant, so ink will flow across it slowly.

The *Shiuan* paper that is used today is made from the bark of mulberry trees, rice stalks, and the like. In the West it is called rice paper in most art supply stores and in some stores with Far Eastern products. Books of raw paper with long fibers are also sold for use by calligraphers and painters, although the format may be somewhat small for some uses. The most asked for and easiest to find of these are the raw papers with long and short fibers.

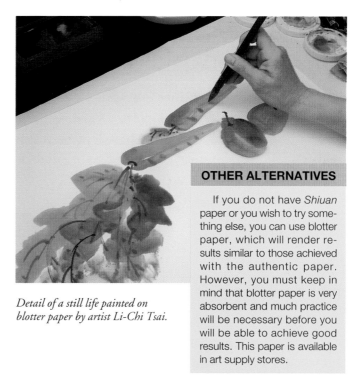

OTHER ALTERNATIVES

If you do not have *Shiuan* paper or you wish to try something else, you can use blotter paper, which will render results similar to those achieved with the authentic paper. However, you must keep in mind that blotter paper is very absorbent and much practice will be necessary before you will be able to achieve good results. This paper is available in art supply stores.

Detail of a still life painted on blotter paper by artist Li-Chi Tsai.

PAPER FOR PRACTICE

In Chinese painting and calligraphy it is customary to make a practice version of the work that you will paint, much like a sketch. To preserve your *Shiuan* paper, practice on newsprint before making the final painting.

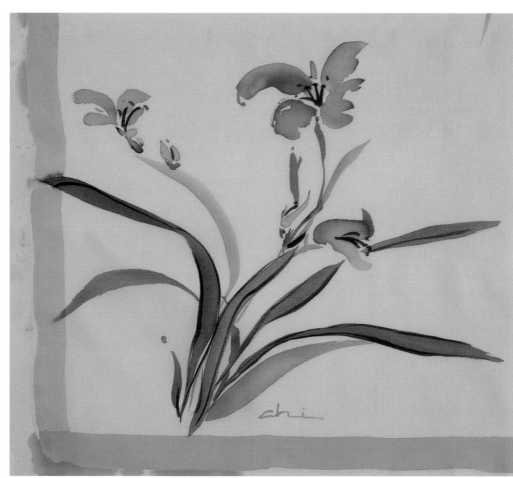

Silk is a traditional material in Chinese painting. After drying, the color of the painting is more intense than that painted on paper. Even though a large number of great works of art were painted on this type of support, nowadays only feminine themes and ornaments are painted on silk. This silk scarf was painted by Li-Chi Tsai.

材料及工具

Other Tools in the Studio

In addition to having the four treasures of the studio, already discussed, it is important to have available other implements used for painting as well as the vessels used for holding the most important tools used by Chinese painters and calligraphers.

A decorated porcelain box is excellent for keeping the ink for the seal.

The ceramic cup contains clean water for rinsing the brushes.

UTENSILS FOR THE INK

Ink, especially if it is of good quality, is a valuable element that must be cared for, so it is a good idea to have a tray or container just for the ink stick, to hold it while it is still wet.

After the stick has dried, it is kept in its box. The most common types of box are made of cardboard; higher-quality boxes are made of sandalwood or black wood. They serve as both protection and decoration.

Cotton rags are required, as are pieces of rice paper, which are used for tests. They can be used for wiping your hands or the brush and for drying the brush if it is holding too much water or ink.

FOR THE INK STONE

A proper box is used for holding, transporting, and protecting the ink stone. These boxes are usually made of lacquer or wood, and also, though more rarely, of metal.

A "bed," or special base, for the ink stone can also be used on the desk. It has a dual function, since besides being ornamental it helps keep the ink stone stable and safe.

A group of porcelain objects consisting of a cylindrical container for the brushes, a bowl for the ink, a cup for clean water, a jar that is used as a model, and the box of ink for the seal, which should be made of the best materials to keep the ink in perfect condition.

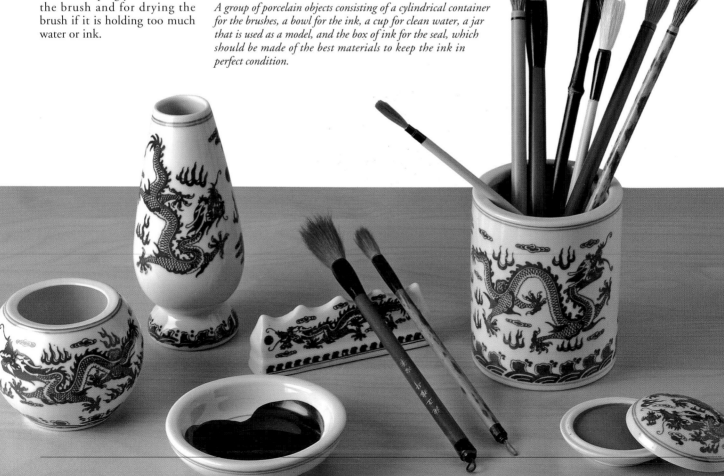

FOR THE BRUSHES

The following tools help the artist care for his or her brushes and conserve them so the bristles do not deteriorate and negatively affect the quality of the paintings. These tools are:

The brush rest. The brush rest is used to hold the brushes while the artist is painting. They are small supports whose shape is usually reminiscent of mountains. They can be made of many materials, among them stone, jade, copper, iron, bamboo, wood, ceramic, and the like.

The brush "bed." The brush bed is different from the brush holder. It is a small bamboo mat for keeping and transporting the brushes. It is rolled up for carrying and held closed by a cord.

Brush hangers. Brush hangers are most commonly made of bamboo. They are used for air-drying the brushes, which hang from the cord attached to the end of the shaft. It is not a good idea to hang them when they are wet or very damp, because tiny drops of water will accumulate at the point and damage the hair. The long Chinese brushes and some kinds of hair absorb a lot of water.

Jar for the brushes. The jar for the brushes is one of the most common tools on the desk for holding dry brushes with the brush end up. These jars are made from various materials and in various forms.

Cup. The cup is the container in which the brushes are washed. The most common types of cup are ceramic, and their varied forms can be surprising.

A brush hanger made of wood and bamboo. Dry brushes are hung on brush hangers so the tips do not become deformed.

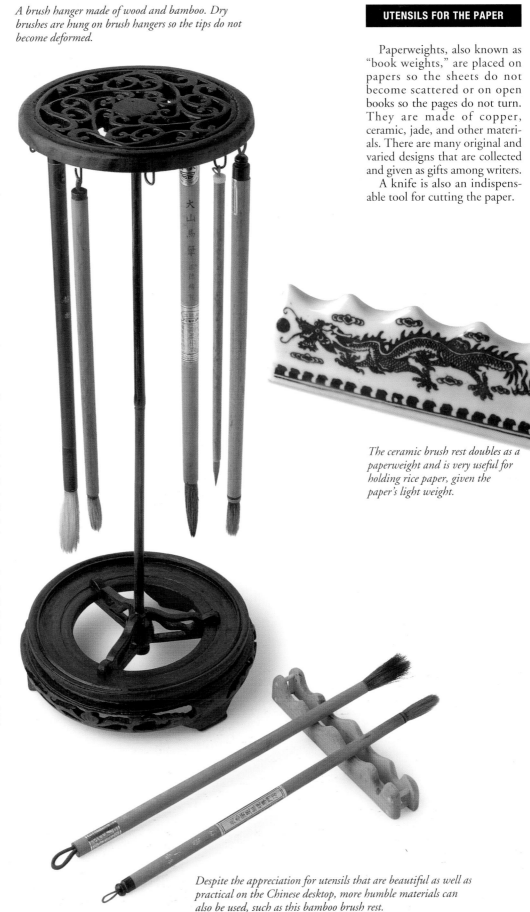

UTENSILS FOR THE PAPER

Paperweights, also known as "book weights," are placed on papers so the sheets do not become scattered or on open books so the pages do not turn. They are made of copper, ceramic, jade, and other materials. There are many original and varied designs that are collected and given as gifts among writers.

A knife is also an indispensable tool for cutting the paper.

The ceramic brush rest doubles as a paperweight and is very useful for holding rice paper, given the paper's light weight.

Despite the appreciation for utensils that are beautiful as well as practical on the Chinese desktop, more humble materials can also be used, such as this bamboo brush rest.

材料及工具

Using Brushes and Their Strokes

Until only a few years ago, brushes were made by hand in a process that involved sixty or seventy procedures. The principal steps in the process were wetting the animal fur chosen, extracting the hair, making a selection, dividing it, boiling, binding, mounting, cutting, trimming, and gluing. Of all the steps, selecting and binding were the most important ones because they were directly related to the quality of the brush and reflected the process's level of complexity.

The quality of a brush is a very important factor in the execution of a work. This means that before beginning to paint or to write the artist must choose good brushes to achieve the best results.

CHOOSING A GOOD BRUSH

In art supply stores there are many brushes of a great variety of origins, qualities, and prices available for Chinese painting. Brushes should be chosen carefully so they can be used for the purpose for which there were chosen, and this requires that the artist know how to tell them apart. Normally, the inscription on the handle, which defines the brush's characteristics (although it also bears sayings and advice), is in Chinese. Therefore, the artist has to trust the experience of the salesperson and then compare the various brushes' qualities on his or her own. The following photographs provide the primary criteria.

BEFORE USING A NEW BRUSH

In a new brush the long hairs are compressed by starch or by glue to prevent the bristles from opening or spreading. The brush must be prepared before use. To do this, the brush should be placed under the faucet, facing the same direction as the running water. Little by little, the hair should be pressed between the fingers, beginning at the base of the brush and continuing through the tip, while the brush is turned slowly with the other hand so the glue can dissolve evenly.

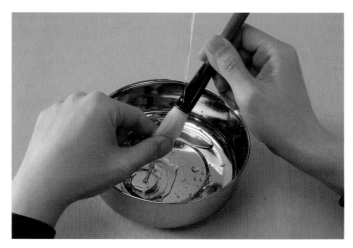

To eliminate stiffness, while holding under running water, the hair is pressed between the fingers while the brush is turned slowly and carefully.

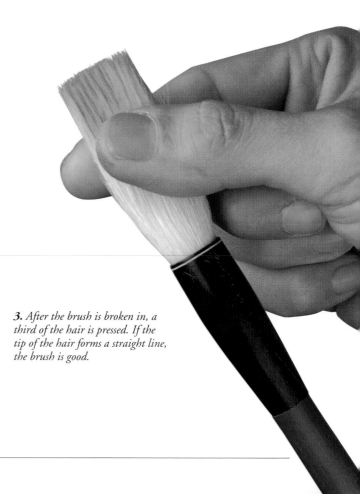

3. After the brush is broken in, a third of the hair is pressed. If the tip of the hair forms a straight line, the brush is good.

1. When the hair is wet but does not have a lot of water, the tip is pointed.

2. When a brush is saturated with water, the outline of the hair forms a continuous rounded line.

HOW TO HOLD A BRUSH

The way a brush is held is very important because good control has a decisive influence on the quality of the work. There are five criteria for holding a brush properly: first, the thumb touches the shaft; then the index finger and the thumb oppose each other to apply pressure on it; then the middle finger touches the shaft, and the nail and finger of the ring finger oppose the middle finger; and finally, the little finger joins the ring finger as support. The pressure of the fingers must find the appropriate balance to apply the desired brushstrokes or lines.

These main five criteria aside, the brush can be held in two ways, as shown in the illustrations.

INCORRECT USE OF THE BRUSH

If painting with a Chinese brush is done improperly — for example, writing as we would with a pen — the result will never be good; the start of each brushstroke must always begin with the tip of the hair, especially in calligraphy.

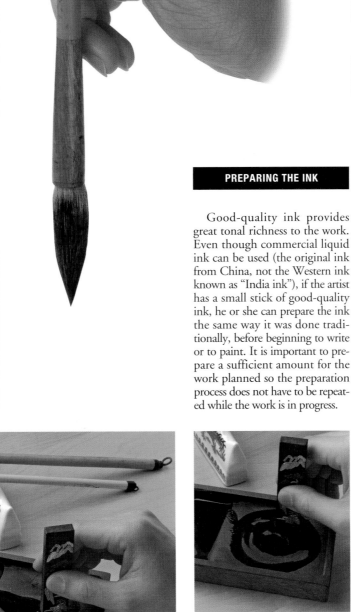

Singular grip: the shaft is held with the thumb and the index finger.

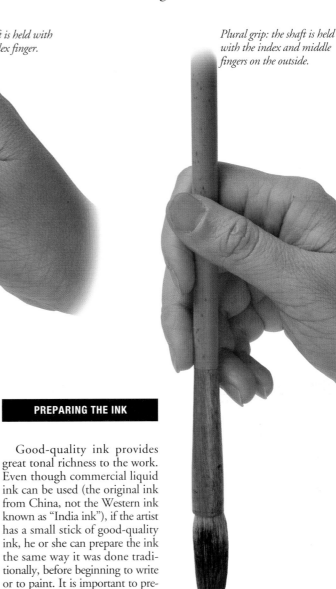

Plural grip: the shaft is held with the index and middle fingers on the outside.

PREPARING THE INK

Good-quality ink provides great tonal richness to the work. Even though commercial liquid ink can be used (the original ink from China, not the Western ink known as "India ink"), if the artist has a small stick of good-quality ink, he or she can prepare the ink the same way it was done traditionally, before beginning to write or to paint. It is important to prepare a sufficient amount for the work planned so the preparation process does not have to be repeated while the work is in progress.

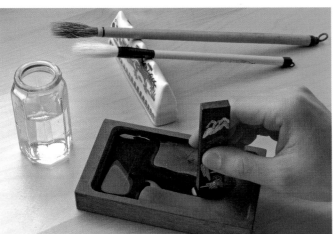

1. To prepare the ink, a small amount of water is first transferred from the inkwell to the flat area.

2. Next, the small ink stick is ground by rubbing it against the circular stone.

3. Finally, the prepared ink is pushed into the well, and the process is repeated to prepare more ink until the desired consistency is achieved to begin writing.

THE TONES

Basically, the different shades of ink are produced by diluting a greater or lesser amount of the thick ink in the inkwell. If a "chrysanthemum palette" or any other palette is available for mixing, several tones needed for the work are prepared. Before the painting is begun, the shade is tested on a separate piece of paper to make sure that it is the desired one. One must also keep in mind that wet ink has a darker tone than dry ink.

To begin, five ink shades are prepared from the initial tone, the darkest one, and then more tones are mixed as needed.

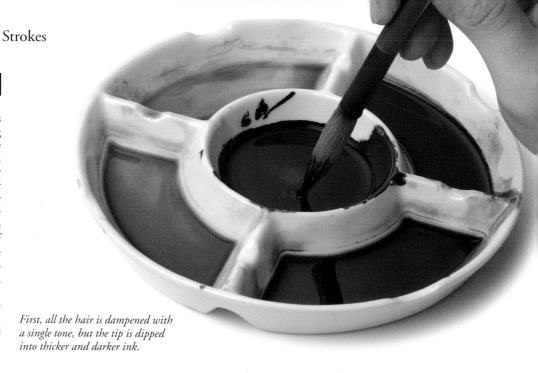

First, all the hair is dampened with a single tone, but the tip is dipped into thicker and darker ink.

THE PRESSURE OF THE BRUSH

Besides the tone of the ink, whether thick or thin, pressure is important; as a result of pressure different shades and a range of line thicknesses can be obtained, depending also on the thickness and the type of hair. Only with experience can the artist evaluate properly the infinite variety of possibilities.

The essence of wetting the brush and its immediate effects: five tones, from darker to more diluted. Starting with these, the artist can achieve an entire range of grays—or tones of another single color, if the artist is using an ink other than black.

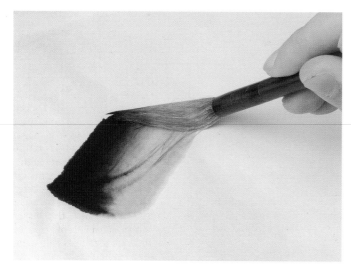

After a horizontal brushstroke is applied, the richness of the blended tones can be appreciated.

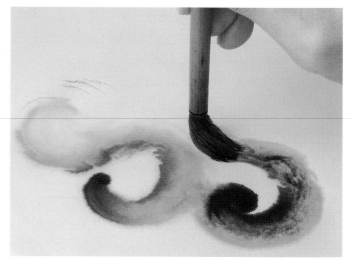

With the same method for wetting but this time dragging the brush, a curved brushstroke is applied with the force of the wrist's rotation. This is how a darker-to-lighter tone can be achieved.

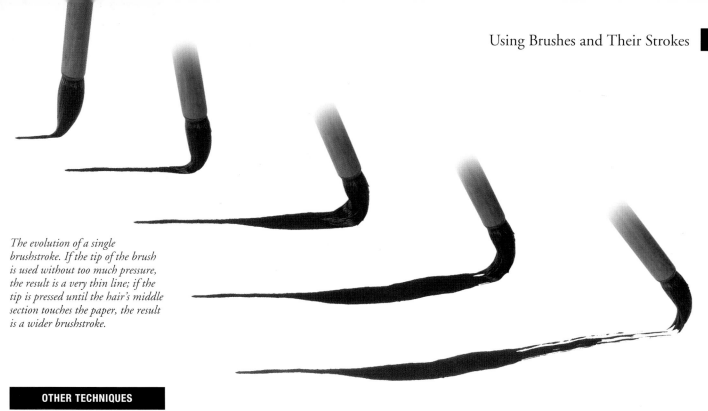

The evolution of a single brushstroke. If the tip of the brush is used without too much pressure, the result is a very thin line; if the tip is pressed until the hair's middle section touches the paper, the result is a wider brushstroke.

OTHER TECHNIQUES

This section shows current uses of Chinese painting to obtain certain effects.

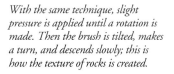

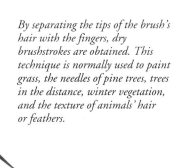

By separating the tips of the brush's hair with the fingers, dry brushstrokes are obtained. This technique is normally used to paint grass, the needles of pine trees, trees in the distance, winter vegetation, and the texture of animals' hair or feathers.

With the same technique, slight pressure is applied until a rotation is made. Then the brush is tilted, makes a turn, and descends slowly; this is how the texture of rocks is created.

CLEANING THE BRUSH

When the work is finished, it is recommended that the brush be washed immediately, so the ink, which contains a binding agent, does not compress the hair. The brush is washed by letting abundant water flow in the direction of the shaft and pressing on the center of the hair while turning the shaft slowly with the other hand. Little by little the fingers move toward the tip of the hair, continuing the process until there is no water left.

Detail of how the hair of the brush is rinsed.

材料及工具

Calligraphy and Its Relationship to Chinese Painting

Chinese writing has existed for more than two thousand years, and the graphic aspects of simple drawings that represent everyday objects, which have evolved to the point of acquiring symbolic significance and shape, date back six thousand years.

Chinese calligraphy is an art that consists of completely abstract lines that are based on ideograms. As all abstract art, it is based on, and its forms determined by, the purity of the rhythm, balance, and the harmony of the lines.

Each Chinese character, from the simplest to the most complex, is formed with six basic lines; later derivations involve eight lines that can be combined in different ways. Even and regular forms are discouraged; each calligraphy shape must be alive, in such way that an ideogram should be neither symmetrical nor perfect; instead it should convey the sentiment and the rhythm of the artist who painted it.

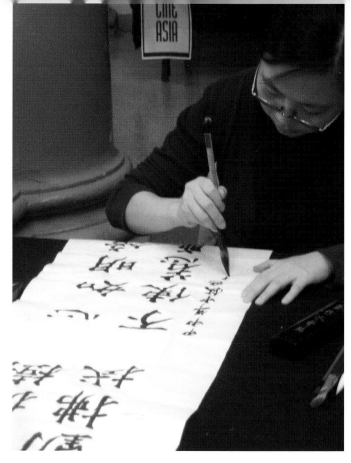

The calligrapher Hsiao-lin Liu executes a work in a public demonstration. Her body is in an upright position, her elbow remains suspended in the air, she writes by moving only her wrist, and she exhibits absolute mental concentration.

CALLIGRAPHY AND ITS INFLUENCE ON PAINTING

Calligraphy consists of creating meaningful lines with black ink on paper through the flexible movement of the brush and the consistency of the ink. The calligrapher's brush is an extension of the fingers: the rhythm of the brush, its speed, softness, flight, pause, and transition are powered by subjectivity, becoming a channel for the artist's emotions and spirit. At the same time, calligraphy is an expressive art whose goal is to reflect silently the impressions, the knowledge, the aptitude, and the personality of the artist through his or her own works. From that come the expressions: "characters are the reflection of personality" and "writing is the soul's mirror."

Calligraphy is tightly linked to traditional painting. It is even said that calligraphy and painting share the same origins, because at the beginning the same tool was used to write and to paint. Graphically speaking, calligraphy is comparable to painting for its ability to spark emotions through the rich variety of shapes and features. The main inspiration for Chinese calligraphy, as for painting, is nature.

Other disciplines such as ancient Chinese sculpture also share the characteristics of calligraphy: the veins in the sculpture are a combination of lines, and the decorative characteristics of the modeling maintain an internal relationship with *Chuan shu* and *Li shu* in calligraphy. Much like ancient Chinese architecture, from the distribution to the structure of columns and beams, it follows without exception the rules of symmetry, balance, and relationship between main and subordinate elements, and so on. The suggestion, the integration of the landscape in the architecture of the Chinese garden, as well as the freshness and elegance contained in the buildings, pavilions, kiosks, and galleries cannot be separated from the essence of calligraphy. Without a doubt, calligraphy has influenced the different artistic genres and disciplines in such way that it can be considered "the soul of Chinese art."

Beginners normally use ruled rice paper with the "nine imperial squares" 九宮格, very useful for drawing the lines correctly.

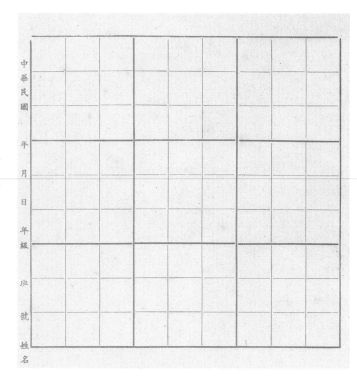

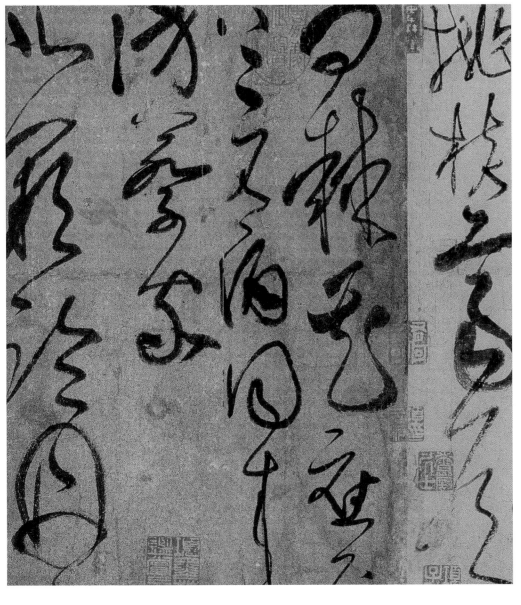

Chang Shiu (?–748), Four Ancient Poems. *In the work of this important calligrapher the lines are very powerful and bear resemblance to painting. This suggests that the basis of Chinese painting has its origins in calligraphy. Therefore, to paint well, one should first learn calligraphy. On the bottom right side of this ancient and very well-known calligraphy, many abstract lines can be observed, which due to their texture, ink flow, turns, and expressive power are comparable to painting. Taking three fragments as examples, which are shown later, on pages 54, 70, and 79 of the chapters on technique, we can see that the lines are not different. This is so because the ink as well as the brushes used in all the cases are the same. The art of calligraphy and painting are completely related.*

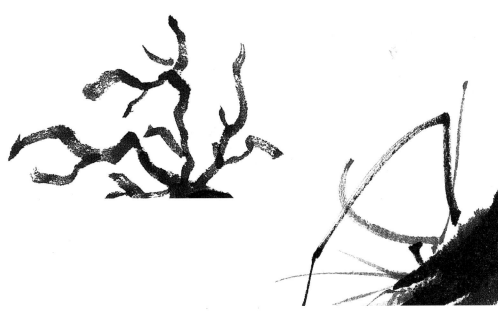

材料及工具

MATERIALS AND TOOLS

THE ESSENTIAL STROKES

To be able to write Chinese characters and to find them in dictionaries, it is important to know well the number of lines in each character, and the character's shape and writing sequence. Putting aside for the moment the tool used—traditionally the brush and nowadays the pen—each character is a graphic unit that is reduced to eight different forms or basic lines, which, written separately, combined, or repeated, produce close to fifty thousand different individual figures or characters. The famous calligrapher Wang Shi-chih (321?–379?), after searching and experimenting for fifteen years, discovered that the character *Yong* (infinity) contained all, and only, the eight basic lines of Chinese calligraphy. These basic lines, written with a brush, are called (1) comma; (2) horizontal line, from left to right; (3) vertical line, from top to bottom; (4) hook, folded upwards; (5) nail, from left to right; (6) tail, from top to bottom and from right to left; (7) short mark, from top to bottom and from right to left, and (8) rubric, from top to bottom and from left to right.

The eight basic lines of Yong *(* 永 *).*

1

2

3

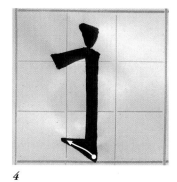

4

THE ORDER OF THE WRITING

The general principles that must be kept in mind to write or to count the features of each character are the following:

1. The upper lines are written first and then the lower ones are added.

2. If the character has two vertical parts, the lines on the left side are written first, followed by the ones on the right.

3. The horizontal lines are written before the ones that cross them.

4. The lines that turn to the left are written first and then the ones that turn to the right.

5. A central line is written before other symmetrical lines.

Following are represented several simple examples that show the writing process of several ideograms that correspond to words with very different meanings, allowing us to understand the order and the direction of each line; that is, how they are written step-by-step from beginning to end according to the criteria presented. The same orderly line construction system is commonly used in dictionaries to find the ideogram.

Complete Ideogram

El-two

二

Niu-woman

女

Chung-middle

中

Iu-rain

雨

Ma-horse

馬

The same character or ideogram for Yong *written in the* Tsao shu, *or cursive or abstract, style. Here we can see that the line has been simplified compared to the one that is shown above. Although it may look easy to write, in reality much practice is required to create a very beautiful character. The calligrapher that practices this style of calligraphy contributes his or her maximum concentration and inner strength and creates it practically with one or two very quick strokes. This concept is very different from the patient labor of calligraphy in Western cultures.*

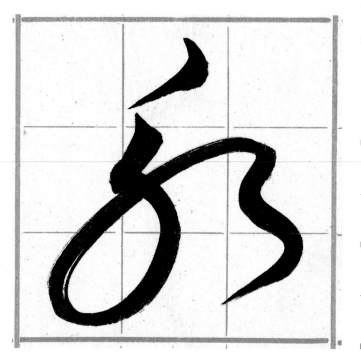

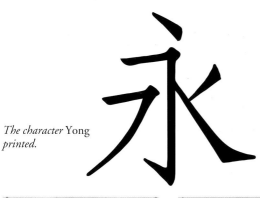

The character Yong *printed.*

5

6

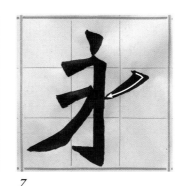

7

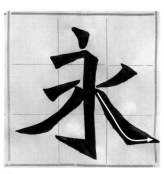

8

The Writing Process

THE DIRECTION OF THE WRITING

It is well known that Chinese characters, as well as those from other Asian languages, are made of vertical lines that are read from right to left; this is why Chinese texts begin in the direction opposite that of the writings from European and other Western countries.

一 二

人 女 女

口 口 中

一 厂 冇 而 而 雨 雨 雨

一 厂 厂 匚 匚 匡 馬 馬 馬 馬 馬

材料及工具

Carving Chinese Seals

Chinese painting and calligraphy are well known for the philosophical poetry and spirit that they are able to transmit. This gives a particular artistic expression to the calligraphy characters, meaning that, with a few defining brushstrokes, artists are able to suggest an entire hidden universe, a vital energy that gives a spiritual background to calligraphy, to the way of painting, and even to the seals that are traditionally printed on the work. The next section covers this last concept, the seal, its importance, the design, and how to make it.

THE IMPORTANCE OF THE SEAL

In Chinese culture the seal is equivalent to the signature that is used in Western cultures, but it has a more profound signifi-cance. It also denotes a sign of artistic cultural refinement. Its origin is as old as calligraphy itself, from which it is derived, and therefore, it also possesses great esthetic and artistic interest.

ORIGIN AND VARIATIONS

The seal was first used beginning in the eighth to fifth centuries B.C.E., but its widespread expansion occurred between the fourteenth and nineteenth centuries. In the beginning, the function of the seal was not as meaningful as it is now; rather, it was used as testimony of the exchange of merchandise.

Prior to the thirteenth century, creating seals was the job of a few specialized craftsmen who carved the characters written by a calligrapher. Beginning in the eighth century, the ancient *Zhuan*, or *Chuan*, writing was the one most commonly used in all the seals made of jade or other stones. The new writing styles were dismissed and were even considered in bad taste. In the thirteenth century, a new material became popular; it was a softer stone than those used before, and it allowed the artists themselves to carve the seals that they designed. In this way, the essence of the carving, a mechanical procedure executed by craftsmen, turned into an artistic process, and seals became a much-appreciated element in Chinese art.

In painting, seals were first used around the seventh to tenth centuries. In addition to the nominal seals (bearing the name or the surname of the artist or even the studio), the "pleasure" seals, for lack of a better word, made their appearance in painting. These seals placed value on the work: they were evidence of appreciation for the painting, or for a collector, bearing dates, a small image, phrases, and the like.

Hong Shang-hua (1969), a specialist in Taiwanese seals, has carved one entitled Living As He Pleases. *In it he reveals the feelings of the author at the moment of making it.*

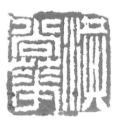

Nominal seal created by Hong Shang-hua.

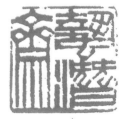

Pleasure seal (with the name of the studio), created by Hong Shang-hua.

Seals with various shapes on the work The Colors of Autumn in the Shiao and Hua Mountains, *by Chao Mong-fu (1254–1322).*

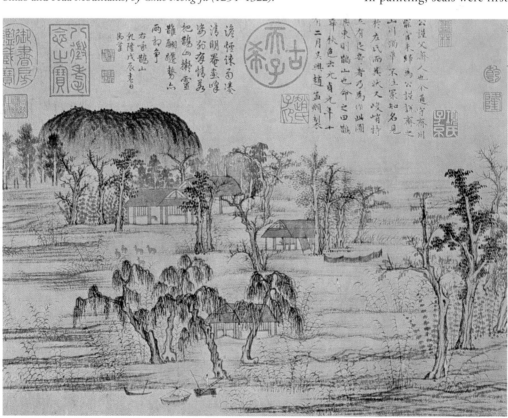

An illustration of several seals seen from their carved side. They can have different shapes: rectangular, square, oval, and so on.

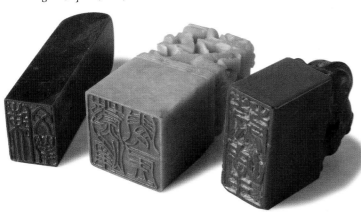

Different stones whose hardness is not an obstacle for carving seals. Walter Chen has personally tested and confirmed that the hard seed of the ivory palm (pictured on the right) can also be used for carving seals.

STONE IS THE ESSENTIAL MATERIAL FOR THE SEAL

Before approaching the design and carving of a seal, it is important to gather a series of basic tools. The most essential of them is the stone for the seals. The old seals were made of hard materials such as jade, gold, silver, rhinoceros horn, lead, glass, wood, bone, and ceramic. The most commonly used materials nowadays are the *Quing-tian*, or *Ching-tien*, stone (which is black, thin, and strong; the best being the purest and most pristine, transparent or semitransparent) and alabaster, which is easier to work. The quality of the stone is also important; fine stones without flaws must be selected.

Less-sophisticated materials, such as wood or bamboo, can also be used for making seals. The illustration shows one made of bamboo, which is carved on the shaft's joint.

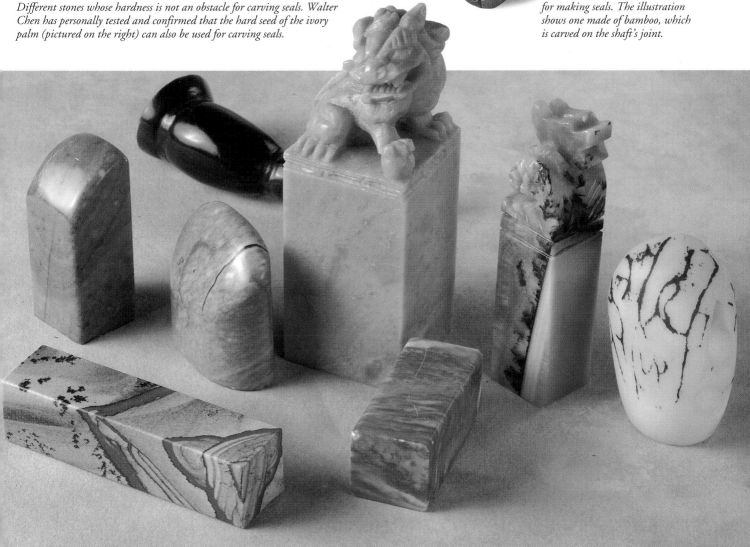

MATERIALS AND TOOLS FOR CARVING THE STONE

In addition to the stone for the seals, there is a series of very important materials and tools that are required. They are:

Dictionary. When carving a seal, it is important to be familiar with the structures of Chinese characters in *Zhuan*, or *Chuan*, writing, for which it is essential to have a good dictionary with illustrations of the strokes.

Graver. Two types of graver are available: flattened tip and slanted, although very few people use the latter kind. In reality, an expert needs only the sharp edge of a knife to carve the character.

Support for the seals. A support for the seal, which is a tool for beginners, helps hold the seal securely in place during carving.

Ink paste. Quality and price of ink paste vary considerably according to the composition. Different colors are available, as chosen by the user, but red ink is the one most commonly used.

Sticks for seals. In the old days the sticks for seals were made of ivory, but nowadays they are made of cow bone. They are used to mix the ink paste. When the paste is left in the container for a long time, the oil rises to the surface, and the sticks are used to mix it with the pigment.

Ruler for seals. The ruler is a tool used for determining where to position the calligraphic characters.

Brush, ink, paper, and inkwell. A wolf-hair brush is used to make the sketches with Chinese ink on rice paper.

Paste in a box has lower quality and therefore is more affordable than ink in ceramic containers.

Emery paper. Emery paper is used for rounding off the edges and for buffing the seals.

Arkansas stone. Arkansas stone is a soft abrasive used for buffing the seals.

Mirror and brush. The mirror is used to check the result of the seal by examining its mirror image, and the brush is used for cleaning the particles produced from carving the seal.

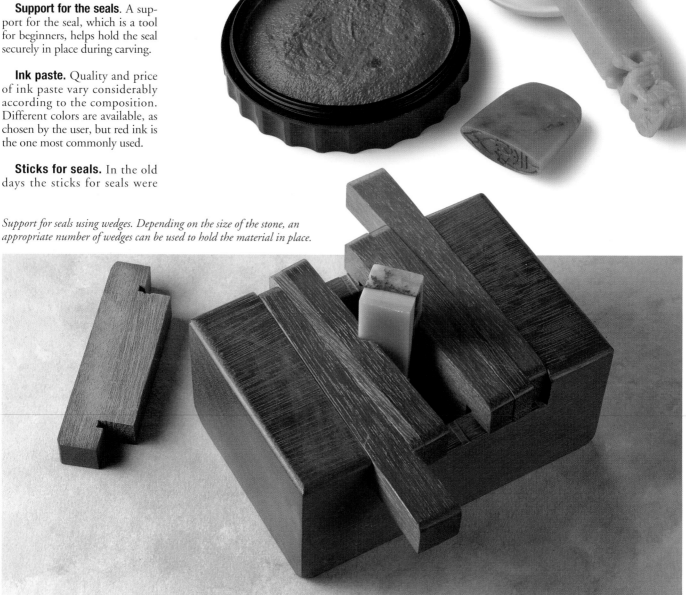

Support for seals using wedges. Depending on the size of the stone, an appropriate number of wedges can be used to hold the material in place.

There are several dictionary editions about ideograms for carving seals. The artist should select one that suits his or her personal taste. In this illustration, the character for "human" (人), can be seen, which has several writing variations for the seal.

Square made of bamboo by Walter Chen.

The mirror is used to check the reverse image of the stone carvings.

CRITERIA FOR CARVING THE STONE

When the decision is made to create a seal it is important to think about the composition, that is to evaluate the proportion between the surfaces with relief and without, which is known as "red on white" or "white on red," referring to the color of the ink and also to the two carving procedures: relief or intaglio.

To create a seal, first, certain decisions need to be made regarding the characters that will be carved, whether the background is going to be red or white, whether it will have heavy or thin lines, and whether the lines are going to be round or square. It is important to know how to modify the background and the borders, and so on. To learn these basic elements, it is necessary to study the master works from different dynasties and then to try out each technique, because they can only be mastered after much practice.

Next, basic considerations for carving a seal are established:

1. Balance. Balance is a vital condition for carving a seal. The size of the characters, the thickness of the lines, and the spaces must be distributed proportionally.

2. Density. Density is one of the main conditions for expressing the contrast between a design that is spread and one that is compact. In general, a medium range is chosen so as not to overwhelm the design of the seal or to leave it too sparse.

3. Adding and taking away. This criterion affects the lines. When the lines of the written characters are very similar, the design may be difficult to execute. So, a line may be added or deleted from the design.

4. Moving the lines. During the composition's design process some lines or parts of the design can be moved to inspire freshness and to prevent lack of flexibility and going against the principle of character creation.

5. Harmony and homogeneity. The design must be diversified with diagonals, crossed lines, triangles, and so forth.

6. Line joints. In certain old seals the lines appear to be connected, as a result of the wear and tear or the ink built up in the spaces. Today this effect is used to enhance the beauty of the form and to solve the problem of multiple or single lines.

7. Borders. To diversify the composition, the shape of the rice field "田" and Sun "日" ideograms are used as borders in old seals to bring about a special artistic effect.

Seal in relief, or "red on white," for the personal book collection, executed by Hong Shang-hua.

"The spreading ink is like the rain," seal made with the intaglio method, or "white on red," executed by Hong Shang-hua.

材料及工具

HOW TO USE THE KNIFE

There are two ways to hold a knife. One is by grasping the handle in your fist, the other by holding it as if it were a pencil. The former requires a dexterous wrist, since it depends on the strength of the wrist and that of the arms. The second is nimbler and requires the strength of the fingers and the wrist.

The way the knife is held affects the seal's beauty directly. After many centuries of practice, the ways for holding a knife have been reduced to thirteen. However, these forms are very complex for explaining in simple words; the most important thing is to master handling the graver or the knife with flow, strength, and energy. As with the brush in calligraphy, rhythm and strength are also important.

The design chosen for the seal to be made. It corresponds to the phrase "Cultivate your heart."

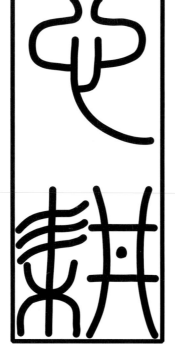

Graphics for the phrase "Cultivate your heart" in Chuan writing.

MAKING A SEAL

First, it is important to plan the design. After some study, the phrase "Cultivate your heart" has been chosen for this example. In Buddhism, the heart of the human being is like a plot of land that we have been entrusted with and that we have the obligation to care for so it produces fruit (to be useful to others).

The word *cultivate* in Buddhist philosophy means "to contribute something good to the people that surround us so our environment can change." This way, we sow our seeds for the transformation of the world, hoping that others will do the same by following our example.

THE CARVING PROCESS

In summary, this process consists of the following phases: the placement of the stone in the support, followed by the transfer of the desired character or design, and then the carving itself. After the process is finished, it is important to check the result first with the mirror. If there is an error, the characters or the design can be corrected, and that completes the process. Finally, the seal can be stamped.

1. A rectangular stone that has already been smoothed is selected. It is placed in the center of the support, and the wedges are adjusted to hold it in place.

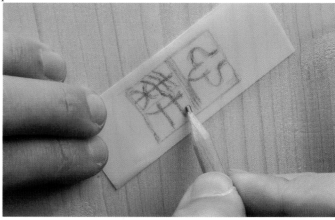

2. The phrase is written with a pencil on tracing paper and redrawn with a marker.

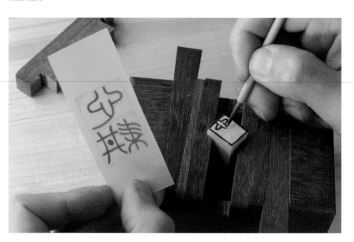

3. The paper is turned over, and with the phrase reversed, the stone is painted with black ink using a very thin brush.

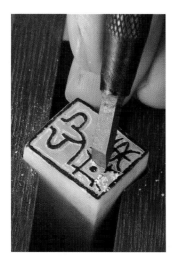

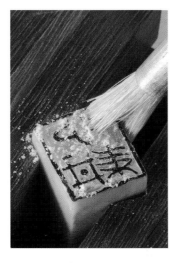

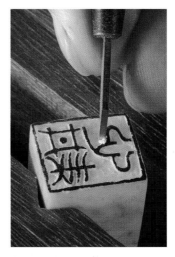

6. *Now a thinner graver is chosen to define the edges of the lines. The frame can be rotated at any time if needed.*

4. *When the carving is begun, the outlines of the lines and the inside of the frame are marked with a flat graver. When this is done, carving is begun from the edge of the lines outward, slowly. Only the last two fingers are placed on the frame as support.*

5. *From time to time, the dust on the stone is wiped off with a brush so the lines are always clearly visible. We continue hollowing out the seal, trying not to move the wrist; only the fingers push the graver.*

7. *When the carving is finished, the mirror is used to make sure that the composition is correct. If a mistake is found, it is corrected.*

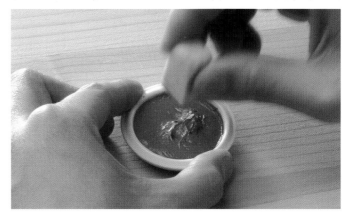

8. *Before the ink is used, the entire surface is cleaned with a brush. Then the seal is gently tapped several times on the ink.*

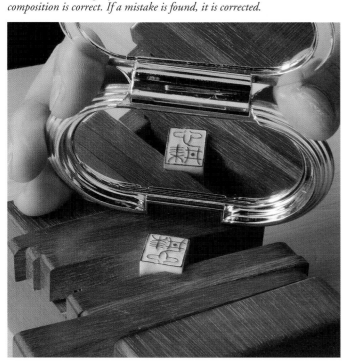

9. *A sheet of rice or Shiuan paper is laid over a soft, thin cloth, and the seal is lowered slowly, pressing on the paper. Then the seal is lifted up a little bit.*

10. *To finish, the stamping is checked, making sure that the composition of the seal is evenly distributed.*

材料及工具

Displaying Paintings and Calligraphy

When a painting is completed, the artist must choose the most appropriate display method to create a perfect way to present it. The most common display formats are the vertical scroll, the horizontal scroll, bound pages, a frame, diptychs, and multiple paintings, among others. Therefore, when we talk about painting scrolls we are referring to that type of presentation.

VERTICAL AND HORIZONTAL SCROLLS

The display process, which is the equivalent of framing in Western painting, consists of adhering the painted works onto *Shiuan* or rice paper, allowing it to be sufficiently flexible to be scrolled. It is at once a practical way of protecting the painting, transporting it, and showing it.

The scroll can be vertical or horizontal. The vertical scroll is commonly known as the "central salon." It is used primarily for vertical decorative hanging. This type of decoration appeared between the years 475 B.C.E. and 221 B.C.E. The horizontal scroll, or "long scroll," cannot be hung, but it can be viewed spread over a table. This method is very convenient for showing a series of images or stories that take place through time. It was used to store most of the works during the Wei (220–265) and Jin (265–420) dynasties.

The oldest preserved vertical and horizontal scrolls are from the tenth century and belong to the Northern Song dynasty. In those days, vertical displays had all four sides framed in silk. At the bottom two silk ribbons were added to frighten birds away from inside the house, preventing them from ruining the scrolls with their droppings. In present-day scrolls these two ribbons are also present, but now they play only a decorative role.

During the Ming dynasty, vertical scrolls had a space in which to write verses, called "salon for verses," reserved at the top. Horizontal scrolls from this period had white paper adhered to the front of the painting for writing inscriptions. Each dynasty introduced variations for the presentation and decoration of painting scrolls.

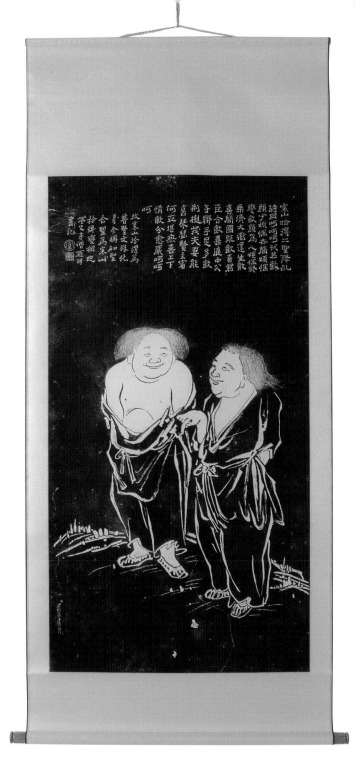

Portrait of the monks Han San (left) and Shy De, exact copy of an inscription found on a tombstone of the temple Han Shy (established in 502–519, during the Southern and Northern dynasties). During the Tang dynasty, the two monks went on a journey to the temple, and from that moment on its name was changed to Han Shy.

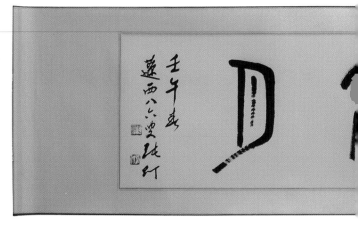

MATERIALS AND TOOLS

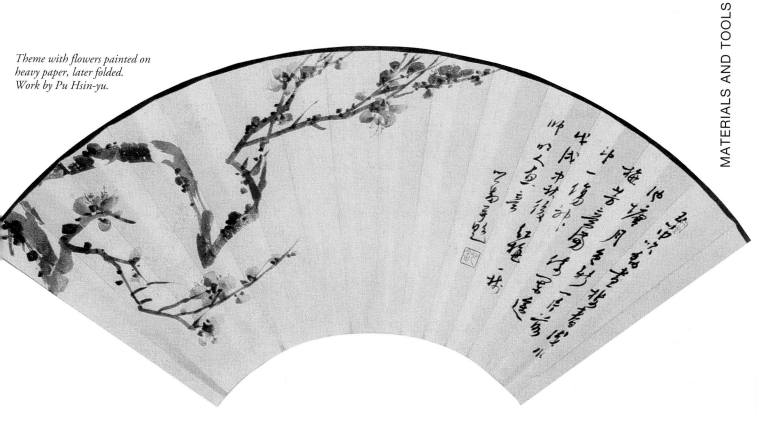

Theme with flowers painted on heavy paper, later folded. Work by Pu Hsin-yu.

DIPTYCH

Diptych is a commonly used method. It consists of adhering the work to a support that is folded in half, forming two panels. This display method made its appearance at the end of the Ming and beginning of the Qing dynasties.

BOUND PAGES

Bound pages are, as the name suggests, a bundle formed by small paintings and many sheets. They are presented as volumes, whose sizes vary considerably, and they can be opened either vertically or horizontally.

GROUPED PAINTINGS

Grouped paintings are a series of paintings placed on panels resembling a folding screen. Generally, they consist of four, six, or eight parts, with a maximum of sixteen. They are arranged in this manner to form a complete painting, and it is not recommended that they be hung separately.

FRAMING

Framing is the display of a single sheet placed behind a glass panel, the same format often used to display a Western watercolor.

HORIZONTAL FORMAT

The horizontal display format is suitable for paintings that are not too long. The difference between this format and the horizontal scroll is that this is shorter, can be hung on the wall, and can be enjoyed permanently. It is quite popular.

FAN

The fan is a traditional Chinese display method in which the painting is done on *Shiuan* paper that is more durable than the standard *Shiuan* paper so it can withstand the opening and closing of the fan.

Cultivating the Cloud, Planting the Moon. Calligraphy work by Chang Tin (1917), created especially for the Walter Chen "Cultivate" exposition of 2002.

材料及工具

PREPARING THE LAMINATION

Traditional paintings and calligraphy use silk, rice paper, and *Shiuan* paper as supports for their delicate quality and softness. When the work is dry it tends to wrinkle, and for this reason it is necessary to apply a somewhat harder and heavier support underneath to flatten it, to make it sturdier, and to allow it to be displayed.

Lamination is the initial step of the display process of a work; it is considered a very involved procedure. Great patience is required when making the glue and applying it to the support. In the following exercise the initial process for the display of a work of art is shown.

PREPARING THE GLUE

The process is based on the elimination of gluten from the flour and the preservation of starch to make a paste that is not too adhesive but that maintains its elasticity.

REEMAY

Reemay is an acid-free product made of 100% non-woven polyester, whose fibers are randomly arranged. Reemay has proven to be, through the years, a very durable and useful material for restoration and conservation techniques. Even when wet, it maintains its physical properties, and when there are changes in the levels of moisture, its dimensions are stable. It is used for the restoration of paper, as a support for drying, for rebinding, to separate sheets, and as a liner. It can be used over and over again, and it withstands washing.

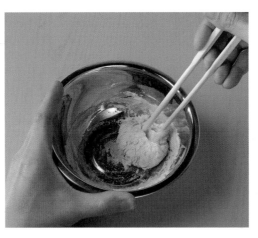

1. Flour is combined with distilled water using chopsticks to mix it in a bowl. At the beginning the sticks are rotated in the same direction, and then the dough is kneaded with the hands until it becomes very elastic.

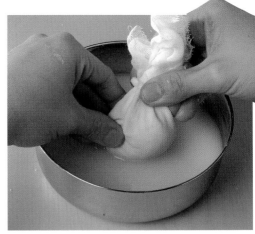

2. The dough is placed inside a pouch made of two layers of very thin gauze (cheesecloth). Then, the pouch is washed inside a larger bowl filled with distilled water. The gauze is squeezed between the fingers to remove the starch little by little.

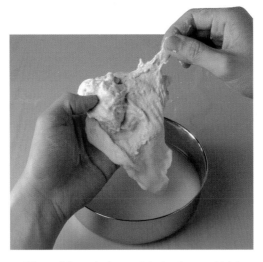

3. What is left inside the pouch is the gluten, which is discarded.

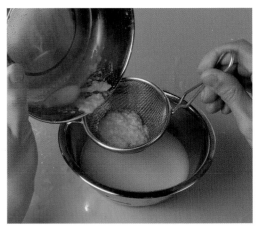

4. Next, the liquid is poured through a fine strainer and the material that is retained in it is discarded because it could contain gluten. The paste that is left in the new bowl is used to make the traditional starch glue.

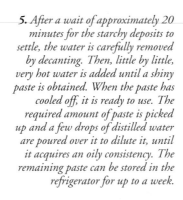

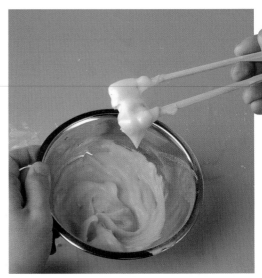

5. After a wait of approximately 20 minutes for the starchy deposits to settle, the water is carefully removed by decanting. Then, little by little, very hot water is added until a shiny paste is obtained. When the paste has cooled off, it is ready to use. The required amount of paste is picked up and a few drops of distilled water are poured over it to dilute it, until it acquires an oily consistency. The remaining paste can be stored in the refrigerator for up to a week.

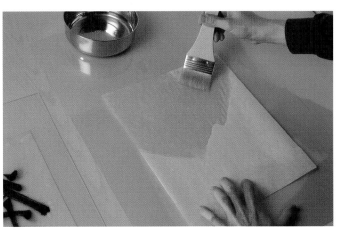

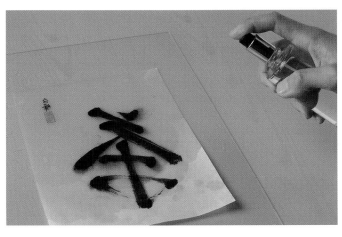

6. *The process begins by applying the glue. To do this, the work is laid facedown on a very flat surface (such as a piece of glass), and with a water spray bottle the backside of the work is sprayed evenly.*

7. *Separately, a transparent sheet of somewhat heavy plastic is attached to Shiuan paper or the prepared rice paper. Glue is applied to the sheet with a wide brush beginning at the center and moving outward.*

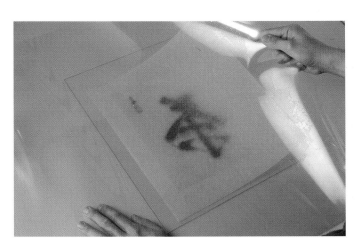

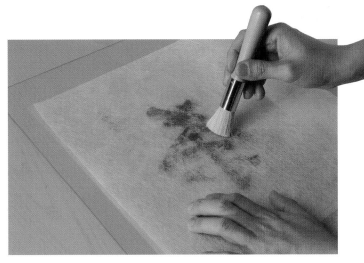

8. *The entire plastic sheet is transferred over the work, with one of the corners lowered first, until the work and the support are glued together. One of the edges of the plastic sheet is lifted very carefully.*

9. *After the initial plastic sheet is removed, the Reemay is placed over the work to protect it and is gently tapped with a stencil brush to push the bubbles out. Finally, the Reemay is removed.*

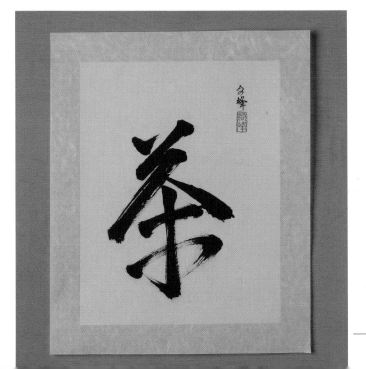

10. *The work is left on the table with the glass for twenty-four hours. After that period, the work can be lifted at the corner. This is how a laminated work can be created, which in this case was the calligraphy character for* Té *executed by Walter Chen.*

ANOTHER ALTERNATIVE

Nowadays, commercial methylcellulose glues can be used. They are excellent for repairing torn paper and for gluing silk. They produce a matte finish when used diluted. Methylcellulose is a powder that is mixed with distilled water. It does not stain or discolor the paper, and it is odorless, nontoxic, and not affected by heat or cold. It has a neutral pH and becomes transparent when dry.

材料及工具

Techniques for Representing Vegetation

Beginning with the Tang dynasty (618–907), the new art of landscape painting emerged in China, evoking a poetic reevaluation of nature. Painting mountains, valleys, forests, and gardens became a very important genre because nature is a subject matter that allows the artist to escape the materialistic world and to enter the kingdom of peace and tranquillity transmitted by nature. Landscapes are not simply a physical representation but an emotional reality that the artist must sense and transmit with the strokes of his or her brush. In contrast with the Western world, where originality is the constant quest, in Chinese landscape painting the teachings of the masters, which have been compiled through the centuries in model books, are venerated and have been followed for centuries.

Pages of a model book, which explain the many ways of painting leaves and how to apply color.

MODEL BOOKS

The album of the *Chieh Tzy Yuan* (芥子園畫譜) model is considered a painting manual that communicates the techniques and the artistic criteria of the great painters of the past. It offers some guidelines for the best ways to represent the main themes related to Chinese painting through the evolution of the dynasties. Its writing and compilation began at the beginning of the Qing dynasty (1644–1911), thanks to the work of several authors and artists.

This book begins with the most basic concepts of painting: the use of colors, the brushes, the ink, the texture, the coloring, the styles, and the composition of the work. Then there are illustrations of trees, mountains and rocks, people, houses, pavilions, vegetation, insects, flowers, and still life in the *Gongbi* style, which serve as a reference for the

amateur painter. Finally, the book shows selected paintings by the great masters as a reference point and support for the development of a personal style.

These models are good for beginners and for experts: as an initiation for the former and for the latter to create their work by blending tradition and its deep meaning.

ORGANIZATION OF THE MODEL BOOKS

The *Chieh Tzy Yuan* book first introduces the theory and then shows examples as models classified by category, and within them by theme, of every kind of artistic element (plants and their parts, animals, rocks, figures, etc.). To conclude, models by the great masters are represented.

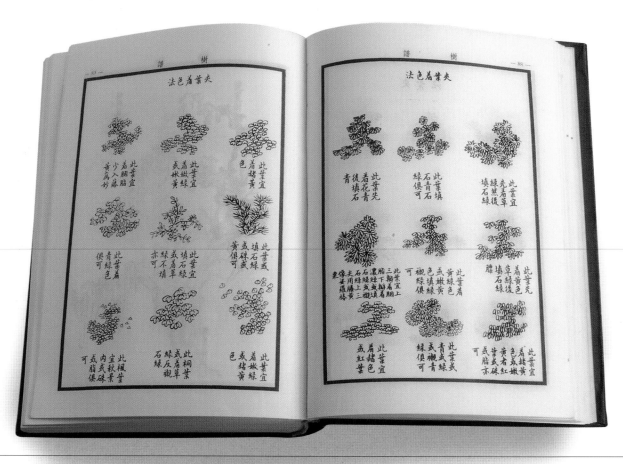

TREES AND THEIR BASIC FORMS

Trees play a very important role in Chinese painting and are represented in many ways. In general, the outer lines of the tree are painted first, followed by the thick branches, and finally the thin ones, using a stiff, fine-hair brush.

If the artist wants the trees to have thick foliage, the branches are covered with a multitude of dots that convey the movement and nature's sense of transformation, while leaving the branches empty represents winter's silence, tranquillity, and calmness. Different models are shown below. The names correspond to the translated definition of the book of models.

THE "DEER HORN"

The branches of a tree have a tendency to grow upward, with a little bit of a curve. This model often represents an autumn forest. To achieve greater depth, the ends of the branches are painted with very dense ink. If the artist wants to paint the onset of the spring, green touches are added to the branches. And if little red dots mixed with brown are added, it gives the effect of frost on the landscape.

Tree painted like "crab claws."

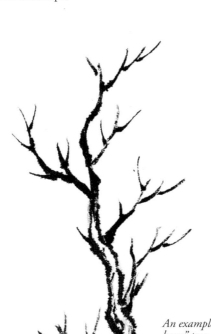

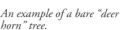

An example of a bare "deer horn" tree.

A tree full of vitality is created with simple lines and turns. The arrows and the numbers show the sequence of the lines.

THE "CRAB CLAW"

The structure of this tree is practically the same as the previous one, but here the branches hang down like the claws of a crab. First it is painted with dark ink, and then it is washed with very diluted ink. The result is a forest covered by mist. If the wash is done within the outlines of the trees with very wet ink, the result will be dew-covered trees.

技巧與習作

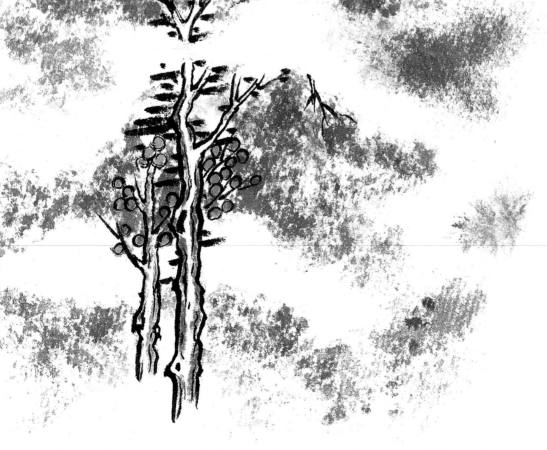

A TREE AGAINST THE WIND

This model is usually placed on a single rock or on a mountainside, keeping in mind that most of the branches should be painted in the same direction. The tree is placed in a position of danger, facing the strong wind; this is why some branches are superimposed over others.

This tree is usually painted in a small size on the steep mountainsides of Chinese landscapes.

The light painting done with various inks conveys a greater or lesser degree of vitality to the vegetation and reveals the season.

SMALL TREES AMONG THE CLOUDS

When trees are painted in distant planes, the artist must consider the environment in which they are located. These two trees are placed in an environment surrounded by thick clouds; therefore, not many leaves are visible. Very thin, short, and horizontal lines painted with the tip of a horsehair brush provide a very special expression because it is easy to define the separation between the leaves and the clouds. Here, a small tree with round leaves has been added. Sometimes, the leaves are filled in with black, diluted ink, but they can also be tinted with a very light brown when there is need for a very subtle touch of liveliness in a work painted completely in gray tones. This type of tree is normally painted faraway and small, and it is often used to complete a landscape, when the artist considers that the composition lacks some component. In such cases, it is a good idea to add natural elements like this one.

DISTANT TREES WITH NARROW TRUNKS

This type of tree has a slender trunk, which is typical of conifers. These trees are painted from top to bottom, beginning with the trunk and continuing with the branches, going from the trunk outward. It is a good idea to use a single diluted tone and to apply it with darker ink on the tip of the brush. This way, the top of the tree is visibly darker than the bottom. This tree may not look like a real one, however; the environment and how it looks at the end should be the main objective. When a wash is added to the work, it should be extremely light, and should be applied following the direction of the needles. The washes do not necessarily have to stop at the lines. They need not be applied with a single stroke either; they can be successive, to highlight the depth and richness of the tones each time.

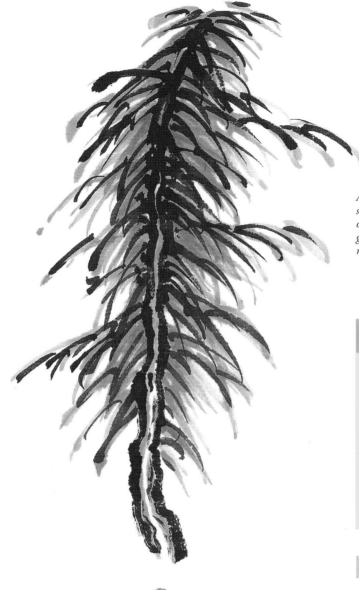

Although Asian conifers look somewhat different from those of other areas, Chinese painting is not greatly interested in achieving a realistic look.

THE SIZE OF THE TREES

Trees are painted large if they are located in the foreground, and they are painted smaller if they are supposed to show distance, reduced to small dots when they are far away. Therefore, trees, like other objects, must relate to one another proportionally according to the ground that they occupy.

A DISTANT CYPRESS FOREST

To represent the cypress tree, the trunk is painted first, with two strokes, followed by the leaf mass, with horizontal strokes, which are applied with the tip of a horsehair brush. The trees in the foreground are darker, while those behind them become lighter to indicate the effect of the distance. If the forest is surrounded by fog or is in the clouds, the area is painted with a little bit of very diluted blue. If the painting represents a summer landscape with a clear sky, then the trees are painted with light green. Traditionally, the trunks are painted light brown, but this is a general guideline. Sometimes, they are painted with other colors or with denser ink with greater coverage, depending on the feeling that the model inspires in the artist.

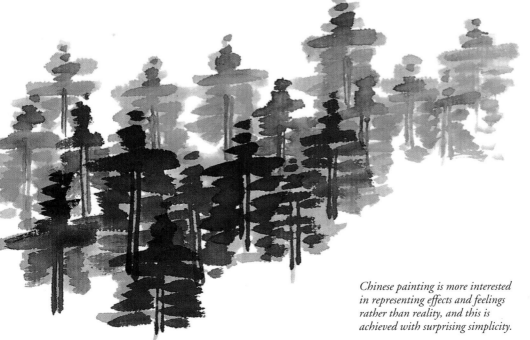

Chinese painting is more interested in representing effects and feelings rather than reality, and this is achieved with surprising simplicity.

技巧與習作

THE THREE FRIENDS OF WINTER

In China there is a very old adage: "the pine tree, bamboo, and the plum tree are the three friends of winter." This means that the pine tree lives in cold climates and remains unchanged through adverse conditions; bamboo keeps its leaves through the harsh winters; and the plum tree looks radiant this time of the year because it is in bloom. Next, the basic techniques to represent a pine tree *(song)* and bamboo *(ju)* are shown; the plum tree will be covered later.

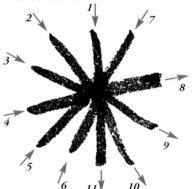

The needles of a pine tree, which have a starlike configuration, can be painted in different ways according to personal style. Here, one method is shown; the left side is painted inward and the right side outward.

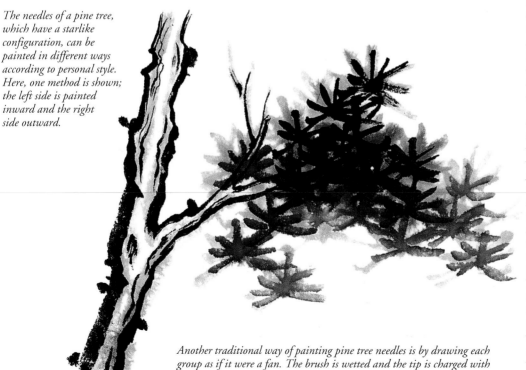

Detail of the texture and the needles on small branch of a pine tree.

Another traditional way of painting pine tree needles is by drawing each group as if it were a fan. The brush is wetted and the tip is charged with black ink; the needle shows the richness of a graduated ink effect.

THE PINE TREE

In Far Eastern cultures a pine is considered the "tree of life," literally, which means that even in old age it appears green and fresh. It is very cherished as the symbol of immortality and longevity and of eternal conjugal happiness. In Chinese art, the pine tree *(song* 松 *)* is a symbol of firmness, because even in cold winters it preserves its needles, whose arrangement, in pairs, symbolizes the duality of a married couple.

When a pine tree is painted at close range, the texture of the trunk and the bark is very important. A very stiff brush is used, charged with a small amount of thick ink. A few areas of the trunk, which represent moss or broken branches, are left unpainted, and the scaly texture is created by repeating oval shapes with the nearly dry ink. For the needles, the mixed-hair tip of a medium-size brush is used, and they are painted using star shapes. The branches should not be excessively covered with needles; empty spaces should be left for the composition to breathe. They are tinted with a very diluted wash, and when they dry, they are painted over with light blue mixed with very diluted ink.

竹

BAMBOO

The bamboo plant plays an important role in the art and symbolism of Eastern cultures, besides being a very useful plant all over the world. The cane, which shows an "empty heart" when opened, is related to modesty; its unchanging color (it stays green all the time) and its slender look symbolize old age. Pieces of bamboo put in a fire burst with a loud noise, chasing away evil spirits.

Traditionally, bamboo is painted in the *Shieyi* style, with black ink, and *Gongbi*, with very thin lines painted green. In this case, bamboo is represented with a range of reds. Dark red is applied for the foreground, and very light, diluted red for the distant leaves. This means that the different tones that are to be used must be prepared in dishes before the process begins. If after finishing the overall painting the artist notices that a stalk or leaves are missing, new washes are added until a well-balanced result is achieved.

Bamboo branch painted with black ink, in which the different tones mark the proximity or distance of the leaves and the small branches.

In this fragment of a bamboo plant the three basic forms of the bamboo—the cane, the thick branches, and the elongated leaves—can be seen. The harmony with which they are arranged is vital for conveying its beauty and poetry.

技巧與習作

LEAVES, GRASS, AND VEGETATION

When painting a tree that is in the foreground, it is important to check that the texture and the form of its trunk and leaves are clearly distinguishable; if so, the tree can be painted realistically, in detail. However, if the model is far away from the spectator, the details are less distinct; in this case the most important thing is the artist's interpretation. Every artist chooses the type of leaves that he or she wants to add to the tree. This selection responds to personal choice; the goal is for the painting to convey the desired emotion. The spirit, the emotion, is more important than the real form.

BASIC FORMS

Below are some basic examples showing how to create the texture of vegetation. The groups of leaves shown are suitable for representing the foliage of trees, the grass, and other plants in the landscape. The way the strokes are applied is similar in all cases, although it can be changed according to the type of texture that must be represented.

Small patterns used for different vegetation effects.

SMALL STROKES

These leaves are painted with a horsehair brush because the hair is stiffer, making the brushstrokes easier to control. This type of brush is used to paint the foliage of the cypress tree, moss, and the texture of rocks. A common way to handle this is to angle the brush, using only one-third of the bristles.

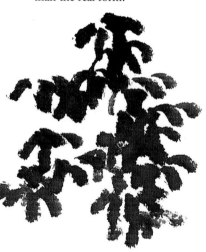

The leaves and the masses of flowers of this ornamental tree, the parasol, are represented with these patterns.

BRUSHSTROKES FOR THE PARASOL TREE

To paint the parasol tree, an ornamental tree of Chinese origin, each leaf is painted independently; each unit requires four brushstrokes, beginning with the two central areas. Sometimes, one or two shorter brushstrokes can be added according to the composition of the tree.

BLACK PEPPER SPECKS

The black-pepper-speck brushstroke is often used to paint forests on mountains in the distance, and tree leaves and vegetation near the water. Sometimes, if the brush is wetted with only a small amount of paint, this brushstroke can be used to represent the texture of the rocks.

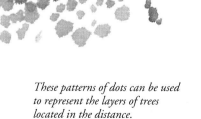

These patterns of dots can be used to represent the layers of trees located in the distance.

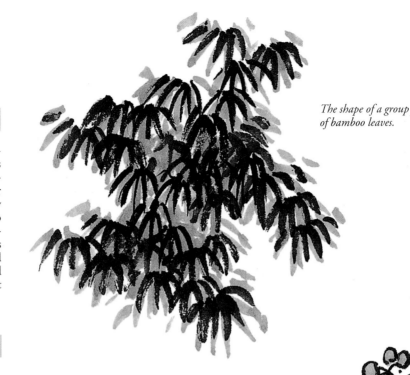

The shape of a group of bamboo leaves.

YOUNG BAMBOO

Bamboo appears often in Chinese painting. If the brushstrokes are short, they resemble the texture of tree leaves. If, on the other hand, they are elongated, they represent bamboo leaves. To paint this type of tree, a medium-round brush with mixed hair is used. The leaves can be painted with light blue or green diluted ink depending on the season that is being represented.

LEAVES MADE WITH LINES

Leaves made with lines belong to the bamboo family. Normally, a single color and a very thin brush are used to paint the leaves. Then they are tinted with more-diluted brown ink if the artist is portraying an autumn landscape, or with yellow-green if it is spring.

This representation of the foliage of a plant related to bamboo is drawn with pairs of thin lines.

This plant texture was created with very simple brushstrokes forming very small circles like specks of pepper, but fewer and thicker. They can be painted yellow Garcinia cambogia or green if they are young blooms.

Even though triangular shapes are not common in Chinese painting, this model is sometimes used to highlight certain areas that have soft elements. They are usually painted red or brown, and yellow is avoided.

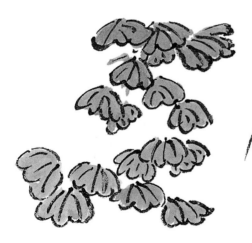

Folded parasol tree leaves can be drawn with very thin lines and are painted emerald green if they are part of a spring or a summer landscape.

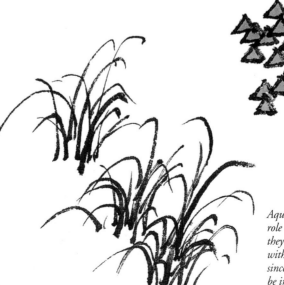

Aquatic plants do not play a central role in Chinese painting, however, they are not unusual in landscapes with waterfalls or water in general since their free shapes allow them to be integrated in compositions between land and water.

技巧與習作

THE LONG LEAVES

Before painting a plant, it is important to study its characteristics and shape. In the representation of this vegetation, the shape and distribution of the leaves play a decisive role, especially when the model is nearby. It is important to study the long leaves that stem out of them—how they grow, their thickness, their outline, how they fall, and their color—because this is the only way to distinguish botanical species, a subject recurring often in Chinese painting.

NARCISSUS

With a round thin brush, the nearest leaves of the narcissus are painted with very thin lines starting at the root and going up to the tip. Beginner artists should move the wrist slowly. When the brush reaches the point where the leaf begins, the hand should move in the shape of an S. The *Gongbi* style, shown here, requires great concentration and attention to the line.

It is also common to paint long leaves hanging down. The shapes of the leaves are painted with light lines and the texture with even thinner lines, creating an effect of movement.

Narcissus leaves painted in the Gongbi *style, with only black ink.*

DAYLILYS

Daylily leaves are similar to those of the narcissus, the difference being that the outlines form a subtle curved shape; therefore, the movement of the wrist is more abrupt in the case of the narcissus. Normally, the top is colored with yellow-green and the reverse with dark green.

Daylily leaves showing the color change depending on whether the leaves are facing up or down.

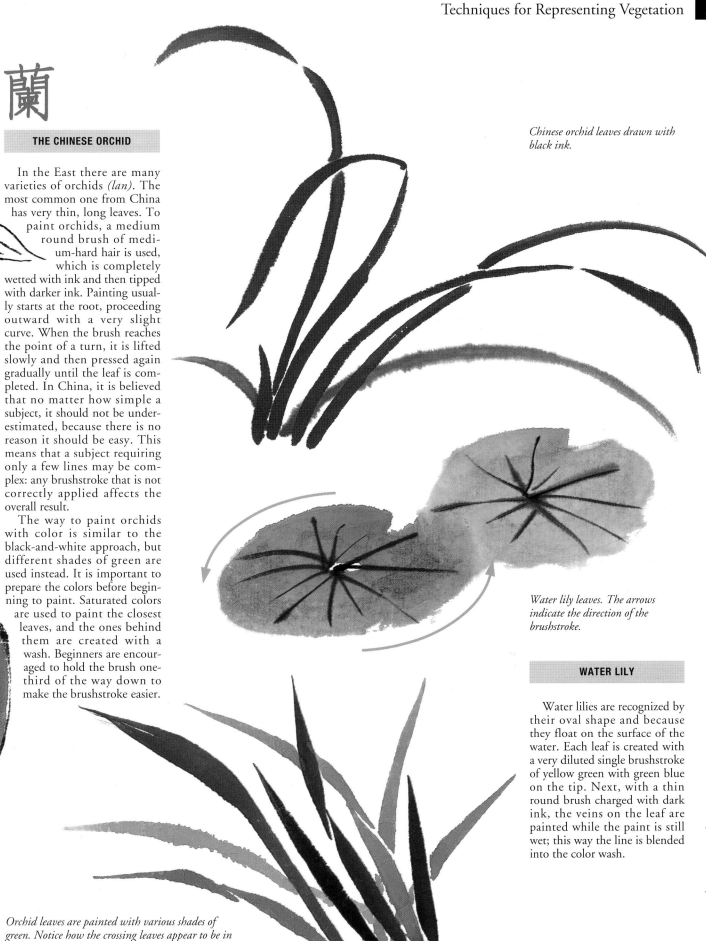

蘭

THE CHINESE ORCHID

In the East there are many varieties of orchids *(lan)*. The most common one from China has very thin, long leaves. To paint orchids, a medium round brush of medium-hard hair is used, which is completely wetted with ink and then tipped with darker ink. Painting usually starts at the root, proceeding outward with a very slight curve. When the brush reaches the point of a turn, it is lifted slowly and then pressed again gradually until the leaf is completed. In China, it is believed that no matter how simple a subject, it should not be underestimated, because there is no reason it should be easy. This means that a subject requiring only a few lines may be complex: any brushstroke that is not correctly applied affects the overall result.

The way to paint orchids with color is similar to the black-and-white approach, but different shades of green are used instead. It is important to prepare the colors before beginning to paint. Saturated colors are used to paint the closest leaves, and the ones behind them are created with a wash. Beginners are encouraged to hold the brush one-third of the way down to make the brushstroke easier.

Chinese orchid leaves drawn with black ink.

Water lily leaves. The arrows indicate the direction of the brushstroke.

WATER LILY

Water lilies are recognized by their oval shape and because they float on the surface of the water. Each leaf is created with a very diluted single brushstroke of yellow green with green blue on the tip. Next, with a thin round brush charged with dark ink, the veins on the leaf are painted while the paint is still wet; this way the line is blended into the color wash.

Orchid leaves are painted with various shades of green. Notice how the crossing leaves appear to be in the background.

技巧與習作

TECHNIQUE AND PRACTICE

FLOWERS

Flowers have always had an important place in the daily life of Chinese culture. Most of the art and decorative themes of houses, interior and exterior, are based on them, even if they are small details such as relief on doors, windows, and columns, or the decoration of food.

The idea behind representing flowers is to capture the essence of their beauty: a realistic copy of the model is not important; rather, creating a spontaneous feeling that highlights their esthetic value and that conveys the personal interpretation of the artist.

The way the brush is handled is very important because it transmits "the movement of the energy" of the stems and the petals. Also important are the gradations that are created by changing the density of the ink color, the flow of the external lines that mark the outline of the model, and the preservation of the appropriate compositional balance among flowers, branches, and leaves.

FOUR CRITERIA FOR PAINTING ORCHIDS

Following are four simple methods for representing a Chinese orchid *(lan)*:

1. Drawing with lines and painting in color. This method requires great technical mastery in the use of very thin brushes and in drawing very diluted lines. The orchid's outline is painted with black ink starting with the stem and following with the flower, with each petal drawn individually. Finally, the spaces are filled in with red and green washes.

2. Painting areas of color. To produce this effect, the entire brush is dipped in a single color. Then the tip is wetted with a different, darker color. When the line is painted on the paper, a two-color area, which blends to form gradations, can be observed. To achieve this effect, use a goat-hair brush dipped in white and tipped with dark red. At the beginning, for the first petal, the dark red extends up two-thirds of the brush. As the rest of the petals are painted, gradually less red is used. This way, the resulting effect is very natural in each brushstroke, and there is no need for glazing.

Orchids can also be painted cascading down, placing the roots in the upper part of the painting. To achieve this effect, long brushstrokes are used to paint the leaves, and short ones to paint the flowers. Then, with a more diluted tone of ink, the branches are drawn stemming out of the roots.

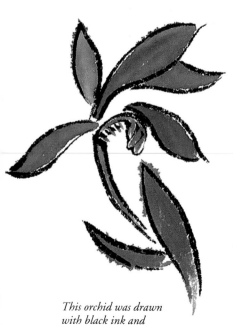

This orchid was drawn with black ink and painted with color.

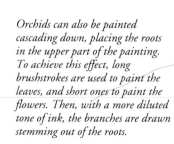

Orchid painted with blocks of color.

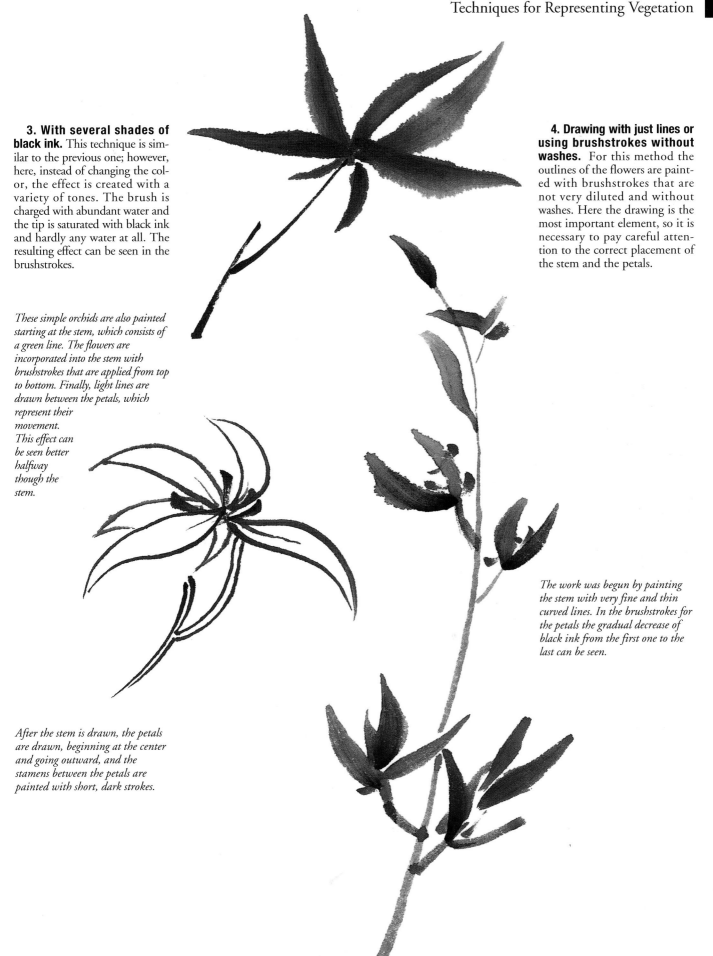

3. With several shades of black ink. This technique is similar to the previous one; however, here, instead of changing the color, the effect is created with a variety of tones. The brush is charged with abundant water and the tip is saturated with black ink and hardly any water at all. The resulting effect can be seen in the brushstrokes.

These simple orchids are also painted starting at the stem, which consists of a green line. The flowers are incorporated into the stem with brushstrokes that are applied from top to bottom. Finally, light lines are drawn between the petals, which represent their movement. This effect can be seen better halfway though the stem.

After the stem is drawn, the petals are drawn, beginning at the center and going outward, and the stamens between the petals are painted with short, dark strokes.

4. Drawing with just lines or using brushstrokes without washes. For this method the outlines of the flowers are painted with brushstrokes that are not very diluted and without washes. Here the drawing is the most important element, so it is necessary to pay careful attention to the correct placement of the stem and the petals.

The work was begun by painting the stem with very fine and thin curved lines. In the brushstrokes for the petals the gradual decrease of black ink from the first one to the last can be seen.

技巧與習作

THE CHRYSANTHEMUM

The chrysanthemum is very similar across all the countries in the Far East. In China it is believed to promote longevity. The chrysanthemum *(jiu)* is considered a symbol of simplicity, natural spontaneity, and discretion. Its flower has a regular form, and its petals are arranged in the shape of sunrays. In the East as well as in Europe it is considered a flower of autumn, the season of peaceful life when the work in the fields has been finished.

The chrysanthemum's front view. The front view of the chrysanthemum is painted beginning at the center, with very strong pairs of lines, forming a circle. When the first circle is finished, painting continues, keeping in mind the perspective of the angle from which the flower is seen, until the chrysanthemum is completed as if it were a ball. Notice the flow of the lines. It is very important to paint with firm and decisive brushstrokes.

Front view of a painted chrysanthemum.

菊

Flower designs vary from painting to home decoration to food. This is a special interpretation of the decoration for a dish, a chrysanthemum made from the peels of several oranges. Work by Walter Chen.

The chrysanthemum's side. The stem and the base of the chrysanthemum are properly painted with loose brushstrokes, followed by the petals. The painting of pairs of lines is continued from the base outward, painting only the tips of the petals that are concealed.

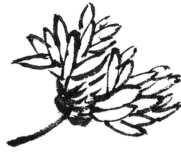

The chrysanthemum seen from the side appears somewhat disorganized. Here, it is seen just at the moment of blooming; therefore, before painting it is important for the artist to plan how he or she wants to represent the flower.

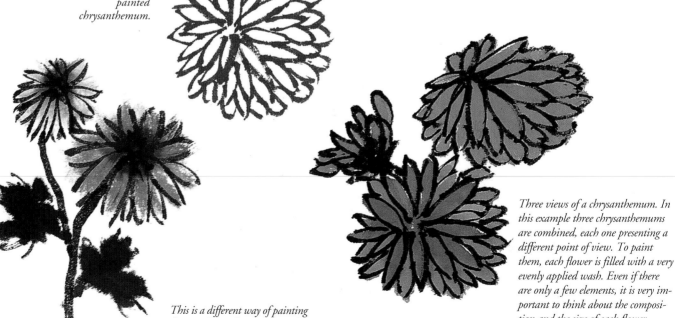

This is a different way of painting flowers. Shown here is a pair of chrysanthemums painted with lines and then covered with very light ink, different from those on the right.

Three views of a chrysanthemum. In this example three chrysanthemums are combined, each one presenting a different point of view. To paint them, each flower is filled with a very evenly applied wash. Even if there are only a few elements, it is very important to think about the composition and the size of each flower, because the space between them contributes to the explanation of the movement of the surroundings.

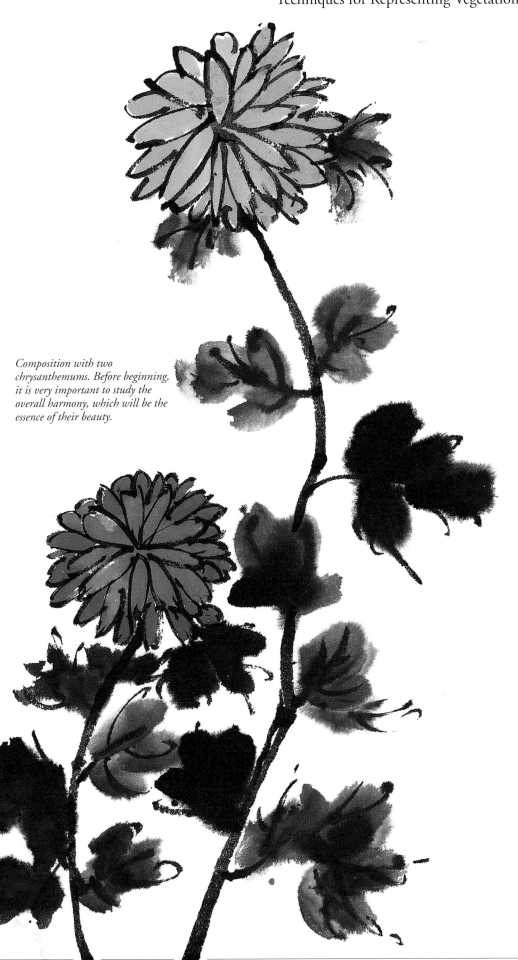

Two flowering chrysanthemums. Here is a more difficult subject. The painting is begun at the stem, leaving an empty space halfway up to paint a leaf later. Then, with a medium goat-hair brush capable of holding more water, the leaves are painted darker, keeping in mind that every leaf requires three brushstrokes. When the leaves are still wet, the veins are painted with a thin round brush dipped in thick ink. Notice how some veins extend out of the area of color, which happens often especially in the *Shieyi* style, because it denotes freedom. When the leaves are finished, the first flower is painted and then the second one, as indicated before. In a painting of more than one flower, how the flowers are positioned is very important since they are treated as if engaged in intimate conversation. The position of the lower one looks almost as if it were leaning on the upper one, and the stem of the latter has a couple of turns, which show the strength of its vitality. This means that "to reach higher and farther one would need to learn more," which is also an unchanging philosophical principle of Chinese thinking.

Composition with two chrysanthemums. Before beginning, it is very important to study the overall harmony, which will be the essence of their beauty.

<div style="writing-mode: vertical">TECHNIQUE AND PRACTICE</div>

技巧與習作

TECHNIQUE AND PRACTICE

荷

THE LOTUS FLOWER

The lotus *(he)* has a showy flower that can be seen on the surface of lakes and ponds. It is a symbol related to escaping darkness and emerging into the light; it is also associated with spiritual fulfillment and purity. In China, the symbolism of the lotus is also related to Buddhism and Taoism. This plant, whose roots are buried in the mud, emerges from it clean, exuding a delicious aroma, with the petals of a beautiful flower that faces up. It constitutes the image of pure desire, and also of a jewel or a precious object.

The richness of the lotus flower resides in the fusion of pink and white colors. In this case, a subtle mixture of colors is used in the hair of the brush, which helps create a poetic painting.

To create this simple flower, fine lines are drawn to form the lotus petals, with some splotches for the leaves, and then a very curved single brushstroke to paint the stem. Then, the texture of the leaf is created with lines and a few small dots for the stem.

THE PROCESS

The stem of the lotus flower is painted first, beginning at the root and extending toward the base with a brush whose hair is neither very stiff nor very soft, charged with a mixture of medium-black ink and brown on the tip. After the brush is used, it is washed immediately and then switched to a darker tone of ink, which is applied with a light dotted pattern on the stem to achieve a very natural fusion of the colors. Then the artist switches to a goat-hair brush, which is softer and capable of holding more water. The brush is wetted with pink paint and tipped in white, and the petals are painted from the outside in. Several brushstrokes meet in the flower's center, creating an interesting effect. Without waiting for the previous brushstrokes to dry, the artist paints a couple of yellow smudges in the middle of the flower. Finally, the water is painted using a few gray washes around the stem.

The Gongbi *technique requires a very steady hand. The shape of the flower, the leaf, and the veins are drawn with a very thin round brush. The following step includes the painting of the petals with a light red, and then changing quickly to light green to add a small amount of it at the beginning, but it also acts as a connection between the stem and the flower. The leaves are painted with light green on top and dark green on the reverse.*

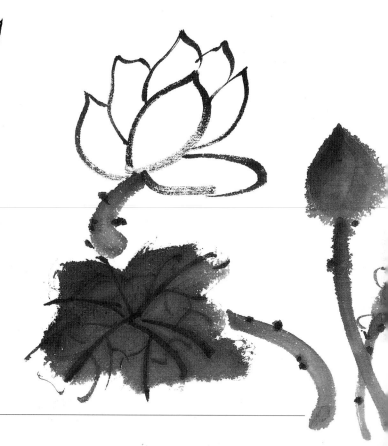

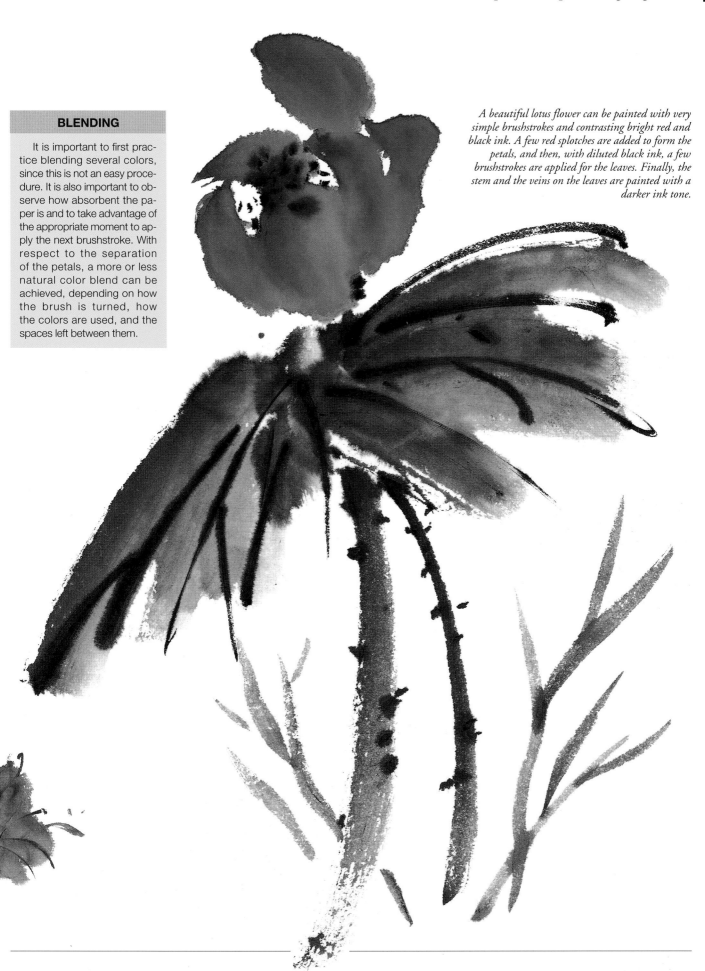

BLENDING

It is important to first practice blending several colors, since this is not an easy procedure. It is also important to observe how absorbent the paper is and to take advantage of the appropriate moment to apply the next brushstroke. With respect to the separation of the petals, a more or less natural color blend can be achieved, depending on how the brush is turned, how the colors are used, and the spaces left between them.

A beautiful lotus flower can be painted with very simple brushstrokes and contrasting bright red and black ink. A few red splotches are added to form the petals, and then, with diluted black ink, a few brushstrokes are applied for the leaves. Finally, the stem and the veins on the leaves are painted with a darker ink tone.

TECHNIQUE AND PRACTICE

THE SUNFLOWER

The common name of this plant includes a reference to the sun, which relates not only to a well-known physical phenomenon but also to the round shape of the flower. In China, the sunflower is the food of immortality. Its changing color is related to its orientation. This flower requires a more-involved technique for its representation than do the previous ones.

The process is practically the same, but after the stem, the petals, and the texture of the center are drawn, the correct place must be

An example of a sunflower, which has been given a feeling of movement that is different from the static look of other paintings.

identified to add the texture of the stem or shell of the petals, with the tip of the brush separated, applying very quick brushstrokes and rotating the wrist, since the sunflower, as its name indicates, follows the direction of the sun. This way the result is a sunflower that conveys movement and vitality.

THE CACTUS FLOWER

To express the coarse and thorny surface of the cactus, the brushstrokes should be very decisive, beginning by painting the body from the root up with generous and intense washes. If the brush runs out of ink, a wash of a similar tone is prepared to continue painting. The thorns are created with quick, small lines that are painted by caressing the paper softly with the tip of the brush wetted with ink.

Here, Walter Chen has painted the cactus on the foreground with very quick brushstrokes and then has resolved the one behind with a lighter, diffused tone to create a feeling of distance between the two planes. In addition, the thorns have been painted with a very thin brush and the flowers with a goat-hair brush when the stem was still wet, to allow the washes to blend.

梅

THE PLUM BLOSSOM

In Eastern cultures the plum blossom is considered the common symbol for young girls because the flowers of the plum tree (*mei*) bloom before the tree fills up with leaves. This flower, which has five petals, also symbolized the five gods of old China's Southwest. The union of the plum, pine, and bamboo trees forms the "three friends" of the cold season. In Chinese painting, artists often resort to the plum tree during winter because it has a distinct flower that symbolizes immortality.

This symbol is present in many everyday objects, in home decorating as well as in fabrics. Shown here is a woman's traditional Chinese costume, with plum flowers embroidered on silk.

Composition with bamboo and plum flower. This is one of the traditional themes in Chinese painting shown in model books, a reduced version of which has been painted here.

CRITERIA FOR PAINTING THE TRUNK AND THE BRANCHES

First, the concept of the composition should be planned—which variety of plum to paint, and which season. Painting starts with the trunk, proceeding from the root up to the main branches with applications that are somewhat thick but not very diluted. Then the smaller branches are painted with the tip of the brush using very quick and broken strokes. All the applications and turns of the brush should be decisive, with no hesitation or doubt. Then, the details such as the shoots and the moss that adheres to the trunk should be painted with more detail. The composition of flowers, painted with a different color, should be well proportioned between those in the closer planes and the ones in the distance; it is a good idea not to include too many flowers.

Two Young Shoots Growing Downward. Painting begins from above with a single brushstroke. Another precise brushstroke begins one-third of the way along the first branch. At this point the movement of the branches can be seen. However, the beginning and end of both branches are painted with a somewhat darker tone; this represents the continuity of the interior strength of the brushstroke from the beginning to the end, a fundamental concept in Chinese painting.

Detail of two plum branches painted facing down.

KNOW YOUR BRUSHES

It is very important to know the ideal use of each variety of brush to be able to change them quickly when necessary without making mistakes.

技巧與習作

Three young shoots grow upward. This example may appear similar to the previous one, but it is more advanced. The lower branch is drawn starting at the bottom and going upward. The second branch is painted immediately after, beginning halfway up the first one in the same direction. The last, thinner one is finished with a small curve. When painting the branches, it is important to think about the logic of their relationship to make sure that the new branch is not longer than the previous one.

Detail of a composition with three branches. The logic of the relationship among them is planned so the length of the new branch does not extend beyond the previous one.

Trunk of an old plum tree. When the tree is very old, the trunk and the branches are painted a little bit thicker and dryer to express the bark's texture. The artist starts at the bottom, moving to the top with a single brushstroke. A small space is reserved between the trunk and the branches, which will later be used to paint the flowers. At the end of the branch the thickness of the brushstroke is changed quickly because since this is an old tree it can have gnarled and knotted branches even if new shoots come out of them. It is the spirit of the plum tree, which never dies as long as there is hope.

The places where the new branches grow out are painted with shorter brushstrokes and with a sudden change of thickness, as can be seen in the middle trunk.

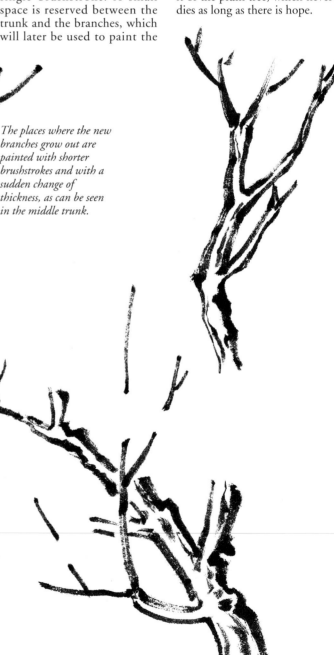

Drawing the plant. The artist continues working on the shape of the plant beginning at the main trunk, with two lines moving up. Approximately halfway through, there is a sudden turn of a branch, which is painted first, and then the other branches behind it are painted, but leaving some space from the front one to create more depth. The shoots are painted with shorter lines and with sudden changes in the thickness of the brushstrokes, as seen halfway up the trunk in the middle.

Representation of an old plum tree. The spaces for the flowers have been left blank, as can be seen on the following page.

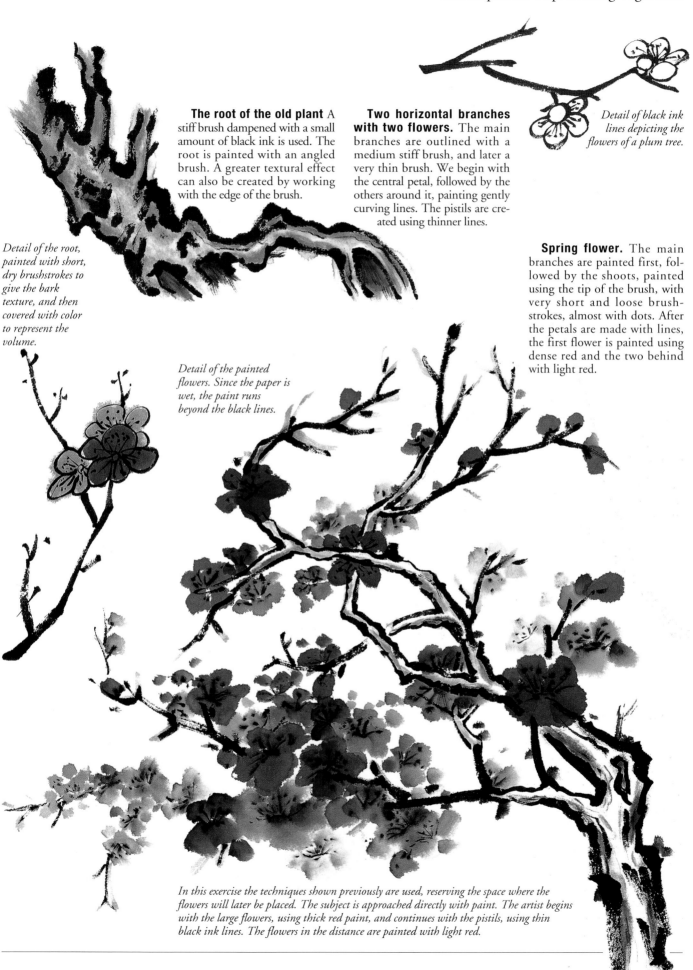

The root of the old plant A stiff brush dampened with a small amount of black ink is used. The root is painted with an angled brush. A greater textural effect can also be created by working with the edge of the brush.

Detail of the root, painted with short, dry brushstrokes to give the bark texture, and then covered with color to represent the volume.

Two horizontal branches with two flowers. The main branches are outlined with a medium stiff brush, and later a very thin brush. We begin with the central petal, followed by the others around it, painting gently curving lines. The pistils are created using thinner lines.

Detail of black ink lines depicting the flowers of a plum tree.

Spring flower. The main branches are painted first, followed by the shoots, painted using the tip of the brush, with very short and loose brushstrokes, almost with dots. After the petals are made with lines, the first flower is painted using dense red and the two behind with light red.

Detail of the painted flowers. Since the paper is wet, the paint runs beyond the black lines.

In this exercise the techniques shown previously are used, reserving the space where the flowers will later be placed. The subject is approached directly with paint. The artist begins with the large flowers, using thick red paint, and continues with the pistils, using thin black ink lines. The flowers in the distance are painted with light red.

TECHNIQUE AND PRACTICE

FRUITS AND VEGETABLES

In the old days, artists were mostly interested in painting landscapes and human figures. Beginning with the Ming (1368–1644) and Qing (1644–1911) dynasties, they began to express some interest in compositions that included fruits and vegetables, which at the beginning were a complement to plants, flowers, and birds. Later they became a subject matter in their own right. Therefore, the expansion of this representation is much more recent if compared with other traditional genres of Chinese painting. Fruit is not chosen for its esthetic attributes, as it is in Western cultures, but it is often chosen for its spiritual significance.

STILL LIFE WITH ORANGES

This simple model is created with medium-dark-tone ink by painting the outlines beginning at the stem. Then the brush is charged with darker ink to apply a wash to the outline. The process for painting the second orange is very similar, but some space must be left between the two to differentiate the planes. When the initial washes are dry, the fruit is painted with yellow-orange washes, using a soft brush. It is important to charge the brush with a generous amount of diluted color, taking care that the color does not flow beyond the outline of the orange. To differentiate both oranges, simply change the color tone.

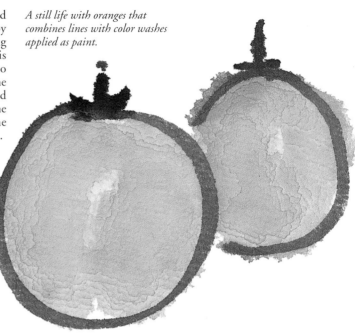

A still life with oranges that combines lines with color washes applied as paint.

HOW TO PAINT FRUITS AND VEGETABLES

Before painting a piece of fruit, it is important to study its characteristics, to observe its most essential parts, the things that determine its appearance. At the beginning, we recommend practicing with the *Gongbi* technique, using short brushstrokes and small areas of color. This method, even though it is more time-consuming, does not cause as many mistakes as the *Shieyi* method. When the method of painting with short brushstrokes has been mastered, the *Shieyi* technique can be attempted. After trying both methods, the one that best suits the artist's personal style can be chosen, and every artist makes an effort at personalizing it.

THE PERSIMMON

The persimmon is popular in both Eastern and Western cultures. In China it symbolizes good luck and happiness, and its orange-red color is representative of many traditional holidays. To paint it, the brush is charged completely with orange ink and the tip with saturated red. With the brush angled, the brushstrokes are applied to create gradations of these two colors. Without waiting for the paint to dry, a brush with stiffer hair is charged with black ink; the base of the stem is drawn with a single stroke. The work is completed with just two or three more brushstrokes. The second fruit is done the same way, but with a lighter tone.

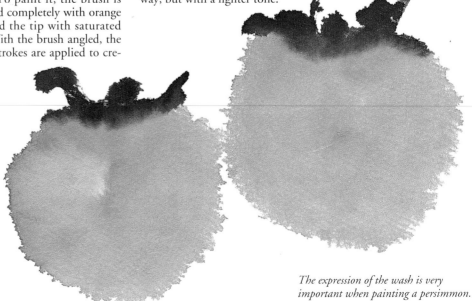

The expression of the wash is very important when painting a persimmon.

THE PEACH

The peach is a very well-appreciated fruit in Chinese mythology, according to which it is present in the garden of "The Mother Queen of the Western Heaven." Each year, during the celebration of the third lunar month, the anniversary of the Queen Mother, peaches are served to the guests. Taoism also recognizes this fruit as "peach of immortality."

To paint it, the entire brush is wetted with an intermediate tone of gray ink and a tiny amount of black on the tip, and an S-shape line is drawn to describe the rounded shape of the left side. Without changing the brush or the ink, and with a sudden movement, painting continues with the brush angled so the line maintains its thickness. The brush is lifted gently when it reaches the end of the line. The brush is recharged with ink to paint the beginning of the stem, and then two areas of color are painted, not very dark, from the stem outward. The drawing is finished with very thin, curved lines for the texture of the leaves.

To draw this fruit with a few brushstrokes, basically two for the body, one must master drawing lines and control the charge of the ink in the brush.

THE LYCHEE

The lychee has been documented in Chinese history for three millennia. It was considered an imperial fruit because it was the one preferred by the empresses of the Tang dynasty. The tree has thin, strong, flexible branches, and the fruit has thin skin, inside of which there is a very sweet pulp. Therefore, when this fruit is painted, very thin but vigorous brushstrokes should be used. The composition must be planned: how many lychees are going to be painted and how the fruit is arranged on the branches. A soft brush with short hair is selected, wetted with red, and tipped with brown. Each lychee is painted with a single brushstroke, from the stem and continuing until a little ball is formed. Then a thin brush is chosen and dipped in black ink to make small dots on the reddish color to represent the texture. The color of the closest lychee is saturated and dark; the color is lighter for the fruit in the farther plane. To complement the fruit, the leaves are painted with several tones of green. The veins are painted with black ink while the green paint is still wet.

A simple bouquet of lychees is an interesting motif to paint.

技巧與習作

THE KIWI

The fuzzy texture of the kiwi, a fruit originating in China, is very special, in addition to its tart flavor. The painting of a kiwi is begun with brown and green washes. With the tip of a very fine brush, small dark green dots are painted over the entire surface of the wash. Finally, a couple of green brushstrokes are applied, with brown ink to represent the small stem.

THE WHITE PEAR

Like the lychee, in the old days the white pear was also considered an imperial fruit. It is depicted here with semi-transparent washes. To do this, a mixture of white and yellow is combined as a base, and the brush is tipped with a small amount of orange. Two splotches are applied to form the body, and the stem is painted at the top with a small touch of black ink.

VEGETABLES

While they are classified differently for culinary purposes, the examples shown below are included in the fruit category even though they are vegetables, greens, and tubers. Their morphological characteristics require a different technique than do those of fruits.

THE ONION

Onions have a very characteristic texture, which can be created by superimposing layers, with an endless array of lines for its surface. After the inside of the shape is painted with a light brown wash, the texture is painted with a very thin brush using a dark brown color and drawing the rounded lines that define the curved configuration of the vegetable, as well as the connection between its body and the stem of the cut-off leaves.

This Chinese green is painted very effectively with only two colors.

The kiwi, because of its Chinese origin, can be included in a still life with Eastern fruits.

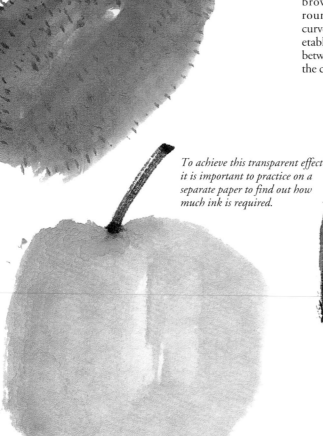

To achieve this transparent effect it is important to practice on a separate paper to find out how much ink is required.

The main color should be uniform. Then a texture made of very thin, fine, curved lines is developed over the wash.

BOK CHOY

A very free technique is used to represent this Chinese vegetable. A very light green wash is applied to make the stem's base, by charging the brush with a mixture of green and very diluted yellow. Then a few brushstrokes of green are added over the leaves. Finally, beginning at the stem, the texture and the leaves are marked with very thin gestural lines using a fine brush.

OTHER VEGETABLES

It is possible to paint all types of fruits and vegetables by alternating several colors. To do it successfully, it is important to understand the shape of the vegetable and to imagine the colors and the lines that will be used to draw it. The techniques used are variations of the ones that were previously explained.

The body of the radish is painted with a single brushstroke, mixing red and white. The tip of the root is completed with an additional very thin stroke. The mixture of both colors on the brush must be evenly distributed.

Red and green are opposite colors in the color wheel; therefore, immediately after the tomato is painted with a range of red colors, the stem is done in green to create a natural blend.

The body of the cucumber is composed of several yellow, light green, and dark green brushstrokes combined, and its texture is created with very thin blue-green brushstrokes.

技巧與習作

Techniques for Painting Animals

The interest in painting animals originated in the court of the Tang dynasty (618–907), which included them in historical and mythological scenes, where they played a secondary decorative role or were used to complement scenes and characters. It was only during the Song dynasty (960–1279) that animals became a subject matter in its own right. The interest of some emperors in compiling information produced a number of books that illustrated the empire's faunal richness. From this time on, the subject acquired prestige and has been interpreted in many ways through the centuries, developing themes that are not very common in the West, such as swimming fish, crustaceans, and insects.

A FISH PAINTED WITH BLACK INK

To begin, a simple fish is painted. A medium round brush is dampened with gray ink and tipped with black. The fins are painted with curved brushstrokes, with the brush held at a steep angle. The brush is recharged, and a long brushstroke is applied, extending all the way to the tail of the fish to paint its back. Little by little the brush is lifted without losing control of the wrist. The tail and the fins are then finished with the same brush. Finally, with a stiff brush dipped in black ink, the outlines of the head, the eye, the gills, the texture on the fins, and the tail are painted.

FISH, CRUSTACEANS, AND INSECTS

Fish are characteristic images in Chinese painting. This is basically for two reasons: on one hand, from the spiritual point of view, they symbolize tranquillity and happiness in Taoist philosophy, and on the other, a more mundane reason—in Chinese the pronunciation for "abundance" and "fish" is the same, thus symbolizing the luck and happiness that its possession represents.

Crustaceans, such as prawns, and insects, such as dragonflies, butterflies, bees, and grasshoppers, also appear in paintings. The latter can be depicted alone or on flowers, and despite their small size they must be in proportion to the rest of the work and respond to the compositional logic (which depends on whether they are at rest or flying, and the direction that they are facing). The function of the insects in the work is to reinforce a feeling of liveliness.

A FISH IN COLOR

A large brush is charged with a wash of well-diluted black ink, and the tip is dipped in dark, thick black ink. The painting is started with the head and continues with a curving brushstroke down to the tail. Then the brush is dipped in red paint and the tip is charged with black ink to paint the left side of the body, finishing at the tail. Next, using a thin brush and while the paint is still wet, the outline of the head, the belly, and the texture of the gills are painted. Finally, when the paint is dry, with a thin brush dipped in white, a line is drawn along the black profile and the eyes are created. White is not commonly used in Chinese painting; it is reserved for snow landscapes and for specific elements such as the eyes of animals.

Fish painted with black ink. First the bulk is created and then the outlines are defined.

The brushstrokes and dispersion of the color caused by the wetness confer movement to the fish. The water is hinted at with a few touches of very diluted ink.

CRUSTACEANS

A crab is the ideal subject matter for practicing Chinese painting. First, the shell is created with a couple of large blocks of color; then, the legs are drawn (four on each side), with a brush dipped in black ink, followed by the eyes, and the pincers, working in such way that each turn of the wrist is made decisively and without hesitation.

The energy of the crab is captured in this exercise painted with black ink.

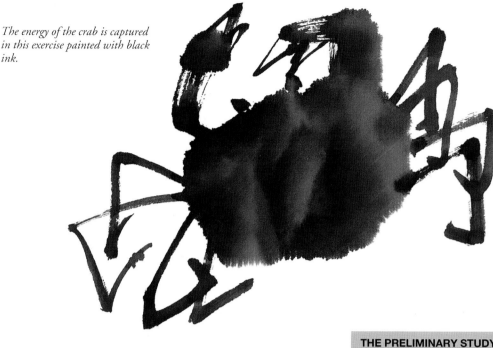

THE PRELIMINARY STUDY

When the artist wants to paint an animal, it is very important to first observe how it moves and how it behaves. When creating the painting, Chinese artists place more emphasis on the animal's essential spirit than on the figure. It does not matter if it does not look exactly like the real one.

技巧與習作

SHRIMP

These three shrimp are painted with a medium round brush charged with diluted black ink in the bristles and saturated ink on the tip. A few strokes are applied first to define the head. The body, the thin legs, and the tail are painted with the side of the brush. The eyes, the pincers, and the feelers are painted with a much smaller brush and black ink. Special attention is paid to the composition of gestural lines that extend from the head, because they are the ones that create the effect of movement.

THE GRASSHOPPER

The name itself describes the insect's hopping ability, resulting from its very strong hind legs. After the eyes are painted with light brown, the body with pink-brown, and the wings with a very light brown, the brush is exchanged for a finer one to paint the antennae and the thinner legs, keeping in mind that sometimes the lines can be discontinuous.

A blurry brushstroke of very diluted color properly highlights and defines the grasshopper.

It is very important to study the posture of the animal and the effect of its movement, which must be conveyed to achieve good results.

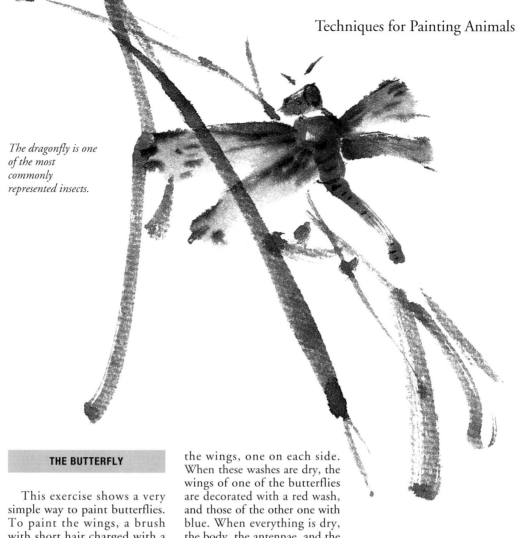

THE DRAGONFLY

First the branches are painted with black ink. As for the dragonfly, painting begins with the head, creating the large eyes with two barely suggested lines. The body is created with the same brush, but this time using red ink and applying a wide line running from the head to the tip of the tail. The brush is recharged with very diluted black ink to represent the four extended wings, which are painted with transparent washes. Finally, small lines are painted with a very thin brush to add texture to the wings and body.

The dragonfly is one of the most commonly represented insects.

LADYBUG ON A SQUASH

The shape of the squash is drawn with somewhat diluted black ink. Then, with a thicker brush, the shell is painted with more diluted brown. Two red spots are added to the insect with a thin brush. Finally, the head and the legs are drawn with black ink.

THE BUTTERFLY

This exercise shows a very simple way to paint butterflies. To paint the wings, a brush with short hair charged with a middle tone of ink is used; short brushstrokes that extend out of the abdomen are applied, leaving white reserves to be painted later with another color. Then two circles are painted below the wings, one on each side. When these washes are dry, the wings of one of the butterflies are decorated with a red wash, and those of the other one with blue. When everything is dry, the body, the antennae, and the legs are painted using a thin brush and black ink. A few brushstrokes are applied to give the wings a more textured effect.

When painting butterflies, the white of the paper is reserved so several colors can be applied without being overwhelmed by the underlying black wash.

Natural life, even if it is very simple, motivates many Chinese artists in their observation and meditation. This still life of a squash and a ladybug is an example.

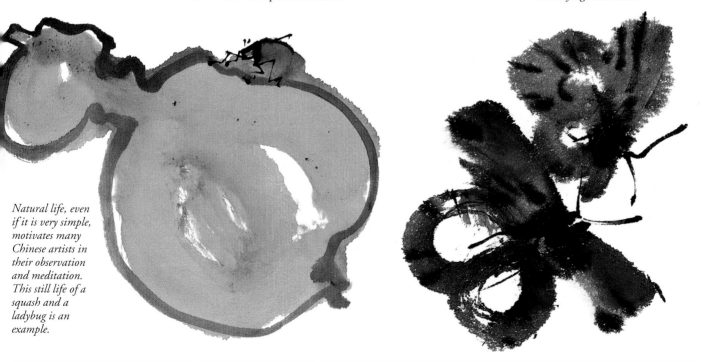

技巧與習作

TECHNIQUE AND PRACTICE

WILD AND DOMESTIC BIRDS

Birds have been subjects of paintings for a long time. It is no accident that Chinese mythology considers the union between the dragon and the phoenix a symbol of perfection. Also, the concept of good luck is directly related to the representation of the crane, a bird capable of existing in any geographic terrain, because it flies through high mountains, pine tree forests, and clouds, crossing the skies at great altitudes.

Birds are rarely shown in isolation; they are usually shown perching on branches or alongside flowers, trees, or plants, which give us information about the weather and the season. This requires a representation in an environment that contributes to the harmony of the composition. The most commonly represented birds are cranes, ducks, roosters, chickens, quail, storks, and peacocks, among others.

THE SWALLOW

The representation of this common bird begins with the head, which is painted with a block of black ink. Extending out of this area some very thin lines are drawn to represent the beak. The outline of the back is created with a couple of brushstrokes. Wide brushstrokes are applied to paint the scissor-shaped tail. The breast is painted with very short brushstrokes, and the claws and the branch are drawn to finalize the painting.

A swallow painted with black ink.

THE STORK

The lower part of the head to the neck is painted with a singled curved brushstroke. The top part is painted with another brushstroke, this one shorter. Next, with the tip of the brush, the beak, the eye, the body, the texture of the plumage, and the legs are painted. The exercise is completed with the application of a couple of light brushstrokes for the tail.

A very thin brush is used for the Gongbi style. First the beak and the eye are painted, and then the head, using very short brushstrokes, already representing the texture of the plumage from the beginning. Little by little, the bird's body is completed. The tail is painted with long brushstrokes. Finally, the legs are drawn with somewhat fuller and darker brushstrokes, which convey strength and the sense of grasping.

To paint a simple-looking stork like this takes great mastery of the technique. You must be able to draw thin, heavy, and curved lines without any problems.

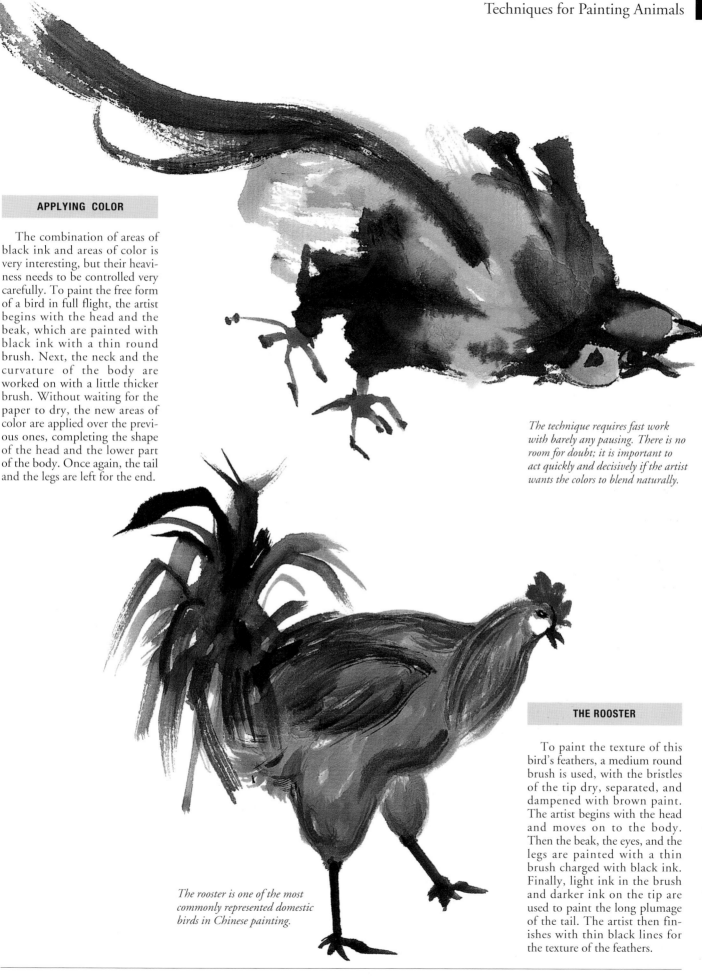

APPLYING COLOR

The combination of areas of black ink and areas of color is very interesting, but their heaviness needs to be controlled very carefully. To paint the free form of a bird in full flight, the artist begins with the head and the beak, which are painted with black ink with a thin round brush. Next, the neck and the curvature of the body are worked on with a little thicker brush. Without waiting for the paper to dry, the new areas of color are applied over the previous ones, completing the shape of the head and the lower part of the body. Once again, the tail and the legs are left for the end.

The technique requires fast work with barely any pausing. There is no room for doubt; it is important to act quickly and decisively if the artist wants the colors to blend naturally.

THE ROOSTER

To paint the texture of this bird's feathers, a medium round brush is used, with the bristles of the tip dry, separated, and dampened with brown paint. The artist begins with the head and moves on to the body. Then the beak, the eyes, and the legs are painted with a thin brush charged with black ink. Finally, light ink in the brush and darker ink on the tip are used to paint the long plumage of the tail. The artist then finishes with thin black lines for the texture of the feathers.

The rooster is one of the most commonly represented domestic birds in Chinese painting.

THE WILD CRANE

This exercise is approached the same way as the previous one, although it is more abstract. The head is painted first with a brown color. Then the body is expressed with a more diluted color that covers more.

A thinner brush with black ink is used to paint the beak, the eye, the legs, and the ground. If, after finishing, the artist decides that he or she wants to increase the contrast of a particular tone, a new wash is added.

A porcupine is a small mammal with a particular type of fur covered with quills. The texture of the quills is created with dry, black, layered brushstrokes, and the body with several shades of very light ink. The head and the legs are painted last, using thin lines.

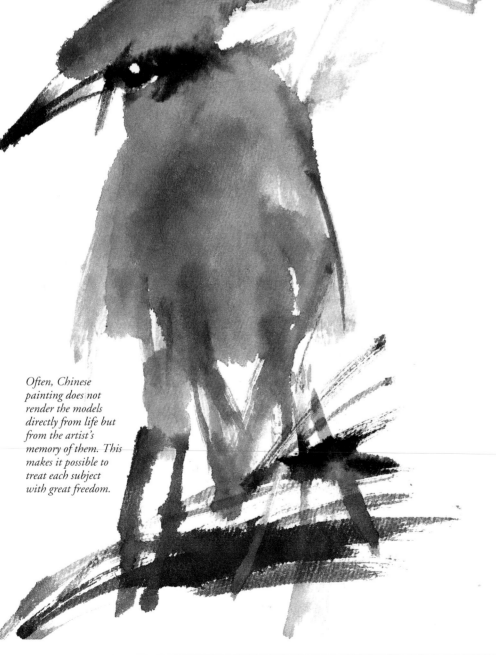

Often, Chinese painting does not render the models directly from life but from the artist's memory of them. This makes it possible to treat each subject with great freedom.

SMALL MAMMALS AND DOMESTIC ANIMALS

Dogs, cats, horses, and the like played a very important role among Chinese royalty; owning them was considered a luxury because they formed part of the entertainment and idle time of the rulers. The horse, perhaps because it is the most noble domestic animal, is the most commonly represented: in many paintings there appear horses and their masters resting under a tree, horses galloping with their riders or tied to war chariots, or flying horses whose origin was lost in the dawn of Eastern mythology.

Eastern painting also shows preferences for other domestic animals such as the ox, or the cat, and even wild animals of gentle disposition such as the panda bear, the hare, and the monkey.

THE PANDA

This animal, the panda, which is associated all over the world with China, has singular beauty. It has been represented in paintings since ancient times. To depict it, the outline of the head is drawn with a thin line; then the ears, the eyes, and the mouth are created with black ink. The arms, which are placed as if they were hugging a tree, are painted with a thick brush. To finish the painting, the outlines of the feet are suggested with lines combined with two long streaks.

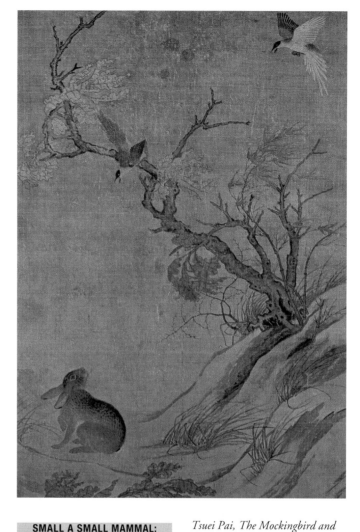

SMALL A SMALL MAMMAL: THE HARE

To paint a hare, very dry areas of color are placed one over the other. The artist begins with very light, dry colors so the outline of the body stands out. Then the tone of the ink and the volume of the body are intensified.

The area where the eyes are located is left white so it can be defined later with thin brushstrokes. The volume of the back is created with several superimposed brushstrokes.

Tsuei Pai, The Mockingbird and the Hare, 1061. Work that combines great technical mastery with the spontaneity of the theme. National Palace Museum (Taipei, Taiwan).

Because of its beauty and endearing appearance, which has captivated humans all over the world for centuries, the panda is one the most commonly represented animals.

THE MONKEY

Various species of monkeys from Africa and southern Asia have been known of in Western cultures since ancient times. In those days, some performers domesticated monkeys and featured them in their shows. Chinese culture paid great tribute to the monkey. Sun Wu-k'ong was a famous monkey that accompanied the pilgrim Buddhist Hsüan-tsang on his trip to India, and it is said that besides great heroic acts it also performed many mischievous tricks.

To paint a monkey, the best approach is to begin with the forehead, applying very dry and somewhat diluted brushstrokes. The head and the ears are completed with areas of color, and lines are applied with very quick motions. The areas that suggest the eyes, the nose, and the mouth are painted with very diluted gray. The body and the arms are painted with a new wash, and the gestures of the hands and the feet are created with thin brushstrokes. The next step consists of using a stiff brush dampened in light brown to apply washes over the previously painted areas. This process should be repeated six or seven times until very rich and subtle tones are achieved. To finish, the eyes, the nose, and the mouth are painted with a very fine brush.

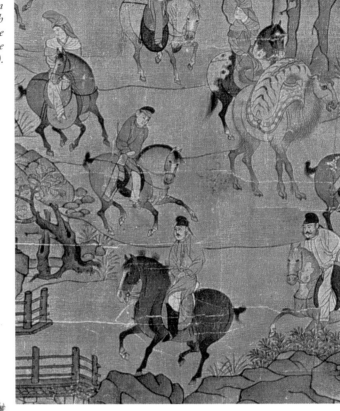

Detail of the Journey of Emperor Ming Huang Toward Chu. *Vertical scroll of ink on silk, painted in the eleventh century over a previous work, both of unknown authors. The delicate technique with which the horses are painted can be appreciated here. National Palace Museum (Taipei, Taiwan).*

THE HORSE

To paint the horses and the characters of this work, very thin lines are used. Later, everything is painted with very light colors. Little by little the color washes are layered until the appropriate tone is obtained for each area. Fewer color layers are needed to paint the people than to paint the horses.

In this exercise a special technique is used, a way to apply consecutive color washes to form the outline of the monkey's figure.

THE CAT

This appreciated domestic animal, which has lived in our homes for four thousand years, is associated with femininity and the night. It has been the protagonist in many paintings, where it has been treated with a great sense of elegance and simplicity.

In this demonstration, the artist has used a worn brush (old brushes should never be discarded). The artist begins by painting the shape of the head, the ears, the body, and the texture of the hair, using very light ink with the bristles of the brush separated. Painting is done following the direction of the cat's hair; the entire figure is constructed this way. Then, the artist switches to a thinner brush to draw the shape of the eyes and the nose. Next, the worn brush is used again, but wetted in black ink to create contrast between the volume and the texture. Finally, the entire body is painted with several colors.

Fragment of The Winter Journey, *1955. Private collection. In the lower part of the work, the miniature-like treatment of the scene with oxen, very typical of Chinese paintings can be appreciated.*

To paint the hair of this young cat more effectively, an old brush with worn hair has been used.

PAINTING UP CLOSE OR FAR AWAY

When an animal is painted as the main character in the *Gongbi* style, all the details must be well defined and painted clearly. However, if the animal is only a small element of the work, then the attention should be directed to the whole rather than to the elements (in this case, animals) separately.

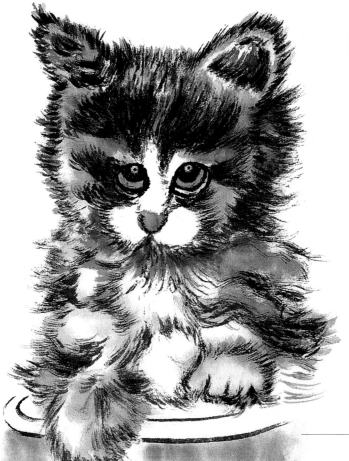

THE OX

In the old days, societies were predominantly agricultural. Rice was a staple then, and continues to be so now. The strength of an ox was necessary to work the land, which is why this animal is represented in many paintings, to symbolize work and physical power. In addition, the ox makes its appearance in mythology as a sign of the horoscope. Oxen are generally presented as part of the landscape in a resting attitude or performing their common agricultural tasks.

To paint them, the carts are drawn first, then the oxen, and finally, with a very thin brush, the people. Next, everything is painted dark brown, keeping in mind that if the ox is placed far away, the color should be diluted with water to represent the discoloration that objects are subject to in the distance.

技巧與習作

The Human Figure and the Portrait

During the Sui (581–618) and Tang (618–907) dynasties, the human figure was one of the most recurring themes. There are many portraits of historic figures and rulers of that period. Centuries later, the popularity of the Song (960–1279) landscapes did not diminish interest in the representation of human figures, which were painted as part of nature. People were shown in a corner of the painting, at a smaller size, engaged in the contemplation of the landscape as a source of inspiration. Ming (1368–1644) and Qing (1644–1911) paintings returned to the representation of isolated human figures to immortalize emperors and courtiers. During the eighteenth century, the female figure and portraits depicting daily life became very popular, and they incorporated a rich array of colors. The Cantonese School produced a great number of them, which were exported to Europe to show all aspects of Chinese daily life.

FIGURES IN THE LANDSCAPE

We will see how the figure is integrated into the landscape. In this case, a man is leaning against a rock, reading, showing that posture plays an important role. Beginners are encouraged to make a sketch with a charcoal stick or a pointed object to indicate the shape of the figure. The facial features are painted with a very thin brush and black ink. Next, the clothing, the book, and the rock on which the man is leaning are painted. Pay close attention when drawing the lines; in a work like this one, which requires precision, it is important to be in a quiet environment and have inner peace.

In landscapes, it is normal to have the quiet presence of the human element. People can be peacefully seated next to a rock or standing, contemplating the landscape.

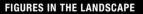

THE RELIGIOUS OR MYTHOLOGI-CAL FIGURE

Religious and mythological figures must be painted with a thin brush that lets the artist apply the same type of brush-stroke through the entire work, which is done by controlling the motions and the pressure applied with the bristles on the paper. This control of the line is created as an extension of the artist's inner strength, directly related to the inner spirit and peace.

Pu Hsin-yu, The Buddha Kuan yin. *The characters of the Buddhist world and mythology are also popular themes in painting. They combine a baroque approach in the details and the clothing, all of it executed with clean lines and surrounded by mysticism.*

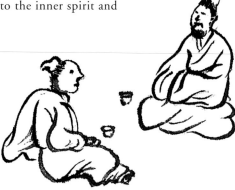

When there is more than one person, we must remember that their postures are very important; therefore, planning them ahead is vital.

The figure of a pilgrim is described by playing with the different shades of just two colors of ink.

Chiang Su-iuan, My Son. *In this work, the artist represents a moment full of emotion.*

PEOPLE

All people, regardless of their age or background, are represented the same way. Here are three different ways of painting them.

We approach the theme with a mixture of gestural lines and areas of color, such as in this traveling man. The face is painted with a thin brush and black ink, followed by the eyes, which are drawn on it. The clothes are painted with a medium-size stiff brush. For the sleeve of the robe, the brush is wetted again with more ink, tilting it to apply a couple of very quick brushstrokes. The painting is continued with the lower part of the robe, the feet, the cane, and the hat. Finally, the areas of skin and also the hat are tinted with light brown.

This other example reflects a more modern interpretation, executed by Chiang Su-iuan. The figure and the lotus flower are painted with very thin lines; next, the hat is painted yellow and the clothing blue. In the background, to paint the water, the flower, and the ground, dry brushstrokes of superimposed colors are used to create a poetic effect.

To illustrate the last method, a painting by Tseng San-shi has been chosen, in which he represents his daughter with very loose lines. He tints the face, the legs, the stuffed animal, and the flowers with various colors, using a delicate and intimate approach.

Tseng San-shi, The Artist's Daughter. *The work has several seals, and it is obvious that this is a more modern interpretation compared to the previous examples.*

技巧與習作

The Landscape in Chinese Painting

The landscape, or nature, is a theme that has been represented since ancient times. In it, the elements we have seen up to now, plants, animals, and the human figure, are combined. The following pages present some of the inanimate, natural, and artificial elements, as they appear in the model books, and they explain how perspective is structured in Chinese painting. To complete it, the work of two masters is reviewed: Pu Hsin-yu (1896–1963) and Cheng Jing-Chiuan (1932–). In China, the work is viewed as a source of millennia of experience of a wise people.

THE TERRAIN, THE ROCKS

"The rocks and the terrain are the origin of nature." This is an old saying, which means that all the vegetation and the poetic atmosphere emanate from them. If we observe the shapes of the rocks, a great variety of structures and textures can be seen. Therefore, observing them, becoming familiar with them, and carefully practicing the different textures are vital for creating a convincing representation of the surface of the rock, as well as for understanding its lines, its layers, and the rhythms that determine the internal essence of this element. It is not sufficient to capture the outside of the rock; one must learn to convey the spirituality within.

Process for painting a single rock. The red numbered arrows indicate one of the ways to begin painting the rock's outline and the main lines with several strokes. The green arrow shows a different way of drawing the rock's contour with a single line. The texture is done later with successive brushstrokes.

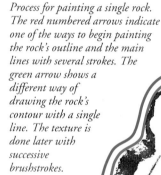

A SINGLE ROCK

To paint a single rock, a stiff brush (made of wild horsehair) is used, dampened in black ink. We begin at one end, painting first toward the left, and then toward the right (with two lines). The rock could also be approached from one end, moving the brush with a single stroke down to the other side. When the brush almost reaches the beginning of the rock, it must be angled or slightly pressed to achieve the tentative volume. Then the texture is created depending on the shape of the rock.

TWO ROCKS

We begin with the first rock, leaving the part that is washed by light with little texture. The one behind is painted next, keeping in mind that if it is very voluminous the texture should be more rounded, and if not, then it should be painted with light lines.

Example of two rocks. The manner and the order for painting the contour lines are the same as for painting a single rock.

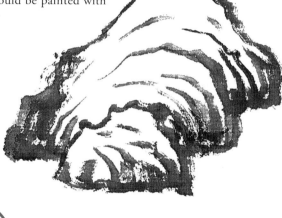

A ROCK WITH A CRACK IN THE CENTER

The entire rock is outlined, and then the crack in the middle, leaving the connection in the upper left side uncut. The texture is created according to the shape of the rock and the crack; therefore, the texture of the rear side ends right on the cut.

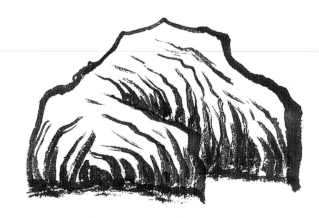

Example of a rock with a crack in the middle. The volume is better appreciated if you squint your eyes.

ROCKS WITH FRACTURED EDGES

After the entire object is drawn with thin lines, the brush is steeply angled, until it is almost horizontal, and is gently tapped on its side to create the texture. If the artist wishes to darken the tones, the process can be repeated as many times as needed.

This rock with a fracture on its side is good for very high mountains, although sometimes it can be used as a base to create a small still life accompanied by flowers.

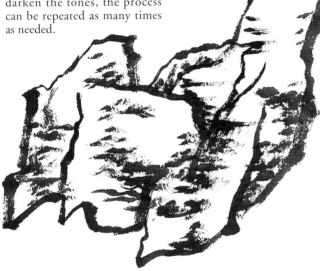

GROUPS OF ROCKS

The closest rocks are painted first, followed by the ground area. For this, the brush is angled, and the texture is created from top to bottom. The closer the group of rocks, the darker the tones applied.

For the washes, the artist begins by painting with very light ink applied in the direction of the texture. The closest part of the rock is worked with darker washes. To finish, a layer of very diluted brown is applied.

Group of rocks done with washes. The darkest tone is used in front.

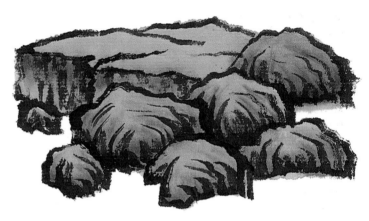

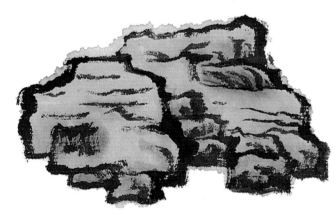

These rocks are mixed with those with a vertical cut to increase the volume. Once the shape and the texture have been marked with thin lines, they are painted with very diluted ink. On the lower left side, the rocks have an inward fracture, which is covered with a darker tone.

The texture of this rock depicts wind erosion. Therefore, the texture is created with straight, short brushstrokes, applied in the same direction to unify the object. Rocks like this one are frequently found on the sides of tall mountains, where the wind blows constantly.

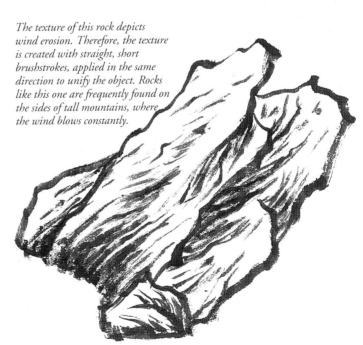

技巧與習作

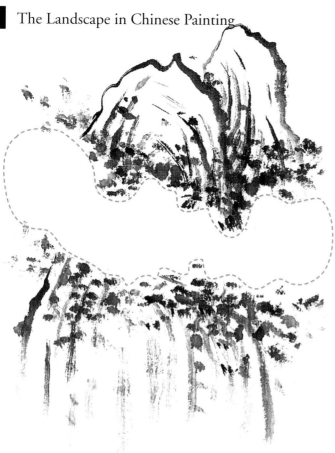

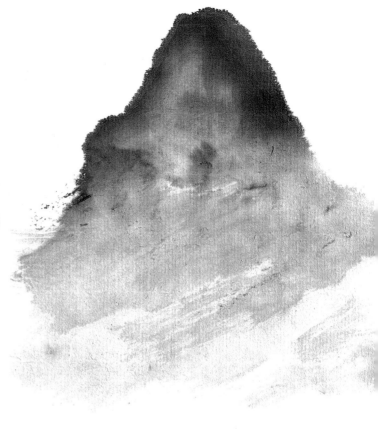

Example of a high mountain where an empty space is created between dry brushstrokes that represent the mist in the clouds.

A mountain in the clouds with two quick brushstrokes. Even though it looks very simple, this has some degree of difficulty, because the entire process is finished in a little over five seconds.

THE WATER

The water, in any of its states (gas, liquid, or solid) and forms (rivers, lakes, falls and cascades, rain, ice, clouds, fog, or snow) is an element that bathes nature in a special atmosphere. Technically, the fog and the clouds are used to create connections between the planes of a landscape. They are not easy to paint but they convey poetry and mystery.

STILL WATER

A pond conveys tranquillity and a relaxing atmosphere. To represent it, first the edge is outlined and then the surface of the water is suggested with small waves that are created with the tip of the brush. The zigzagging brushstrokes are applied with a gentle movement of the wrist. It is also possible to create the texture during the painting process: after painting the water with very light ink, the texture is applied with very dry strokes; since the paper is wet it provides a diffused effect.

CLOUDS IN THE MOUNTAINS

There are several ways of representing a cloud or the mist on the mountaintop.

The area that represents the cloud is left unpainted from the beginning. After the shape of the mountain is painted with washes, using a stiff brush charged with a small, undiluted amount of ink, the white band is outlined. The dry brushstrokes re-create the atmosphere of the cloud, although sometimes they can also represent distant forests submerged in fog.

Another more difficult and faster approach is to use a large soft or mixed-hair brush charged with different shades of ink. The entire brush is dipped in very diluted, almost colorless, ink, and then the tip is charged with a darker tone to create a light blend of both colors. With the handle of the brush tilted, the top right area is painted until the tip of the brush imprints the dark tone on the paper. Without lifting the brush, painting is continued with the side of the brush toward the left and down until the midsection of the mountain is filled. The brush is immediately charged with the same ink or with the tinted water, and the lower part of the mountain is painted, blending this wash with the previous one.

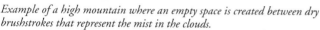

The light undulation of the water can be appreciated better with some "support" elements, in this case two rocks.

WATER FLOWING OVER ROCKS

First, all the rocks that form the banks are painted. Then, with a very thin brush, the crystal-like surface of the water, which shows gentle movement, is suggested. The rounded lines maintain a relationship with the riverbank, and the shape and curvature of the latter in turn depend on the movement of the water and the rocks that are reflected on it.

Flowing water can be used to represent the course of a river or the edge of the sea.

OLD BRUSHES

A brush whose hair is very worn out should not be thrown away, because it can be used effectively for rubbing with dry ink to represent the water that splashes and turns into mist when rushing over a waterfall.

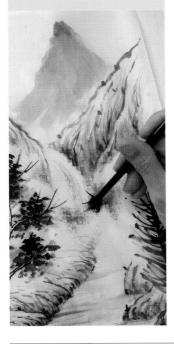

SMALL WATERFALLS

First, the frame or background where the waterfall is to be represented is prepared. After the surroundings (the rocks, the terrain, the uneven ground) are painted, the flow of the river is defined with a very thin brush. To represent the power of the water that flows through the rocks, parallel vertical lines are drawn, as if combing. At the bottom of the cascade a few undulations are formed, a few folds treated with flat and concentric lines.

A sample of how to represent water flowing over small falls.

技巧與習作

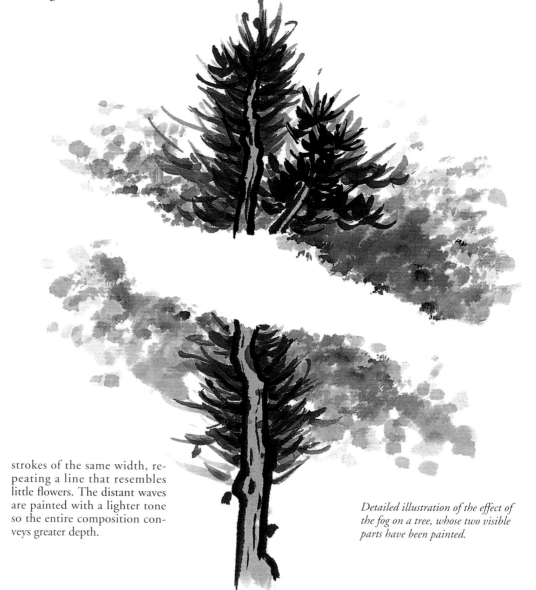

WAVES

To approach this exercise, one must have great inner peace, since all the lines should be very thin and, if possible, the same width. It is also important to control the wash with the brush. The first wave is painted with very light lines, but without losing the wave's inner strength. The lines are controlled with the movement of the wrist, without moving the arm. On the right side, more lines are drawn to suggest the volume. After the second wave is projected, the foam is represented with brush-strokes of the same width, repeating a line that resembles little flowers. The distant waves are painted with a lighter tone so the entire composition conveys greater depth.

Detailed illustration of the effect of the fog on a tree, whose two visible parts have been painted.

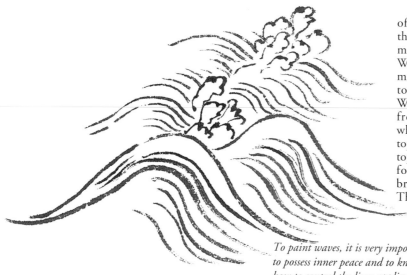

FOG IN THE WOODS

In China, the phenomenon of fog in the woods occurs in the morning hours of the summer or between tall mountains. When a tree is painted in the mist, a band is usually reserved to create the effect of the fog. We begin by painting the trunk from the root up, leaving a white area before we reach the top. The leaves are painted from top to bottom. The effect of the fog is created with very dry brushstrokes of very light ink. The edge of the white space is rubbed with the angled brush to create a jagged edge. A few strokes with the dry brush are needed to achieve a poetic atmosphere. The brush is wetted with very light blue and the same technique as with black ink is used. These brushstrokes do not have to line up with the black ones; the result highlights the effect of movement with an interesting interaction between colors.

To paint waves, it is very important to possess inner peace and to know how to control the lines applied with the brush with precision.

MOSS

The name *moss* refers not only to this botanical group but also to small vegetation and, depending on their size, other natural elements in the landscape as well.

Besides adding an effect of texture to the elements of the foreground, moss is essential for separating planes or for suggesting vegetation far in the distance. This effect is also used to represent the splashing water and the plants that surround a stream. In this case, the rocks are painted first, and then the moss is created with small dots, not very dry, reserving space to represent the waterfall. Finally, with a thin brush the thin lines are drawn that define the waterfall.

A STONE BRIDGE WITH WATERFALL AND FOG

This exercise shows a complex combination of several techniques. Dry brushstrokes are used to represent the rocks, and then the bridge is drawn between two of them. Next, the fog is painted with very thick and somewhat irregular lines. The waterfall is created with a series of light crosshatching. To finish it all, small dry dots are applied on the rocks and others, more diluted, near the water.

Color is applied to the work by tinting the rock brown, the side of the bridge dark brown, the vegetation with small green dots, and the lower part of each section of the waterfall with blue, which emphasizes the volume of the water.

Details of a landscape where several waterfalls are represented together with a stone bridge and area of fog in the middle section.

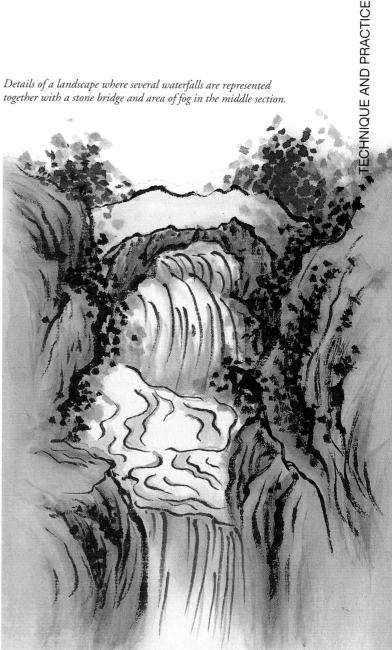

Details of moss with the effect of splashing water next to a waterfall.

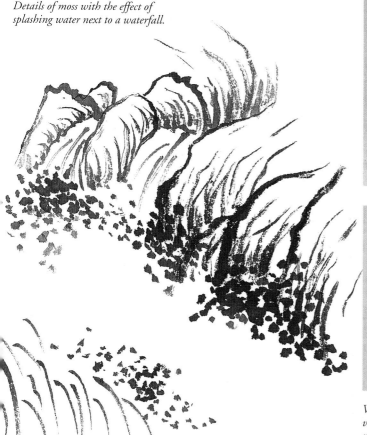

When moss is painted over a rock, it serves the purpose of representing the vegetation as well as increasing the depth, and at the same time it provides volume to the rock and to the plane.

技巧與習作

HUMAN ELEMENTS IN THE LANDSCAPE

In Chinese painting, representations of boats, bridges, and small houses that serve as counterparts to the natural landscape are common and add a human touch. Boats and bridges are the connection between civilization and nature in its pure state. Small houses, on the other hand, represent a refuge within nature, according to Taoist philosophy, which invite us to distance ourselves from an excessively mortal environment to find the inner light.

SMALL STRUCTURES

Traditional straw houses are painted with very dry brushstrokes according to their characteristics. The roof is painted first, followed by the supports and the windows. In this case, it is not necessary to apply the brushstrokes evenly, since straw does not have a regular texture; the roof should instead be made of irregular brushstrokes. The roof is tinted with light brown, the side with dark brown, and the body of the house is painted with brown mixed with light blue to give the feeling of depth.

As an example of the integration of the houses into the landscape, we analyze this work by Chiang Su-iuan. Thin lines are used to define the town. Depth is achieved by creating several layers of color to give volume to the elements. A harmonious landscape is achieved with many applications of washes with no sudden changes of color. Only the roofs of the houses have been painted, perhaps to express the mood of that particular moment.

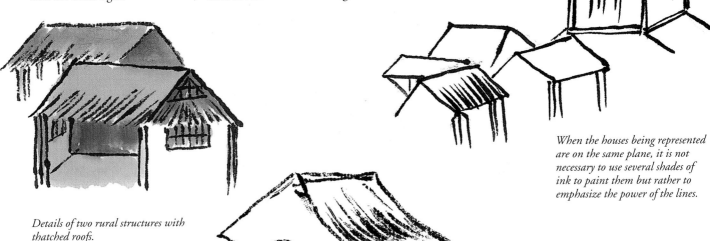

When the houses being represented are on the same plane, it is not necessary to use several shades of ink to paint them but rather to emphasize the power of the lines.

Details of two rural structures with thatched roofs.

BOATS

Small boats, an ancestral and easy mode of transportation, are often seen in Chinese landscapes. The paintings also reflect these elements with precise meticulousness. In general, very thin lines are used to paint a simple boat with one person. First, the body of the boat is painted, followed by the person. The people on boats are painted small because the figure has only to describe what he or she is doing; the details are not important.

Here we can see the simplicity of a boat with its boater. The detailed aspects are not important; they only represent the action.

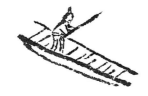

In boats in the distance, only very thin lines that suggest the person's figure are used.

The details are more important for closeup representations; therefore, the tip of a thin brush is used to create the boat and the person, covered with a cape (made of rushes, bamboo, or palm tree leaves) to protect him from the rain.

BRIDGES

Even if they do not play a very important role or are not as common in landscapes as other elements, bridges act as links or communication channels between the people that live on the two separate sides. Although there may be no people represented in a landscape, the simple presence of a bridge speaks of human intervention, adding mystery to their absence.

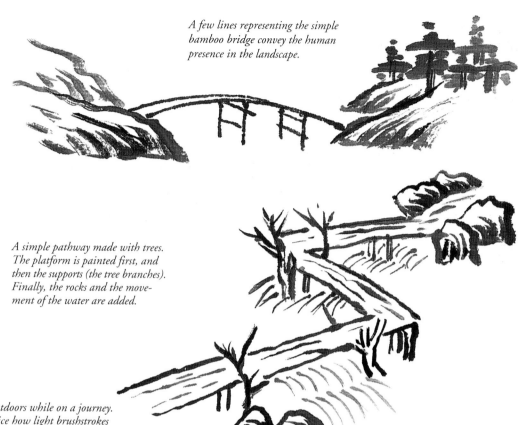

A few lines representing the simple bamboo bridge convey the human presence in the landscape.

A simple pathway made with trees. The platform is painted first, and then the supports (the tree branches). Finally, the rocks and the movement of the water are added.

Chiang Su-iuan painted this work outdoors while on a journey. The interpretation is very subtle. Notice how light brushstrokes have been used to properly integrate all the elements.

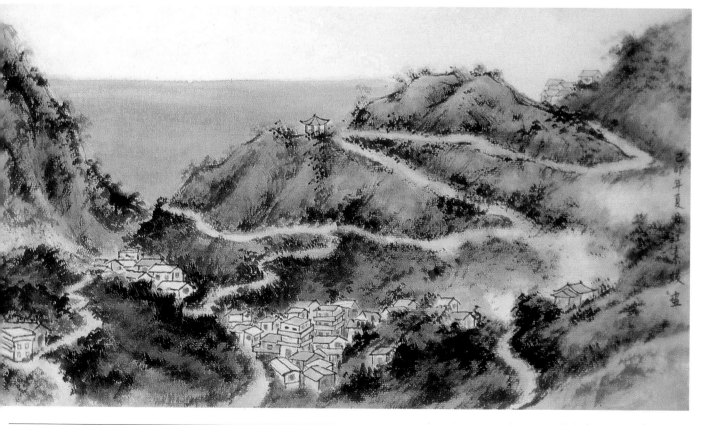

技巧與習作

Perspective and the Composition of the Planes

Chinese painting has its own methods for representing three-dimensional space on a two-dimensional surface. A feeling of depth and distance is created through areas painted white or left unpainted. This is how the fog that looms over valleys or the atmosphere that lies in between is created.

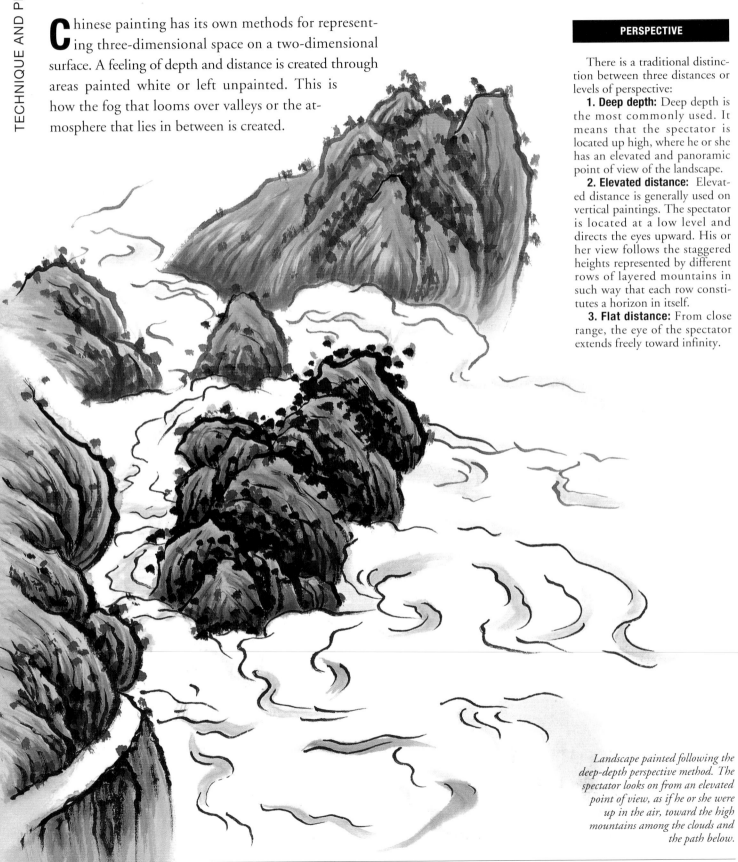

PERSPECTIVE

There is a traditional distinction between three distances or levels of perspective:

1. Deep depth: Deep depth is the most commonly used. It means that the spectator is located up high, where he or she has an elevated and panoramic point of view of the landscape.

2. Elevated distance: Elevated distance is generally used on vertical paintings. The spectator is located at a low level and directs the eyes upward. His or her view follows the staggered heights represented by different rows of layered mountains in such way that each row constitutes a horizon in itself.

3. Flat distance: From close range, the eye of the spectator extends freely toward infinity.

Landscape painted following the deep-depth perspective method. The spectator looks on from an elevated point of view, as if he or she were up in the air, toward the high mountains among the clouds and the path below.

COMPOSITION OF THE PLANES

In large-format paintings, to show a panoramic landscape, each "distance" includes in turn three internal sections that contrast with one another and that emphasize the sense of distance. In deep depth, the painting usually depicts three groups of mountains that extend gradually farther. The three sections that make up each distance are separated by empty spaces in such a way that the spectator is invited to mentally merge with the painting, getting the feeling of jumping from one section to another in a virtual way, since these gaps have the function of suggesting an immeasurable space, which stems from the spirit or from a dream. The spectator's journey through the landscape is then transformed into a spiritual journey, pulled by the life force of Tao.

Thus, the previous mountain-water level is marked by the perspective of elevated distance, which represents the internal mutation; and this level of human being–sky is marked by the third perspective, the flat distance, which represents that which is multiple ("Flat dis-tance generates ten thousand beings"), and at the same time, unity. In fact, flat distance promotes the close-distant and distant-close process, which in the end approaches the return process, *Lau Zi,* which says that "being large, the path flows; by flowing it goes farther; when it has gone far, it finally completes the return."

The movement of distance in space is circular; it returns, and with the return of perspective and of the eye, in the end it transforms the relationship between subject and object (the subject is projected outward gradually, and the outside is turned into the subject's inner landscape).

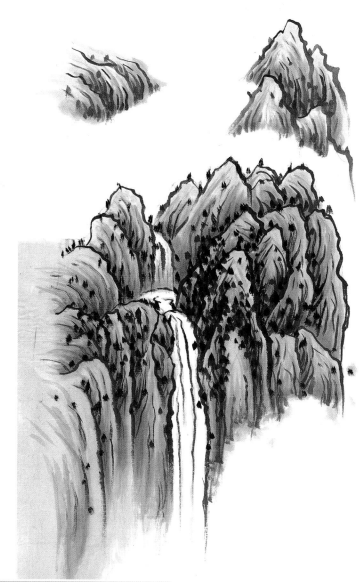

Landscape painted following the elevated-distance method. The spectator is in front of the landscape's midsection, from which tall mountains can be seen from different vantage points that mark the height and the distance.

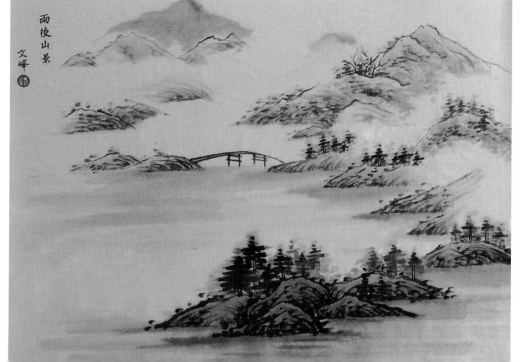

A closer landscape is represented with the flat-distance method, as well as a very faraway one with features in the distance, for example, mountains. This perspective provides greater depth among its different elements.

技巧與習作

A Study of Two Works

Chinese painting has always been based on two fundamental principles: the careful observation of the model and its essence, and study of the work by the great masters of the past, who are a constant inspiration. Some manuals compile their teachings and their most outstanding works for the delight of artists who want to perfect their technique. With this in mind, following is the analysis of two great masters: Pu Hsin-yu and Chen Jing-chiuan.

COMMENTARY ON A LANDSCAPE

This work is attributed to Pu Hsin-yu (1896–1963), an artist of great talent and refinement in painting, poetry, and calligraphy, arts that he dominated to perfection.

COMPOSITION

The work is divided into three planes. On the first one we find the ground, the figure of a man resting in a pavilion reading, and a pine tree that comes out of the edge of the painting and goes up to the sky. Pu Hsin-yu uses "deep depth" perspective, which places the spectator in an elevated position from which a panoramic view of the landscape can be enjoyed.

THE USE OF THE BRUSH AND INK

The brush determines its lines of strength. A brushstroke is not a simple line; rather, it defines form and volume. The ink, depending on its tones and shades, can make the forms of the elements bloom. To create distance and depth in the foreground, the artist paints a pine tree with a stout and ragged trunk. On the lower left side, he places a group of trees with clustered dots. The trunk of the pine tree extends out of the edge of the frame and rushes toward the sky, taking up half the space. The composition and distribution of elements determine this painting's order of observation, which begins on the lower left corner and goes up, ending at the opposite upper corner. The details of the pavilion are created with minimalist and symbolic brushstrokes. Inside there is a figure dressed in red that appears to be seated. On the second plane, the artist presents several mountains with unbroken lines, to represent the thick snow that covers them. On the third plane, he creates a simple landscape with small trees drawn with dots. Farther away, the background is painted gray.

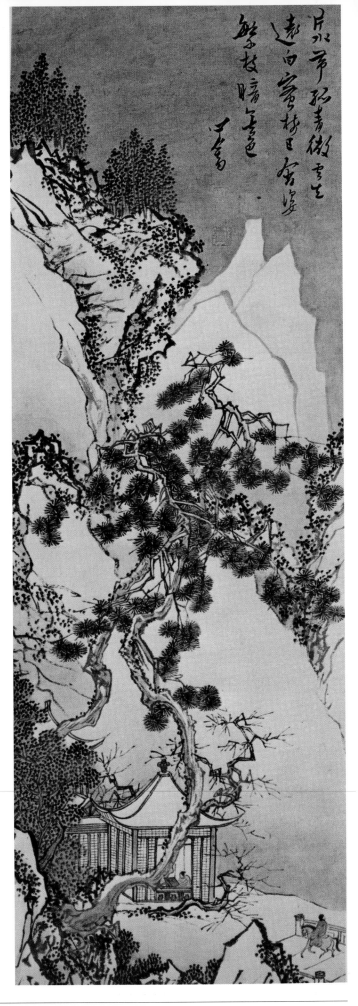

Pu-Hsin-yu, Landscape in Snow. *Vertical scroll, 13 x 43 inches (33 x 110 cm). Private collection.*

CALLIGRAPHY

After reviewing the aspects related to composition and to the use of brushes and ink, the next step is to study the following poem. This is not just a commentary that is added to the work arbitrarily, but a true element of continuity, a spiritual link between the calligraphy symbols and the painted elements. Its rhythm and content relate a vital experience and reveal the artist's state of mind, which complements the interpretation of the work.

"The winter snow has melted, spring will soon be here.
The mountains don a wreath of cottony clouds.
The water irradiates blue-green reflections.
The soft breeze is in harmony with happiness.
Long live the immensity of the cosmos!
Down with the infinity of beings!
The trees shake off the snow and show their figures."

COMMENTARY ON A CONCEPTUAL WORK

The artist Chen Jing-chiuan proclaimed, "As time progresses I believe that creating is a serious and easy endeavor. Before I was 30, I liked to use a brush and to express with it the images that I wished to express, without any limitations. After 30, I thought that if I set limits perhaps I would enjoy more freedom. So I began searching for freedom in a limited area." This concept of freedom is similar to the one expressed by Saint Augustus: "True freedom is not doing what one wants to do, but not doing what one wishes to do."

THE EVOLUTION OF THE ARTIST

When applying his or her particular views about freedom in painting, the artist discovers that everything that the heart and the hand desire must conform to a rule. This rule is based on *Yi* 意, a concept related to the mind, the quality of the soul, which relates to the artist's state of mind during the creative process. The *Yi* must precede the brush and the ink.

COMMENTARY

This work is executed on a piece of scrap paper from calligraphy. After making the appropriate cut, with a serious attitude, digging into the spirit, the artist creates an extensive work with ink to mark the figure, a few subtle brushstrokes, and a large area of color.

The empty space (the area left unpainted) occupies a third of the surface. It is presented as a fundamental concept in Chinese thinking. The empty space is not something arbitrary lacking existence but an eminently dynamic and active element, linked to the idea of a vital spirit. The artist creates a space that allows access to a resonance with the spectator. The empty space is manifested in a more visible and complete way.

The title of this work, *Love the Feathers,* is a saying conveyed by the artist's master: "Love the feathers as if they were the soul of mankind."

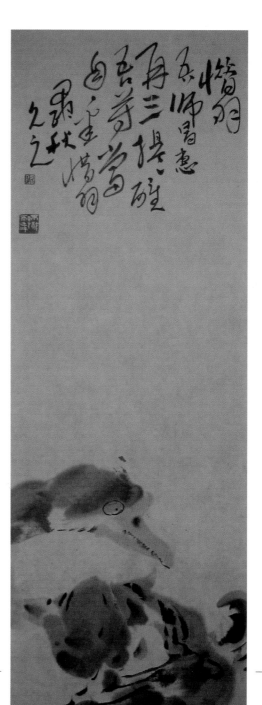

Work by Chen Jing-chiuan, Love the Feathers. *Vertical scroll.*

技巧與習作

Calligraphy Exercise: The Character *Long* (Dragon)

In Asia the dragon is considered a symbol of good luck, capable of producing the drink of immortality. It represents the primary essence, *yang* (from *yin, feminine,* and *yang, masculine*), of the Chinese view of the cosmos, which is related to the concepts of regeneration, fertility, and activity. This mythical creature, often included in the decorative motifs that adorn furniture, and objects, from where they exert protective function against demons. Dragons play a dominant role in many legends and popular stories; they are the main motif in the plastic arts and in crafts. The number of dragons that could be displayed on the brocade clothing of the ancient Chinese generals was strictly regulated. The emperor's clothes featured nine dragons, another example of the symbolic significance of this creature.

Cheng Rong, Nine Dragons. *Detail of a horizontal scroll done in ink and accents of red paint on paper. Work from 1244 (Southern Song dynasty), 32 x 18 inches (10.96 x 0.46 m). Museum of Fine Arts (Boston).*

MENTAL CONCENTRATION

In China, calligraphy is practiced before painting because all the basic lines favor this representation. In both cases, the "bone method" is used, called that because the shape of each line resembles a bone.

The best way for practicing calligraphy is to maintain perfect concentration of the mind, as an extension of the energy found in the brush. But do not confuse the use of the force of the brush with applying more pressure; instead, it consists of controlling the spiritual force.

THE *KAI SU,* OR *KAI SHU,* STYLE

In this first part of the calligraphy exercise, executed by Hsiao-lin Liu, we show how to make the character *long* (dragon) in the *Kai su,* or common, style. This style of writing began to be used at the end of the Han dynasty, and it was defined to perfection in the Period of the Three Kingdoms.

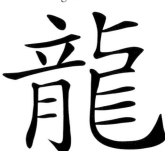

The printed character long, *or dragon.*

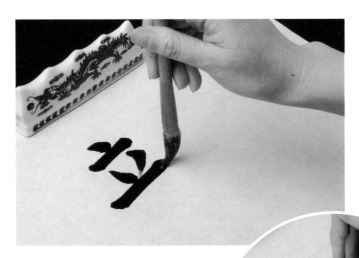

1. Begin at the upper left side with a line that resembles a comma, moving the brush down while relaxing the pressure. Next, a horizontal line is drawn from left to right, from which two slanted lines stem out, converging on a second line parallel to the previous one.

2. The lower left side is drawn, maintaining the same energy. Begin with a vertical line. Then lift the wrist slightly outward, elevating the brush. Continue with a horizontal line beginning at the previous line, followed by a right angle and a vertical line drawn in the same direction as the previous one.

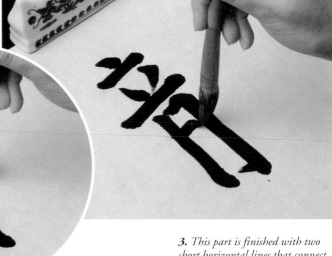

3. This part is finished with two short horizontal lines that connect the two vertical lines drawn before.

4. . On the upper right side a short horizontal line is drawn, to which another short line is added to form a sideways T.

5. Without lifting the tip of the brush from the paper, the protruding portion of a letter S is drawn with straight lines. After that, the brush continues its course toward the bottom part of the paper.

6. The line continues until it reaches the length of the adjacent line, at which point it turns right, forming a curve that ends with a point.

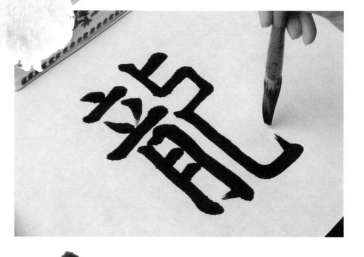

Writing order for the character *long,* or dragon.

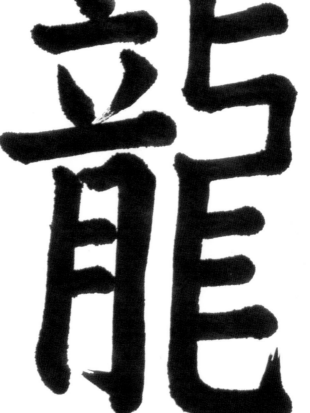

7. Shown here is the finished character in the Kai su *style. The artist stamps her personal seal.*

TECHNICAL ADVICE

The way the brush is held and how the wrist is turned greatly influence the mastery of the stroke. If the brush is not properly held and the movement of the wrist is not correct, the procedure will feel awkward and the lines will lack power.

THE *SIN SU*, OR *XING SHU*, STYLE

This is the common character for dragon. It made its appearance during the Han dynasty as well, and the *Sin su* style is similar to the *Kai su* style, with slight differences. There are no straight lines; they are rounded, the angles become sharper, the curves are more pronounced, and the last three parallel lines become a hook.

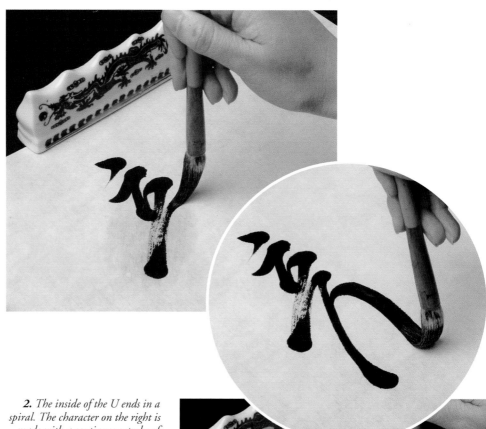

1. The upper part of the character is a zigzag line. The line continues uninterrupted, and the lower part is in the shape of an inverted U. The pressure of the brush is changed to alter the thickness of the line.

2. The inside of the U ends in a spiral. The character on the right is made with a continuous stroke of curves and angles, crowned with a descending curve that ends with a hook.

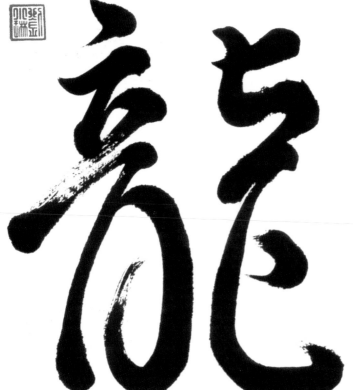

3. Here is the finished character long *in the Sin su* style. *The process for this style is faster than the previous one.*

THE *TSAO SU* STYLE

In the *Tsao su*, or *Cao shu*, style, one can see how the brush follows the musical rhythm of the artist's soul. This is the cursive or abstract calligraphy, the most artistic and the one that expresses the greatest feeling.

1. *The different upper angles are reduced to a point and a line.*

2. *Here, the descending line acquires momentum and make a quick and rounded turn, leaving an almost unnoticable line that crosses the paper until the next form begins. There, the line becomes stronger and forms a curl.*

3. *The line continues with energy with two complementary curves and then goes up slightly, ending with a circular rubric. The seal is integrated in the character.*

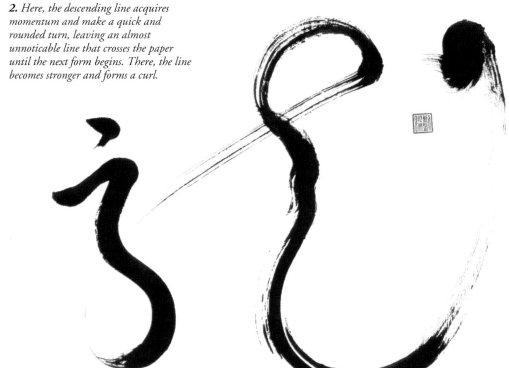

4. *The artist finishes the exercise and stamps her personal seal. Tsao su calligraphy is the quickest and most liberal to draw; for this reason it is also known as abstract.*

逐步示範

Bamboo, Rocks, and Dragonfly

Painting bamboo has a special significance. In the old days, it illustrated perfectly the mysterious and wonderful origin of natural phenomena, since it was part of the artists' environment, their virtual state, and their origin. On the outside, bamboo acquired its characteristic appearance as the sap turned into wood, while the inside of its stalk remained hollow, and, like the body of an ascetic freed from his ties, it reconciled lightness, strength, flexibility, and power.

TECHNIQUE

Thin brushes are used to model the lightness of the elements in an environment bathed by a soft breeze. The space is divided diagonally, from left to right, from greater to lesser volume. The presence of the rock is counterbalanced with the suppleness of the insect. On the right half of the work there are two shoots: one young and tender, predominantly yellow; and the other, the one on the left, older, thicker, and darker in color. The volume and movement of both are achieved by adding a lesser or greater amount of water to the ink, with different tones, and an outline that is almost black.

1. The artist begins with the outline of the rock. A medium round brush is used that is quite dry, and medium-shade black ink since this is a landscape with few planes.

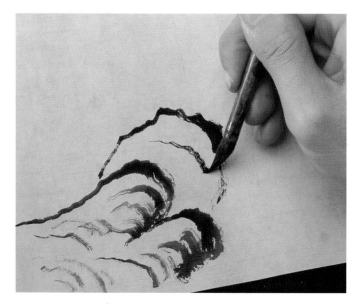

2. When the brush reaches the lower end of the rock, the handle is turned outward and pressure applied to create a shadow effect.

3. A thinner brush is selected and the contour of the stem is painted starting at the ground and moving up to the knot with ink that is not too diluted. Then the knot is painted.

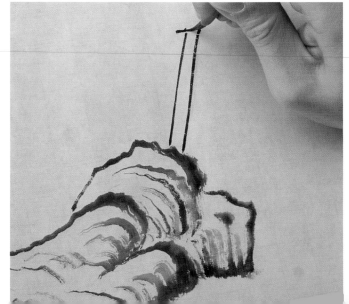

4. *To paint the helicoidal shape of the leaf where the dragonfly will be placed, a line in the shape of an S is drawn, beginning at the tip of the leaf and extending down to the branch.*

5. *The dragonfly is a very delicate insect; therefore, its body is painted with the tip of the brush. The artist begins with the eyes, the head, the body, the wings, and finally the tail. To create the texture of the wings, the transparency must be expressed with even lighter and thinner lines.*

6. *To finish the dragonfly, the legs are painted, connecting them to the tip of the leaf. It is very important to hold the brush steady because drawing the insect is a delicate job.*

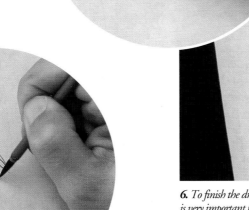

7. *The groups of leaves are painted, mainly the shoots of the first stem. They can be drawn to look as if they were alone; they need not be attached to the branches, because in Chinese painting the emphasis is on the spirit rather than on the rigors of botany.*

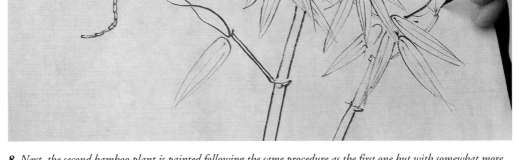

8. *Next, the second bamboo plant is painted following the same procedure as the first one but with somewhat more diluted ink. To increase the feeling of depth, the leaves are painted farther away, and the brushstrokes are thinner to distinguish the planes.*

逐步示範

9. Once the basic elements are established, the effect of the moss and the grass on the rocks and the ground is added. The tones of the colors must agree with the main elements of each plane. Sometimes a small detail that is darker than the overall tone can be added but this effect should not be overdone.

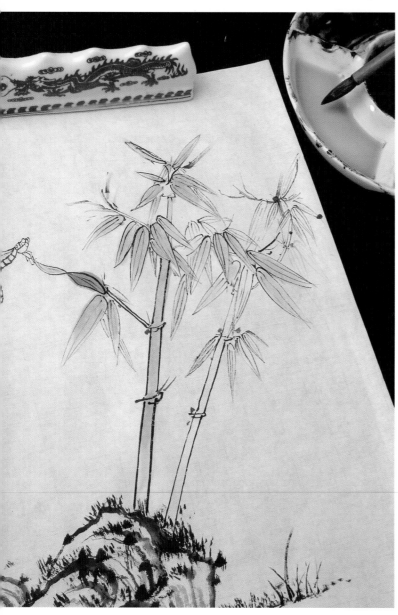

10. The stems, the leaves, and the rocks are colored, until the grass is reached. The brushstrokes of color are applied in the direction of the texture to enrich the depth of each element and to achieve a greater effect of volume.

11. In the case of the dragonfly, the wings are painted with very diluted ink to represent their lightness.

12. The leaves of the darker shoot are painted with a medium tone of green. The stalk is painted first, and before the wash dries, a glaze of the same color is applied over the knots. For the body of the dragonfly, violet mixed with a little bit of blue is used, brown for the tail, and light violet for the wings. All the applications should be very diluted with water. The bamboo located the farthest away is painted with a yellow-green and its leaves with a very diluted, almost imperceptible, green.

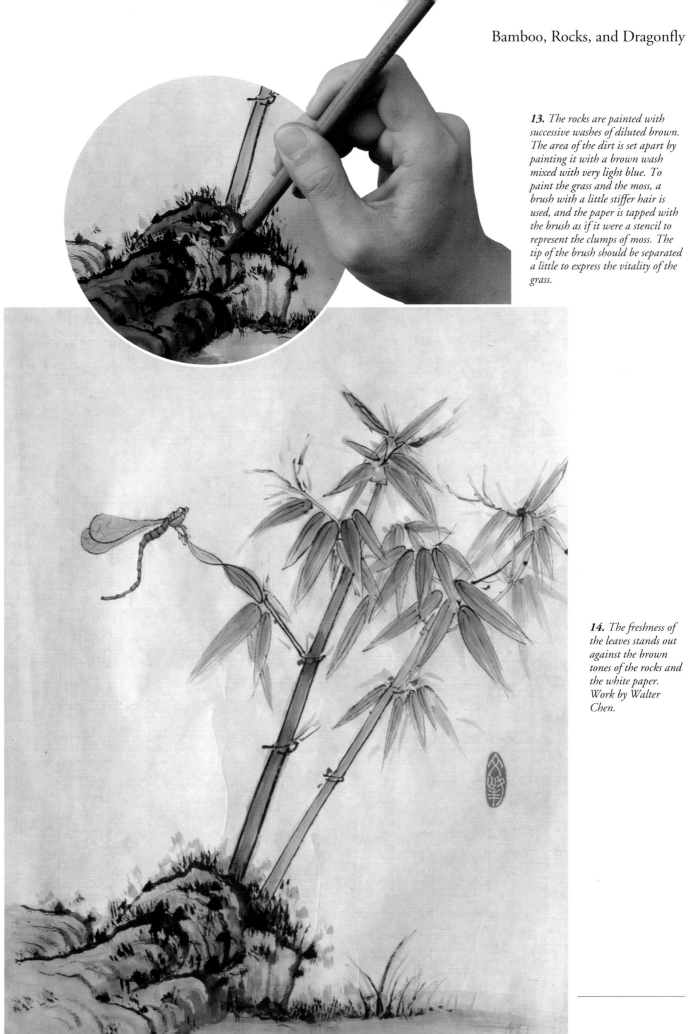

13. *The rocks are painted with successive washes of diluted brown. The area of the dirt is set apart by painting it with a brown wash mixed with very light blue. To paint the grass and the moss, a brush with a little stiffer hair is used, and the paper is tapped with the brush as if it were a stencil to represent the clumps of moss. The tip of the brush should be separated a little to express the vitality of the grass.*

14. *The freshness of the leaves stands out against the brown tones of the rocks and the white paper. Work by Walter Chen.*

逐步示範

A Geranium in Bloom

Several plants of the genus *Pelargonium* are classified under the name of geranium, and they can exude lemon, rose, nutmeg, mint, and ginger fragrances. The aroma of a fresh plant has a calming as well as a refreshing effect on the body and the spirit. According to popular belief, geraniums are used for protection. Negative energy and bad spirits are chased away when the plants are grown in window boxes in the house or when their flowers are rubbed on door handles. The geranium's flower symbolizes the evanescence of things, the brevity of existence, and the ephemeral nature of pleasures. Its shape is the image of the core, of the soul; a receptacle of nature's activities, like rain and dew. The blooms are the result of the inner transformation of the human being, the union of the essence (*Jing* 精)and the spirit (*Chi* 氣), of water and fire.

THE GROUPING

The group of flowers is the manifestation of spontaneous art, the synopsis of the vital cycle, of an instant of life. The color red of the petals is associated with the planet Mars, and it represents strong will, creativity, and expansive energy. In China, red is used on local holidays, in weddings, and for the birth of a child; it represents the warmth of the South, summer, youth, the color of the flag, and the warmth of fire.

Green is associated with Jupiter, justice, and reason. It is the mediator of the two extremes, relaxing and refreshing. It is associated with the East and with spring; it is the generator of energy, the emotion and the warmth of the element wood.

SIZED PAPER

Sized paper is normally used for the *Gongbi* technique because it does not absorb as much water as raw paper and it supports very fine brushstrokes. It is recommended not to use too much water in each brushstroke. Sized paper has been chosen for this exercise to express a cold and dry surrounding because the idea is to represent the geranium on a winter morning.

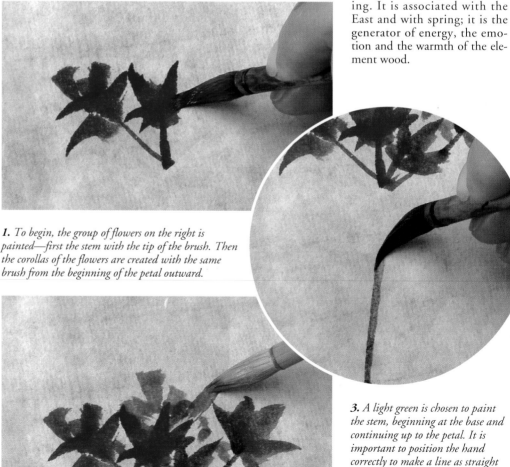

1. To begin, the group of flowers on the right is painted—first the stem with the tip of the brush. Then the corollas of the flowers are created with the same brush from the beginning of the petal outward.

2. The new flowers are painted with an orange-pink. The bunch is created with a combination of both colors.

3. A light green is chosen to paint the stem, beginning at the base and continuing up to the petal. It is important to position the hand correctly to make a line as straight as possible.

4. A second group of flowers is painted. For these the previous red washes are modified with a mixture of violet.

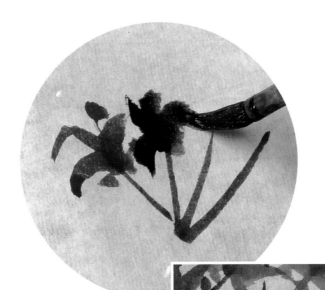

5. The small branches of the two groups of flowers are painted, the closest one with a wash of a medium green tone, and the one farther away with a red tinted with a small amount of green.

MAKING A WIDE BRUSHSTROKE

After the brush is wetted with dark yellow-green, the hair is squeezed between the fingers to paint the leaves.

6. The first section of the leaves is painted with a dark green and a little bit of blue on the tip, from outside in toward the branch.

7. The larger leaves are created with a wash of green and a touch of yellow on the tip of the brush, keeping in mind the shape of the leaves.

8. The veins on the leaves are painted with blue-green. It is not necessary to stay within the lines of the leaf; some veins can be extended beyond them to create mood and a sense of rhythm.

逐步示範

9. *The artist continues filling in the spaces of the closest leaves with darker colors such as green-brown or green-blue. It is very important to plan the combination of green tones beforehand to create an effect of depth for each plane.*

10. *With a thin round brush, the flowers' pistils are painted. The brush is lightly pressed when it reaches the tip of the pistil to create a larger dot.*

11. *When the bigger areas are finished, the smaller ones are painted, beginning with the taller flower. It is important to avoid connecting all the brushstrokes so the painting does not appear too rigid.*

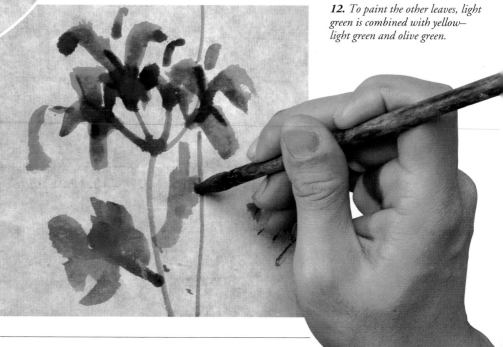

12. *To paint the other leaves, light green is combined with yellow—light green and olive green.*

13. *It is very important to know how to rotate the wrist and the brush. Here we can see that the brushstroke goes from the center outward, but it is turned abruptly with the side of the brush placed almost flat against the paper.*

14. *The leaves on the left side are finished. The colors are intensified or the tones darkened where needed to define the planes.*

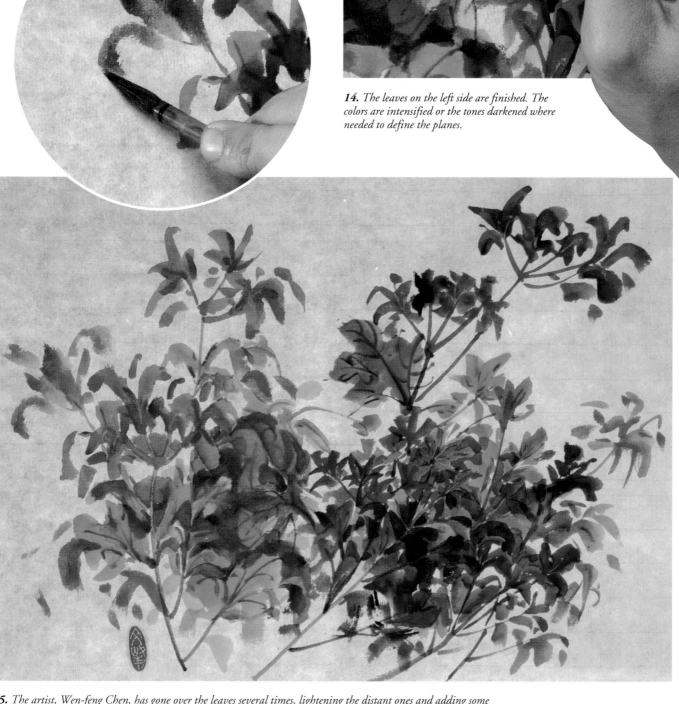

15. *The artist, Wen-feng Chen, has gone over the leaves several times, lightening the distant ones and adding some isolated ones to create depth and to achieve a dynamic grouping.*

Exercise with Two Flamingos

The flamingo is a very tall bird (it reaches 5 feet), with an oval-shaped body that is reminiscent of the sun and very long, thin legs that end in webbed feet. This bird will be the subject of the next exercise—two animals that live together, facing in the same direction and that have the same instincts, which symbolize justice and order, inner harmony, the simplification of many to one, and the overcoming of duality. They are able to live in the water, in the air, and on land, where they maintain a graceful balance in their movements. This is better appreciated in the animal that is closer to the viewer, which despite being in the process of grooming its feathers and standing on only one leg, almost achieves complete spiritual harmony.

For Taoists, the immortals take the shape of a bird as a liberation from terrestrial burdens. It is the presentation of the active individual soul and of the universal spirit, which is pure awareness. The flamingo symbolizes the awareness, one that knows the world of light. This animal is represented standing still, pensive, and calm, connected with the heavens and in touch with the earth. The selection of this pair of flamingos for this exercise was not arbitrary; the closest one represents strength, and the one in the background the wisdom of tradition.

TECHNIQUE

To express the texture of the birds' feathers with the *Gongbi* technique, selecting very fine, good-quality brushes is suggested. The shape of the bird is usually outlined using the fingernail, a pointed object, or a sharp blending stump, by touching the surface of the paper gently. Then the shapes are drawn with a very fine brush followed by painting with color washes, starting with the lightest to the darkest.

Flamingo at Rest

Intertwined, connected like two contiguous links in a single vital chain. A single direction, a single instinct, companions, accomplices, friends, two souls and a single spirit.

Maria Isabel Sallent

1. *A very thin brush is chosen and is wetted with very light ink to draw the bird. The beak, the head, and the neck of the first flamingo are drawn, followed by the body.*

3. *The outline of one of the legs is drawn with a thin, long line that extends from the body to the claws. Then the skin of the legs is drawn and the texture is painted with very thin lines.*

4. *The same process is repeated for the second flamingo. The curve of the neck and the shape of the wing against the body are drawn with rounded lines.*

2. *Using the same color of ink, the texture of the feathers between the neck and the body is painted using a series of curved lines that are drawn with light brushstrokes.*

5. *The legs are created with very fine lines. The texture of the feathers in the breast area is drawn with short strokes using a brush with the hair of the tip open, divided into two strands.*

6. *The first flamingo is painted with a brush made of soft goat's hair charged with very light pink, following the texture of the feathers.*

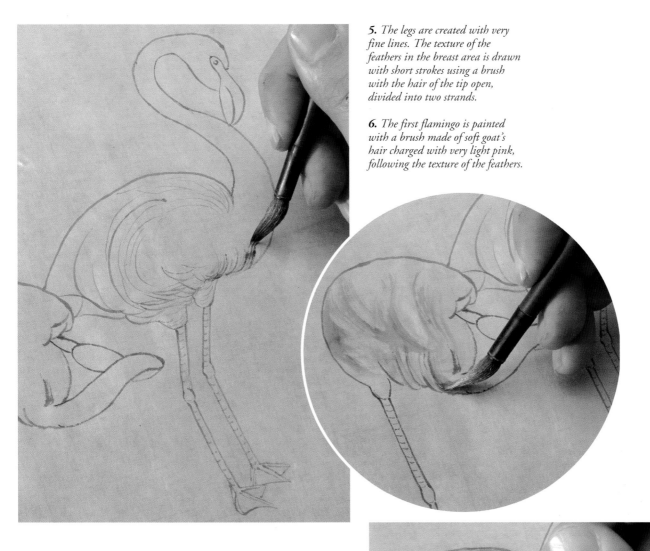

7. *Over the previous layer, new strokes of a little darker pink are applied. This helps define the plumage.*

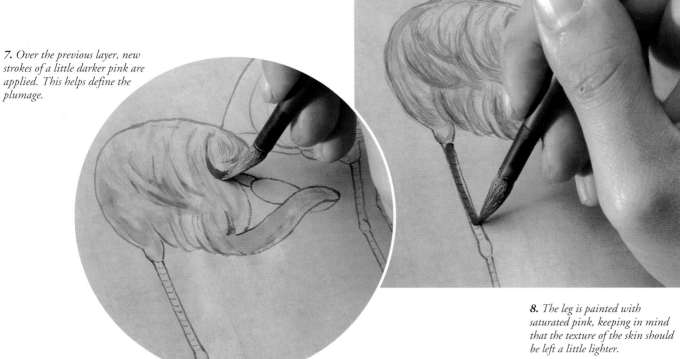

8. *The leg is painted with saturated pink, keeping in mind that the texture of the skin should be left a little lighter.*

逐步示範

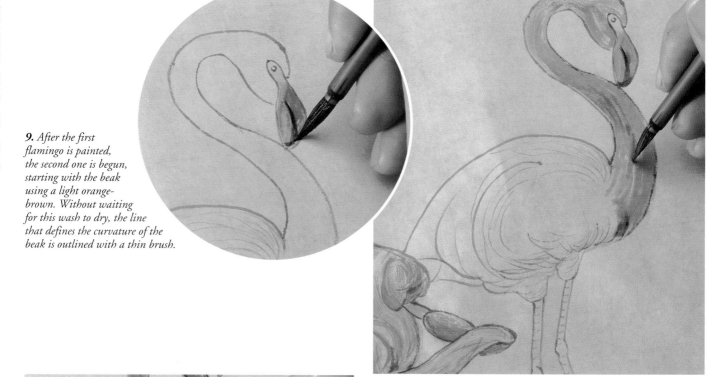

9. *After the first flamingo is painted, the second one is begun, starting with the beak using a light orange-brown. Without waiting for this wash to dry, the line that defines the curvature of the beak is outlined with a thin brush.*

10. *The bird's neck is painted with very diluted red ink. New, somewhat darker brushstrokes are added while the first layer of color is still wet.*

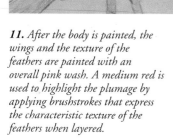

11. *After the body is painted, the wings and the texture of the feathers are painted with an overall pink wash. A medium red is used to highlight the plumage by applying brushstrokes that express the characteristic texture of the feathers when layered.*

12. *Using light orange-pink, the entire body of the closer flamingo is painted. It is important to distinguish the planes in which both birds are situated, to differentiate the distance with the change of color.*

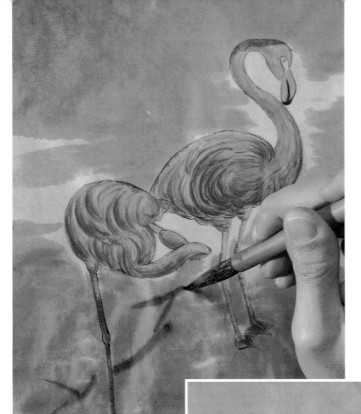

13. *Almost the entire background is dampened with a generous amount of water, and the ground and the distant tree are painted with the diluted ink. These details should not be too obvious; it is sufficient if they are just suggested.*

14. *The artist, Walter Chen, uses darker ink than before to paint the ground and the grass. Notice how the ink has become lighter during the drying process.*

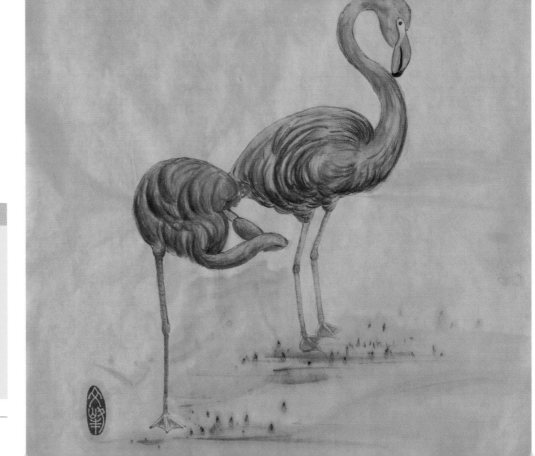

BALANCE

When painting any type of bird, it is important to study the placement of its mass. This and the legs are closely related. If the legs are not properly situated, the bird will clearly be out of balance. The effect becomes even more pronounced when the legs are very long, as is the case of the flamingo.

Landscape with Temples

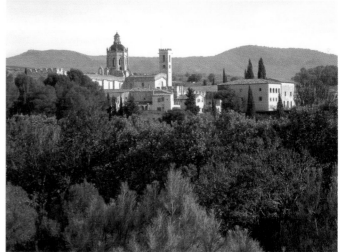

If you have never been to the mountains of China, looking at this painting can give you an idea of how life is in a village there. In the fall, when the sun sets, thick fog rolls into the landscape, making the background almost invisible, which sharpens other senses, such as the sense of smell. All the aromas are perceived with greater intensity: the wet grass, the dry leaves, the tree trunks, and even the incense from a faraway temple. The ear perceives the trickling of the water, the movement of small animals, and the birds flapping their wings. In this background a spiritual and reflective mood is created, interrupted only by the sound of a bell that is answered by another bell from another temple far away, which is a call for the veneration of supernatural beings, as well as for humans. Eastern cultures believe that anybody can fly through the air toward a particular place while hearing that sound. This work symbolizes the spiritual vertical ascent toward the light.

ATMOSPHERE

Before the artist begins to paint, he or she needs to know exactly where each element of the landscape is going to be placed. There is no need for many elements, but it is important to have a good amount of distance between them because the circulation of the air, the fog, and the clouds plays a very important role.

As a model for this exercise we have chosen a landscape, which, although it is not in China, will serve as a guideline, will motivate the artist, and will inspire him or her to paint and to create different planes of an autumn environment that evokes mysticism.

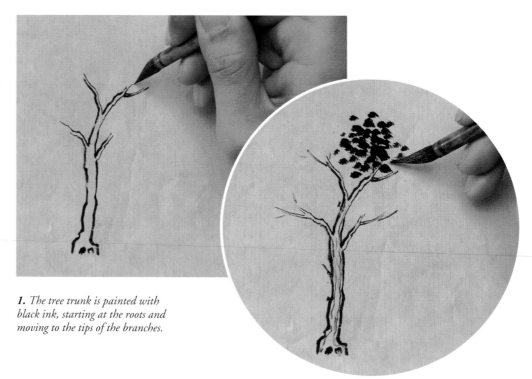

1. The tree trunk is painted with black ink, starting at the roots and moving to the tips of the branches.

2. The groups of leaves are painted around the branches by applying small strokes in the shape of dots.

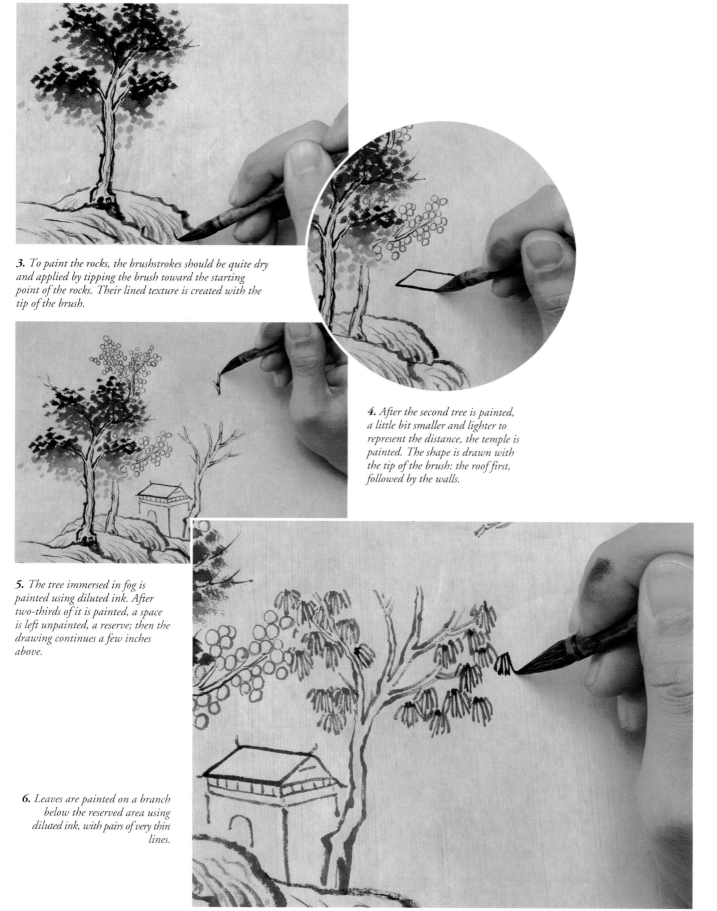

3. *To paint the rocks, the brushstrokes should be quite dry and applied by tipping the brush toward the starting point of the rocks. Their lined texture is created with the tip of the brush.*

4. *After the second tree is painted, a little bit smaller and lighter to represent the distance, the temple is painted. The shape is drawn with the tip of the brush: the roof first, followed by the walls.*

5. *The tree immersed in fog is painted using diluted ink. After two-thirds of it is painted, a space is left unpainted, a reserve; then the drawing continues a few inches above.*

6. *Leaves are painted on a branch below the reserved area using diluted ink, with pairs of very thin lines.*

逐步示範

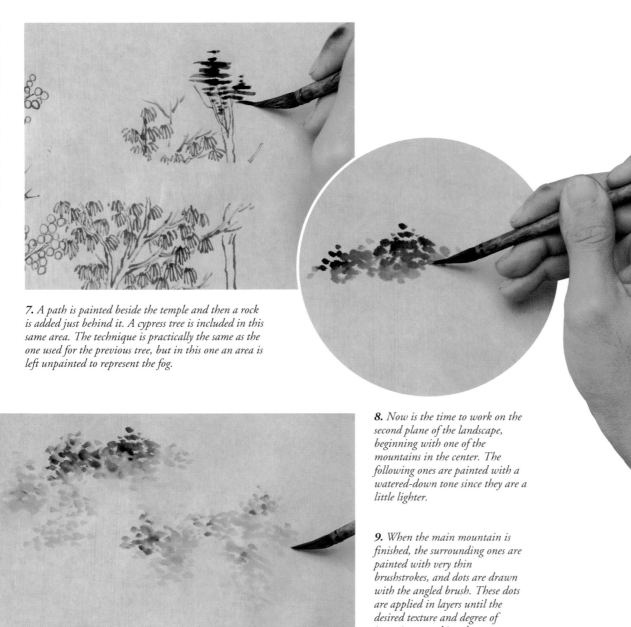

7. *A path is painted beside the temple and then a rock is added just behind it. A cypress tree is included in this same area. The technique is practically the same as the one used for the previous tree, but in this one an area is left unpainted to represent the fog.*

8. *Now is the time to work on the second plane of the landscape, beginning with one of the mountains in the center. The following ones are painted with a watered-down tone since they are a little lighter.*

9. *When the main mountain is finished, the surrounding ones are painted with very thin brushstrokes, and dots are drawn with the angled brush. These dots are applied in layers until the desired texture and degree of intensity are achieved.*

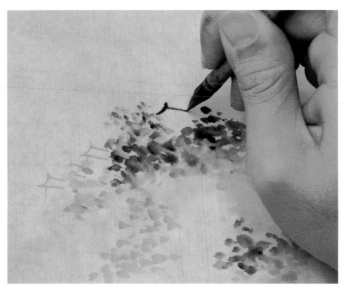

10. *A second temple is painted on the mountain, located in the middle ground using thin and very diluted lines. It is placed between the mountain and the clouds.*

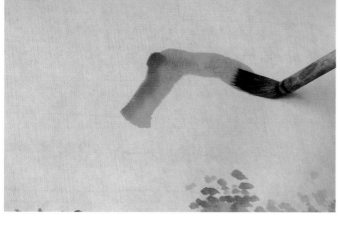

11. *Now the brush is dampened with abundant water and very light ink, and the mountain located in the upper right area is painted, going from the top to the side.*

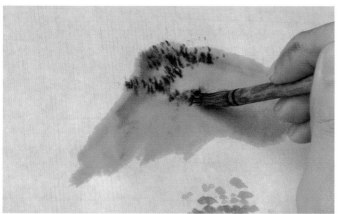

12. *Without waiting for the previous wash to dry, the brush is charged with a little bit darker ink and groups of dots are applied to represent the texture and the vegetation of the mountain.*

13. *The shape of the distant mountain located in the upper part of the paper is painted.*

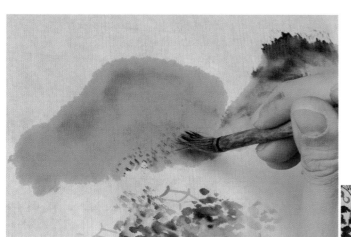

14. *Moss is painted on the foreground with a series of dots.*

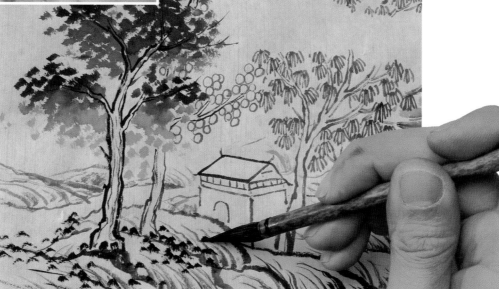

逐步示範

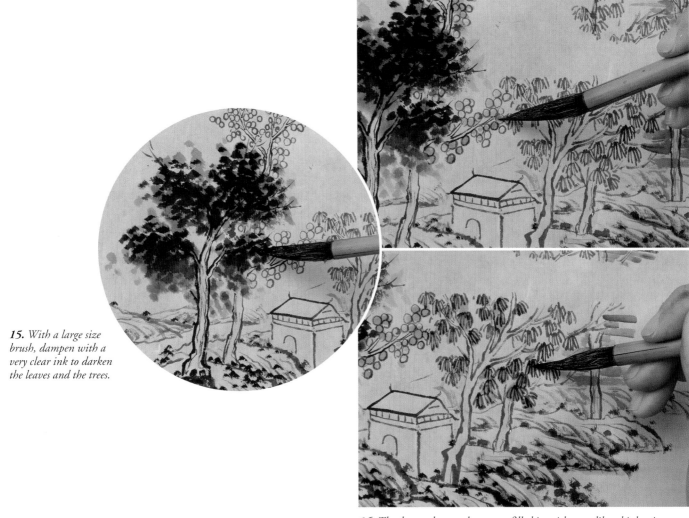

15. *With a large size brush, dampen with a very clear ink to darken the leaves and the trees.*

16. *The dots and empty leaves are filled in with very diluted ink using very light brushstrokes.*

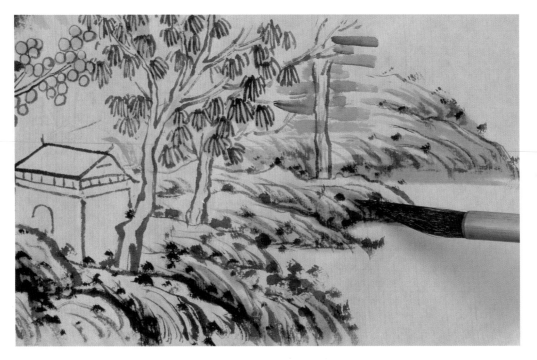

17. *The rocks are painted with very diluted ink, keeping in mind that the direction of the strokes must follow the texture being described. The base of the rocks is painted with a wider brushstroke.*

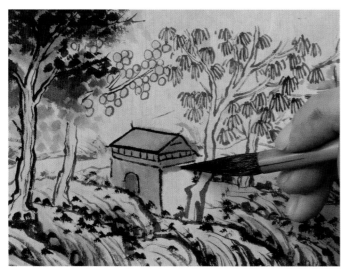

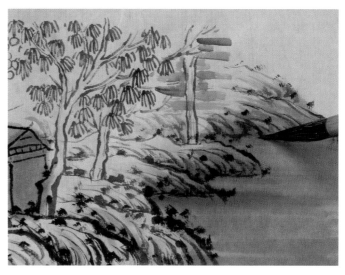

18. *When the temple is painted, different tones are used for the front part and for the sides; this gives the building a feeling of depth.*

19. *The ground is dampened with very diluted ink using horizontal brushstrokes. A little darker ink is used for the bottom of the rock to make it appear more solid.*

20. *The tip of the brush is separated to form two strands. They are charged with very light ink to paint the texture and depth of the fog. This is approached from the edge of the space to produce an airy effect when light dots are applied.*

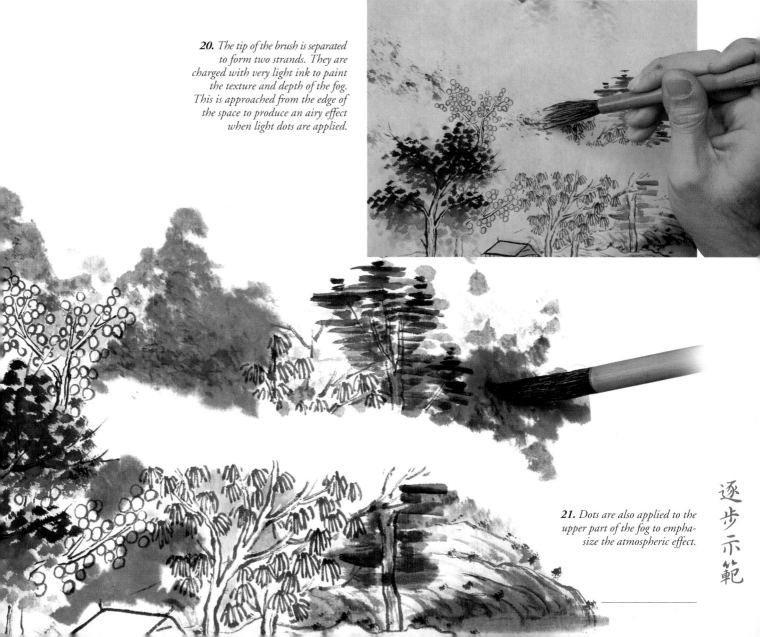

21. *Dots are also applied to the upper part of the fog to emphasize the atmospheric effect.*

逐步示範

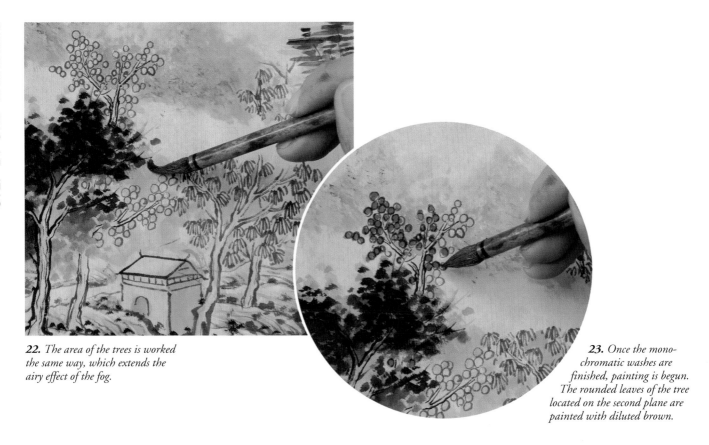

22. *The area of the trees is worked the same way, which extends the airy effect of the fog.*

23. *Once the mono-chromatic washes are finished, painting is begun. The rounded leaves of the tree located on the second plane are painted with diluted brown.*

THE WASH

The washes or tints of black and colored ink must be created with many very light washes, which is a very slow process. A single tone or very thick and dark color should never be applied on a single layer, because it cannot be changed later. However, if many light layers are applied, rich tones can be achieved as well as a very interesting depth while having greater control over the results.

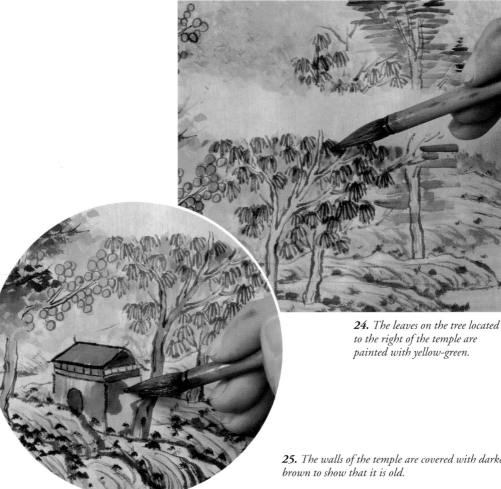

24. *The leaves on the tree located to the right of the temple are painted with yellow-green.*

25. *The walls of the temple are covered with darker brown to show that it is old.*

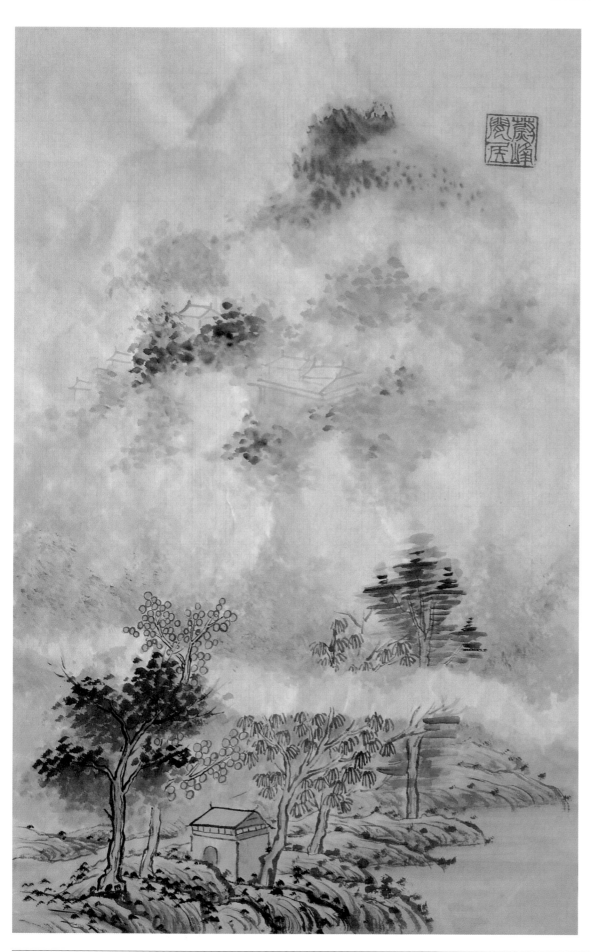

26. *Finally, the rocks are painted with green-brown. Autumn, the wisdom of our spirituality! With the inscription on the seal:* Living Inside the Blue Mountain, *which is the translation of the surname of the artist, Walter Chen.*

逐步示範

Orchids and Bird Painted on Silk

In ancient China, orchids were associated with spring festivities, where they were used to expel harmful forces. The main harmful force was infertility. Also, the Greek origin of the word *orchid,* which means "relative to the testicle," shows its relationship to infertility. In China it is believed that orchids promote regeneration, and the orchid is a sign of fatherhood. The flower is a symbol of perfection and spiritual purity.

SILK TECHNIQUES

This exercise is painted on the traditional Chinese support silk, with specially prepared inks. It is painted using the *Gongbi* technique, which consists of very fine and elaborate brushstrokes. This typically Chinese painting technique is capable of producing delicate and detailed works of art.

MATERIALS AND TOOLS

The following materials are used in this exercise:

A fan in the *paipay* style mounted with tightly stretched silk.

Brushes for watercolors or large Chinese brushes.

A stretcher frame a little larger than the fan. It can be made of wood or any other material.

Dyes for silk that can be fixed with steam. These dyes are made of a type of pigment that is easily absorbed by the fibers of the fabric. They look shiny after they have been fixed, and they can be used to produce delicately painted backgrounds.

A foam brush.

Cotton swabs.

Guta (a gum resin solution that seals the pores of the silk and makes it possible to work the surface without concern for bleeding colors) to prevent bleeding, and benzine (a solvent for guta) to prepare the anti-bleeding material. One part of guta is mixed with two or three parts of benzine.

1. The design, a composition with an orchid and a bird, is drawn on a separate piece of paper with a pencil. The white sheet of paper should not be larger than the fan.

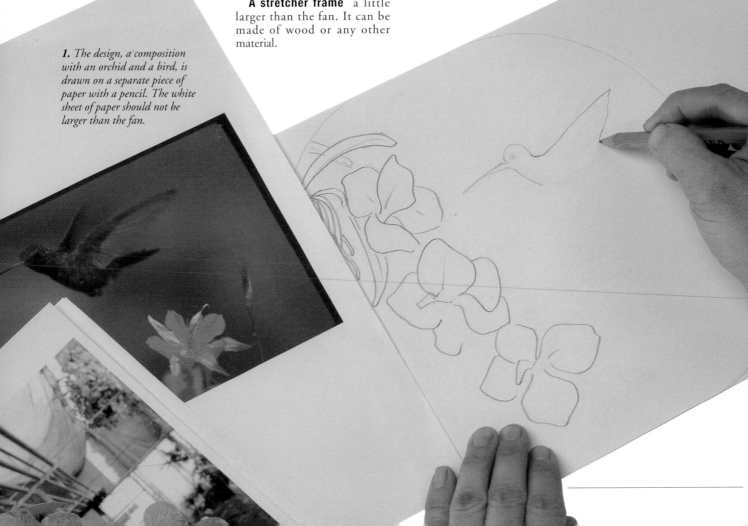

THE DYES

Here is a range of colors that could be used to paint on silk: lemon yellow, orange, vermillion, carmine, maroon, ultramarine blue, cobalt blue, turquoise, Bordeaux, emerald green, yellow-green, olive green, ochre, brown, and black. This range can be complemented with more colors as required for other works.

Bottles of special dye for painting on silk.

2. *The fan is placed on the frame and is painted with the antibleeding compound, spreading it evenly over the silk with the foam brush.*

3. *After the dyes have been arranged on a multiple palette, the paper with the drawing is placed under the fan. Using a thin brush with very light maroon dye, the shape of the flower, the branches, and the bird are traced with very thin lines.*

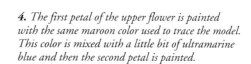

4. *The first petal of the upper flower is painted with the same maroon color used to trace the model. This color is mixed with a little bit of ultramarine blue and then the second petal is painted.*

逐步示範

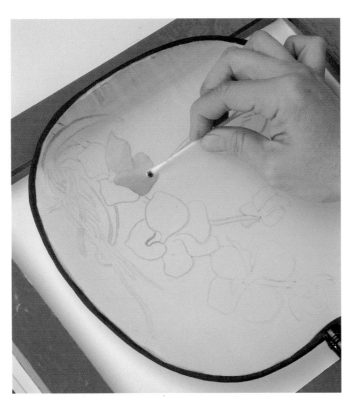

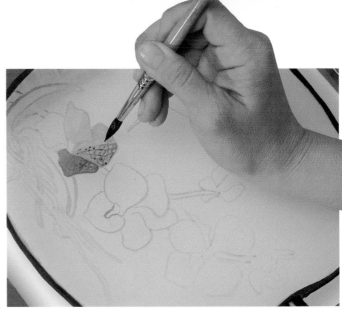

5. *The excess dye is carefully removed with a cotton swab.*

6. *The brush is charged with ultramarine blue to paint the texture of the petal with very fine lines.*

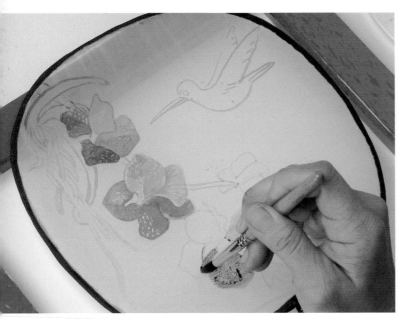

7. *The lower flower is painted with a different maroon using gestural brushstrokes applied from the center outward to create the base of the flower.*

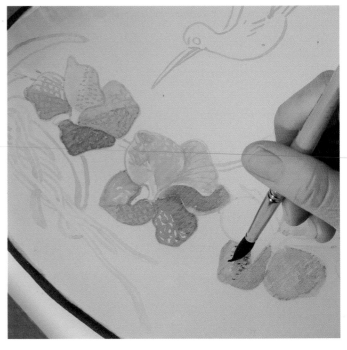

8. *Small dots are applied to the petal with light strokes using an intense maroon.*

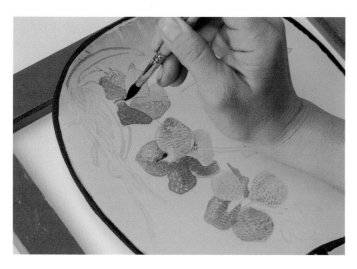

9. *The pistils, which are very bright, are painted with carmine.*

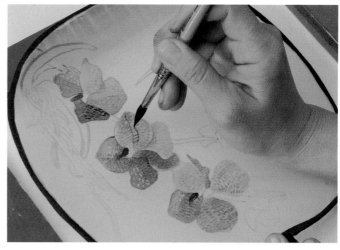

10. *To express the texture of the petal, a couple of very fine lines are painted using a Bordeaux color.*

MODERATION WITH THE DYE

When the *Gongbi* technique is used for painting, it is important to not charge the brush too much. As we have indicated before, this technique incorporates many layers, and time must be allowed for them to dry before a new layer is applied. The work could be ruined if the dye is applied while the layers are still wet.

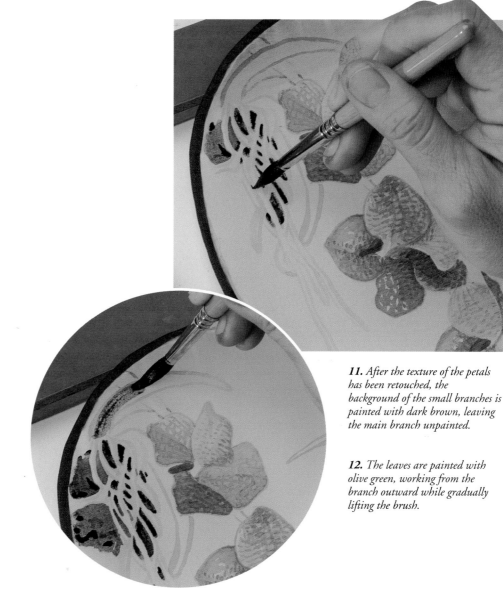

11. *After the texture of the petals has been retouched, the background of the small branches is painted with dark brown, leaving the main branch unpainted.*

12. *The leaves are painted with olive green, working from the branch outward while gradually lifting the brush.*

逐步示範

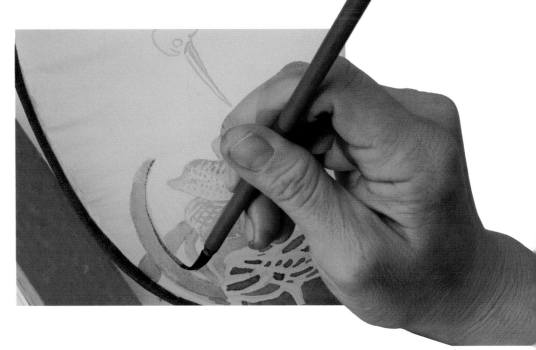

13. *The fan is rotated to make working easier, and the shapes of the leaves are outlined with very fine lines of dark green.*

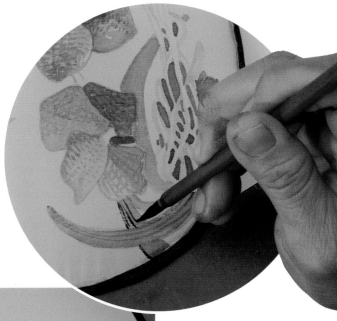

14. *An even darker green is used on the leaf behind to indicate its distance with respect to the front one.*

15. *The fan is rotated again, and now the petals are outlined with dark maroon.*

16. *Work on the flying bird begins with the head, which is painted with olive green, and continues with the body in turquoise blue.*

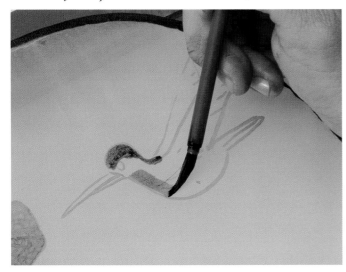

17. *The wing is also painted with a lighter olive green, using gestural brushstrokes applied.*

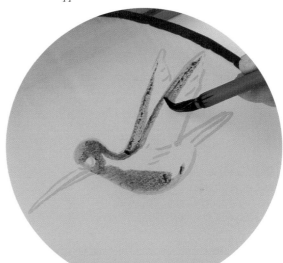

18. *The volume of the bird and the texture of the tail are emphasized with a couple of light brushstrokes of very dark brown ink.*

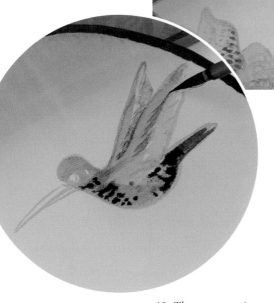

19. *The process continues with a few very fine brushstrokes following the direction of the plumage to create the texture of the bird.*

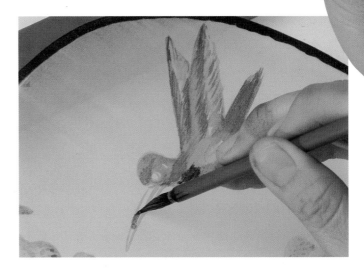

20. *Finally, the long beak is painted with a single brushstroke of red vermilion.*

逐步示範

21. *Now, returning to the plant, the branches are painted a green-brown with very light and diluted washes.*

22. *The artist, Li-chi Tsai, signs with a very thin brushstroke when she finishes the work.*

ADVICE FOR PAINTING ON SILK

Silk is a natural material on which dyes run easily. Running can be controlled by treating the silk with special antibleeding products called gutas, but this stiffens the fabric. Once treated, silk becomes a suitable based for painting and allows the application of detailed lines and very fine brushstrokes.

There are two varieties of guta: one that is water-soluble and another that requires a solvent such as benzine or gasoline. Both types are painted on the silk using a foam brush and allowed to dry before beginning work.

Water-based guta can be mixed with the dyes for additional control and is easier to work with. Finished pieces created with water-based guta cannot be washed; if necessary, they must be dry-cleaned.

Caution must be exercised when using solvent-based guta because it is very flammable. It also cannot be mixed directly with the water-based dyes. Finished pieces created with solvent-based guta can be washed in water, but not dry-cleaned. If it is necessary to remove the guta, the piece must be soaked in solvent.

To fix the dyes permanently on the silk, all finished work must be "set" by either steaming it or soaking it in a chemical bath.

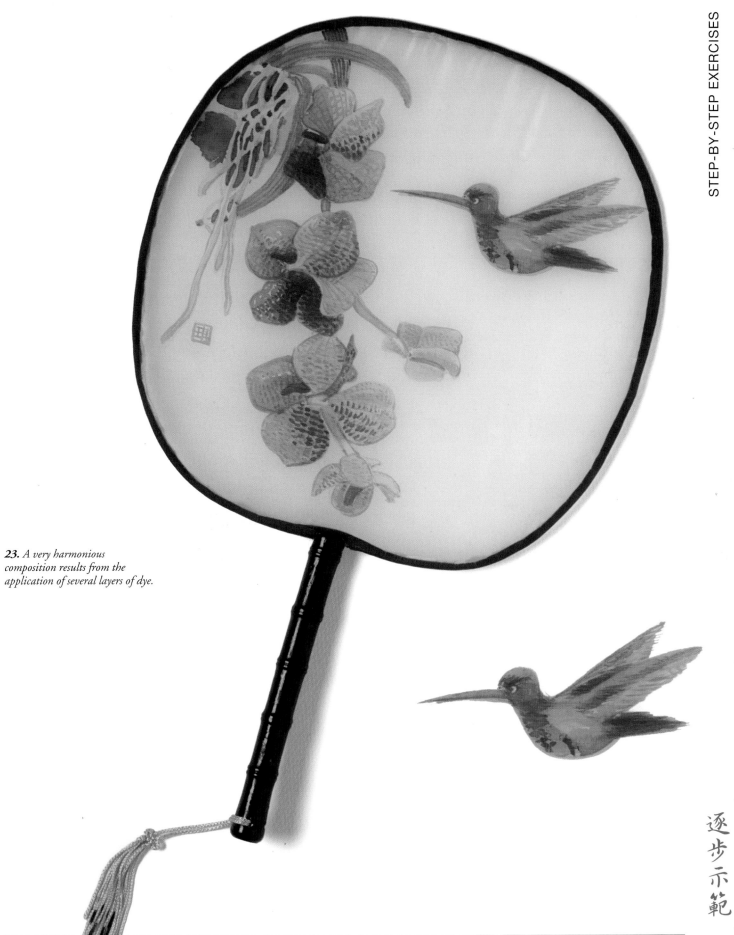

23. *A very harmonious composition results from the application of several layers of dye.*

逐步示範

A Climbing Plant with Fish and a Bird

At the break of a new day the colors are bright, clean, and vibrant. The bird, despite its heavy appearance, is able to stand on one leg on a floating leaf, unaware of its surroundings, absent in thought. After a quiet night, the water of the lake is clear and the surface appears calm, and two fish can be seen looking for food. There is no confrontation between the two animals; it is an example of perfect coexistence. On the right bank an explosion of color and gestural movement can be seen, like a waterfall of vegetation. It is a climbing plant swaying in the breeze, providing a musical and aromatic spectacle that floods the entire area. This is another compositional exercise, a single model that incorporates three different images.

THE USE OF WHITE

White ink is seldom used in Chinese painting. As in Western watercolors, in Chinese painting white is generally represented by leaving the paper unpainted. But white does exist, and it is used, for example, over areas of color or with brushstrokes while the paint is still wet to create a feeling of texture. White ink can also be blended with other colors on the tip of the brush to create an effect desired by the artist.

THE SKETCH

In traditional Chinese painting the figures are marked using the fingernails, charcoal, an awl, or anything that has a hard point. The preliminary sketch is never as elaborate as in Western painting and it is considered only a preliminary step for the proper placement of the elements. It also serves to sketch the basic shape of the figures, and in general, to see how the composition will look before painting has begun.

1. Before the painting is begun, and given the complexity of the bird, the shape of its body is first outlined on the paper with the end of the paintbrush handle. Its placement must be correct since it is the protagonist of the work of art. It is done as a sketch, to be drawn later in more detail with the brush.

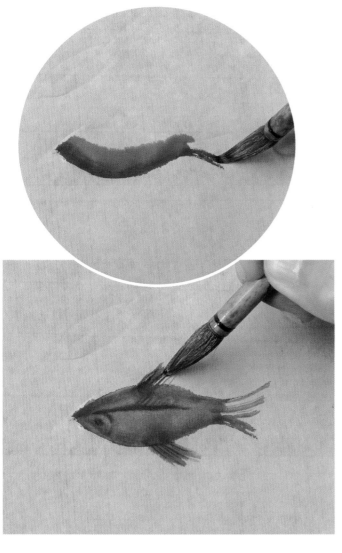

2. A soft brush is charged with light red and tipped with bright red to begin painting the lower part of the fish's head and continuing to the end of the tail. Then the tip of the brush is wetted again with bright red to paint the texture of the tail.

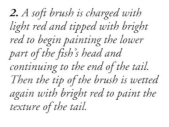

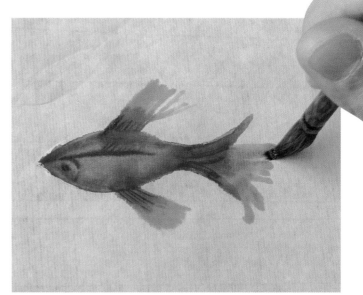

3. After the upper part of the body is finished, the tip of the brush is charged with more dark red, and the gills, the eye, and the fins are painted.

4. The brush is charged with clean water, and without waiting for the previous colors to dry, the gills and the fins are brushed to create a wash effect.

5. The second fish is painted the same way, adding white to the tip of the brush tinted with pink.

逐步示範

6. The bird's beak is painted with darker red and orange using a finer brush. To define the shape better, a very thin line is painted with black ink along the lower edge.

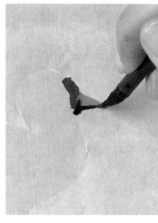

7. The goat-hair brush, which absorbs more water, is now charged with light blue, and the tip with dark blue. The color is applied from the beginning of the beak to the neck to form the head.

8. The same colors are used to paint a curve with the brush to represent the abdomen.

9. The brush is washed and recharged with a medium-brown color to paint the upper part of the body. The brushstrokes should be applied going from the neck to the tail to create the texture of the feathers.

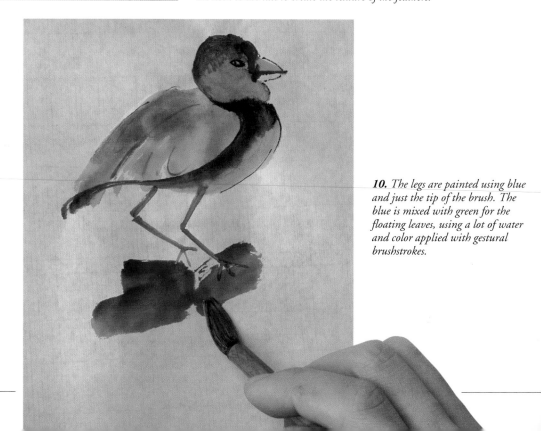

10. The legs are painted using blue and just the tip of the brush. The blue is mixed with green for the floating leaves, using a lot of water and color applied with gestural brushstrokes.

11. *Now the climbing plant is painted, starting with the dark ink lines to define the main branch.*

12. *Keeping in mind the irregularity of the plant, it is painted with very loose brushstrokes. It is important to control the motion and the force of the wrist, because each brushstroke represents the vitality of the plant and the movement of the branches swaying with the breeze.*

14. *If the artist considers that a complement or detail that may explain the shape of the plant is missing, one can be added; however, it is important to let the work "breathe"; in other words, not to completely cover every single space inside the plant.*

13. *The flowers are also painted with loose brushstrokes. A combination of colors is used: red, lilac, and light and dark orange.*

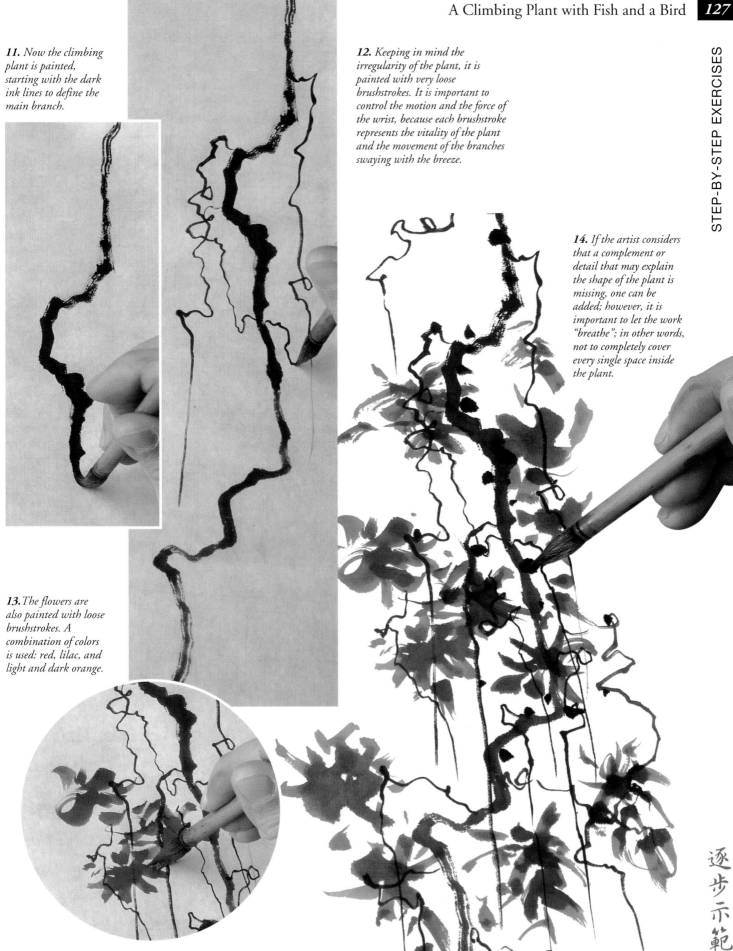

逐步示範

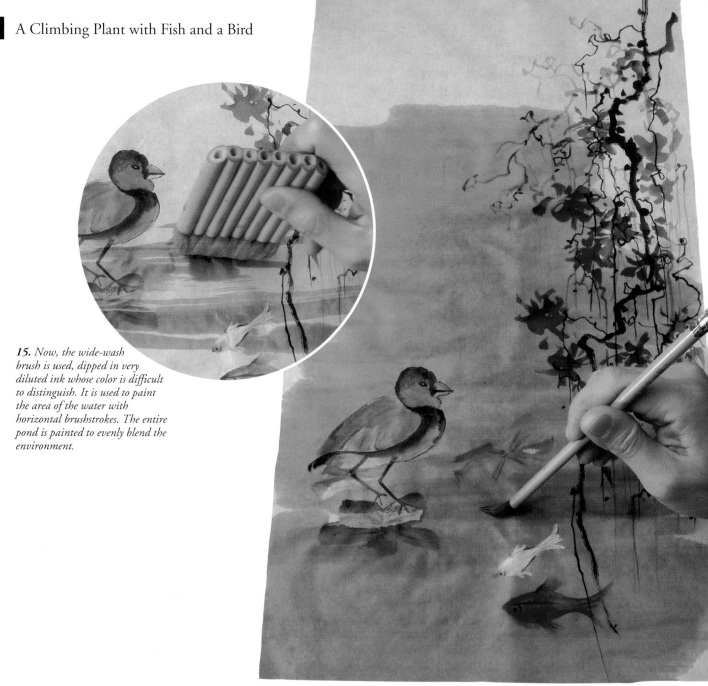

15. *Now, the wide-wash brush is used, dipped in very diluted ink whose color is difficult to distinguish. It is used to paint the area of the water with horizontal brushstrokes. The entire pond is painted to evenly blend the environment.*

16. *After most of the pond is painted with these light gray tones, small amounts of very diluted blue and brown are applied alternatively to simulate the transparency of the water.*

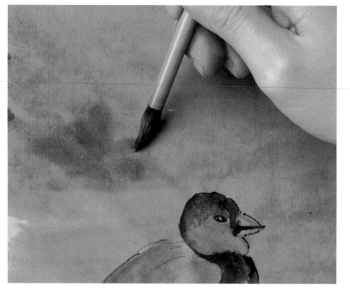

17. *The leaves on the surface of the pond are also painted with very light blue-green tones. The farther away the leaves, the lighter the color should be.*

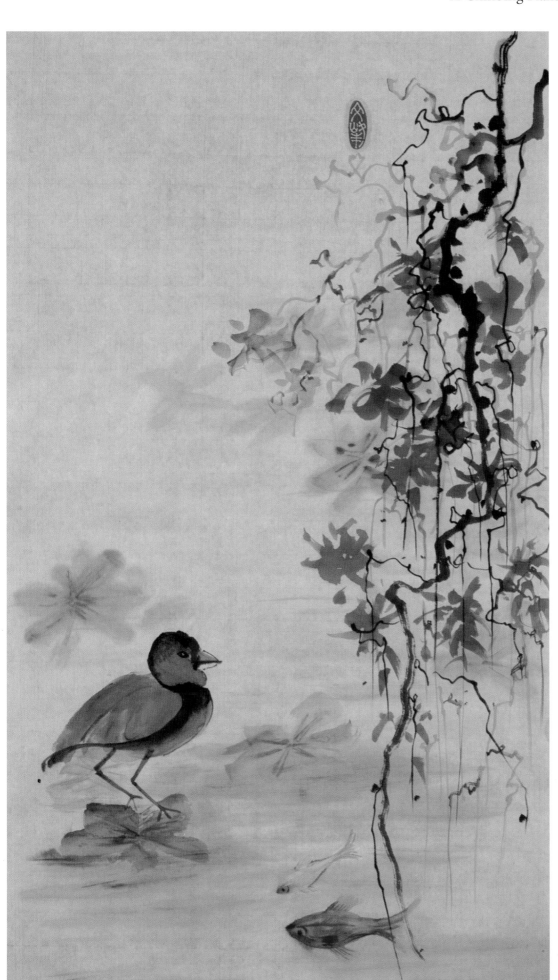

18. *After several color washes are applied, the result is a very diffused, atmospheric, and poetic representation, a peaceful environment for a group of living creatures.*

逐步示範

Landscape with People, Houses, and a Boat

Thousands of years of tradition, culture, and philosophy of life are transmitted through Chinese painting. These traditions respect nature, on which they depend and which they copy to maintain cosmic order. There are some essential, innate guidelines, which are born from the experiences of this people. They can be learned and even copied, but they will never come from the hand of a person who does not feel, breathe, and love them with the same respect. The following work is an example of this.

COMPOSITION

The format of this landscape is horizontal; the symbolic weight is located on the lower left side and is represented by the figure of an old man leaning on a cane at the end of a long walk. He represents wisdom, a timeless essence, the simplicity of the life of a hermit who abandons worldly cares. Thanks to his isolation in the mountains he is able to attain certain special virtues with which he can help those who come to him looking for advice.

The character is placed on a triangular piece of land. Further up, at the top, there is a similar triangular space turned 180 degrees where the distant mountains are painted. If this upper section were connected to the lower piece, they would form a square. This was the emblem of the emperor, the lord of the land. In ancient China, it was believed that the Earth was square, and today this shape is still used to represent the "element Earth."

As the elements are arranged; the space is divided into four areas, which suggest the ideas of opposites and of complementary elements (*yin* and *yang*).

ATMOSPHERE

The sun just came out a few hours ago, and the green vegetation suggests that it is spring. After a period of wintry cold where the ground appears dead, the mane of the mountain returns and springs up. This metaphor refers to the river as the origin of life, an element of spiritual and physical regeneration, the road and pathway between the two states of the soul, the ages of man. The young man, after a few months of introspection and solitude, goes to visit his friend and greets him with admiration and respect. It is then that he begins a monologue; the old man listens to the words, which are swayed by the breeze and returned. He lifts his gaze and encounters the gentle eyes, full of light. The young man, after listening to his own words, notices that what he is looking for is within him. The master comforts him and encourages him to continue his journey.

PEOPLE IN A LANDSCAPE

The human presence in landscapes is painted with fine brushes to make light lines, with no brusque marks like those made for other elements such as rocks, trees, and mountains. Although the people always look small, their shapes must have harmony and proportionality, and must maintain a relationship to the composition of the landscape.

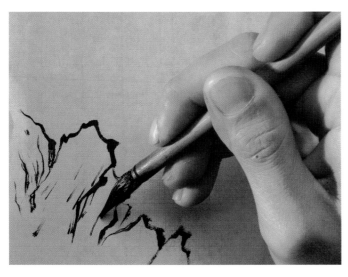

1. *To begin, the foreground, the figure, and the texture of the rock are painted with a stiff brush.*

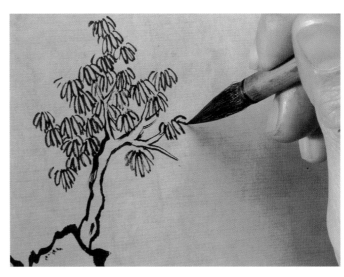

2. *The tree trunk is painted from the ground up, followed by the leaves, with very thin double lines that later will be painted in color.*

3. *After the trunk of a weeping willow located behind the first tree is painted, the brush is switched for a very fine one. The brush is charged with saturated ink, and the old man is painted, starting with the hat, followed by the face, the clothes, and the cane. When the sleeve is reached, more pressure is applied to the brush to create a heavier brushstroke.*

4. *The figure of the young man is painted the same way and with the same ink tone, since both are located on the same plane.*

5. *The lines that form the house are painted with a thicker brush. The texture of the roof is defined with parallel hatching.*

逐步示範

6. After the main elements are completed, the banks of the lake are painted with the brush held at a steep angle, and they are finished with a couple of rocks at the end.

7. The tip of the brush is used to paint the boat. This is a somewhat challenging task because it requires very light lines that will still preserve the inner strength.

8. Now some lighter tones are used to paint the trees located behind the house.

9. When the foreground is finished, the mountains in the distance are painted by applying more diluted ink and a thinner brushstroke. It is important to paint the base of the mountains with horizontal lines.

10. *Once the overall shape of the mountains has been defined, the vegetation is painted with medium gray, layering groups of dots. This method requires patience since many layers of dots have to be applied to achieve the desired texture.*

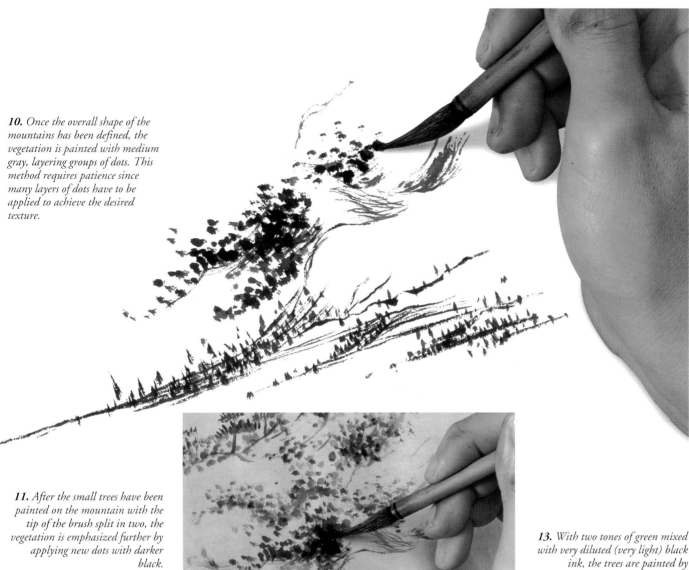

11. *After the small trees have been painted on the mountain with the tip of the brush split in two, the vegetation is emphasized further by applying new dots with darker black.*

12. *The brush is charged with a generous amount of light ink and tipped with black ink to paint the mountain that is located farthest away with a single brushstroke.*

13. *With two tones of green mixed with very diluted (very light) black ink, the trees are painted by following the direction of the leaves. The green brushstrokes should not mix with the black ink. If the paint is applied along the previously painted lines, the effect achieved is much more spontaneous and poetic.*

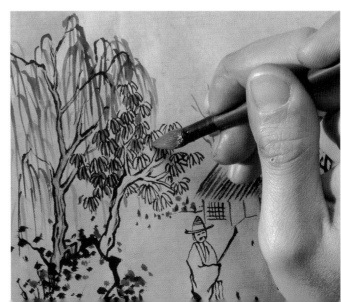

逐步示範

14. Now the old man's hat is painted brown, the clothing with an orange tone, and the neckline gray.

15. The young man's headscarf is painted with light blue and his clothes with dark blue. To complete the foreground, the roof and the window of the house are painted with light brown.

16. Green with light blue is used to paint the volume of the rock by indicating its texture.

THE COLOR OF THE CLOTHING

In painting, as in Chinese opera, the use of some colors is established by tradition. Therefore, the clothes of young people of both sexes are usually blue.

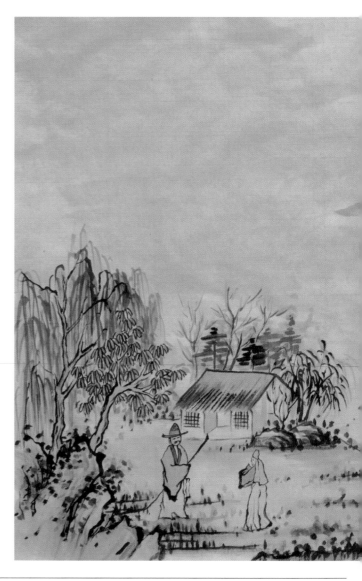

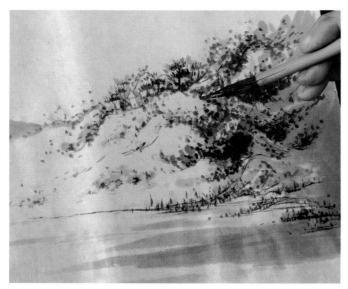

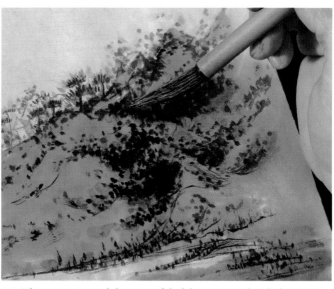

17. *To form the texture and the volume of the mountains and of the vegetation located in the background, the brush is charged with a very light color, so diluted that it will be hardly noticeable when it dries.*

18. *The mountains and the water of the lake are covered with the same exact diluted green. If the color is applied with several layers of washes, the surface of the water will have more richness and depth.*

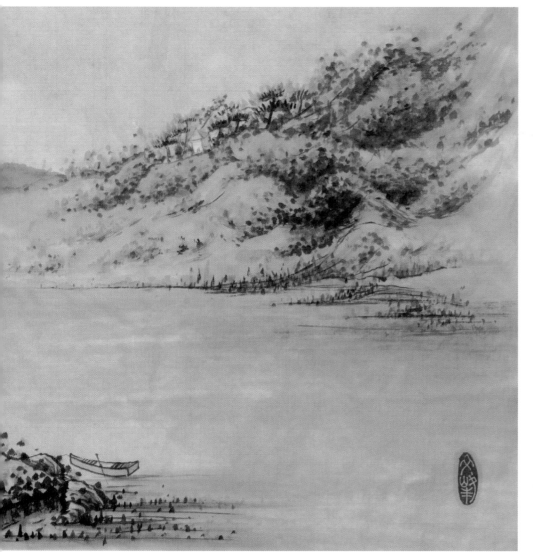

CONSTANT OBSERVATION

During the painting process, we recommend that you observe all the individual elements as well as the overall composition several times very carefully. This will give you opportunities to adjust the range of grays, if necessary, by evaluating the relationship between them. Keep in mind that when the ink is wet the tone will look darker. Tones turn lighter when they dry.

19. *After several layers of paint, a springlike scene finally emerges following the long winter. We recommend repeating this coloring process at least ten times, along with the application of very light inks to increase the vitality of the landscape.*

逐步示範

Portrait of an Old Man

The image of the old man is venerated in many civilizations, among them the Chinese. Old age is perceived as a stage that humans achieve to prolong their stay among their loved ones. Old age is associated with perseverance, endurance, that which participates in the eternal. Each wrinkle, each crease, is a road traveled, an experience lived, which confers solidity, authenticity, and truth to the human experience. The look of an old man, who despite the passage of time maintains a spark, registers that he has had many happy and sad moments, has cried, has laughed, but even so still maintains the internal energy, the desire, to live.

A DIFFERENT TECHNIQUE

The technique used in this work combines dark and light brushstrokes, washes and dry brush, beginning with dark ink and followed by light. If the artist notices at any time that an intermediate tone is missing, the appropriate color can be used again to minimize the difference between the previous brushstrokes.

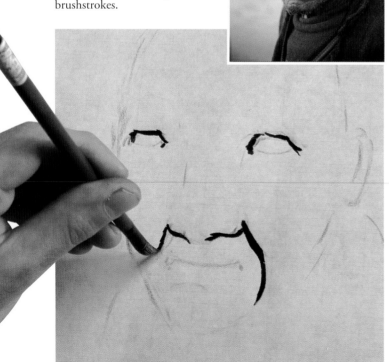

1. First, all the features of the face are lightly indicated with charcoal. The lines should not be very dark so they can be easily erased.

2. The upper contour of the eyes is painted with a thin brush and ink while turning the wrist very gently. Then the fold between the nose and the upper lip is painted with the same tone of ink.

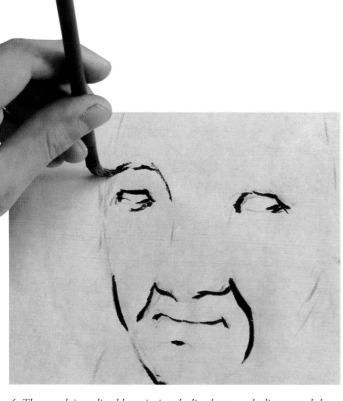

3. *The tip of the brush is separated using two fingers.*

4. *The mouth is outlined by painting the line between the lips toward the left with a movement of the wrist. The eyebrows are painted with the hair of the tip separated, following the direction of the growth of the eyebrow.*

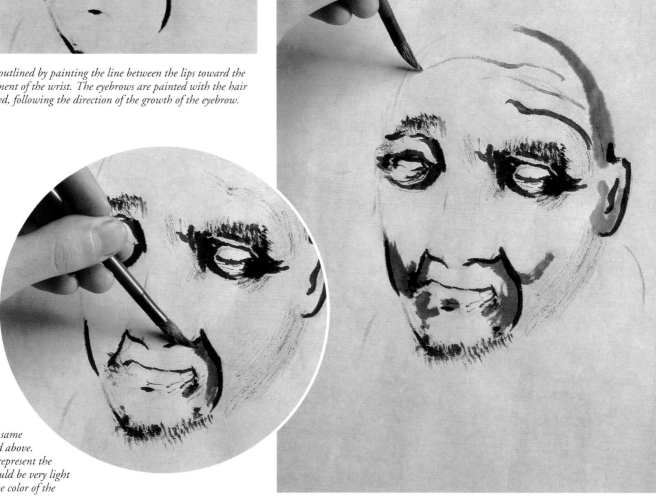

5. *The beard is created using the same method explained above. The strokes that represent the hair's texture should be very light and repeated. The color of the cheeks is painted with wider, lighter, and more diluted brushstrokes.*

6. *The head is painted with the same tone of ink with a single brushstroke from the ear to the forehead while lifting the brush little by little. The wrinkles of the forehead are resolved with several subtle brushstrokes following their width and depth, combining them with more brushstrokes applied with different amounts of pressure.*

逐步示範

7. *The area between the brows is painted with several small, very diluted colors whose intensity varies according to the plane that they represent. New applications contribute to the increased definition of the volume of the nose.*

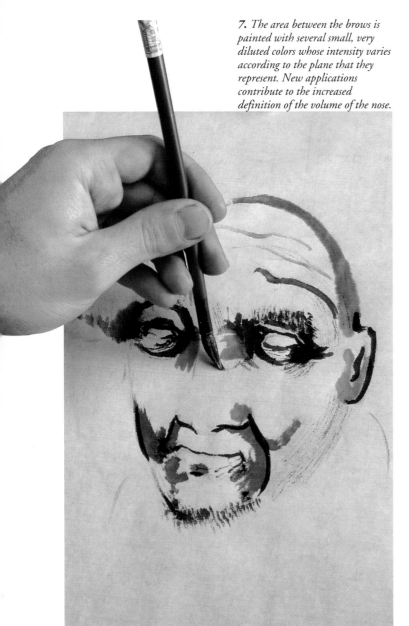

8. *The volume of the chin is painted with several short, light brushstrokes with a slightly dry brush.*

9. *Several very diluted brushstrokes are applied to express the volume of the forehead starting at the side of the head. The painting of the upper part of the clothing is also begun.*

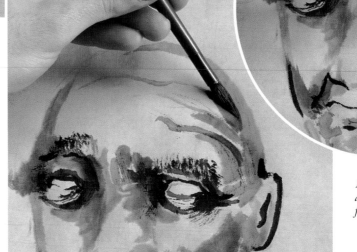

10. *When new darker washes are added to the eyes and the nose, the feeling of volume is enhanced.*

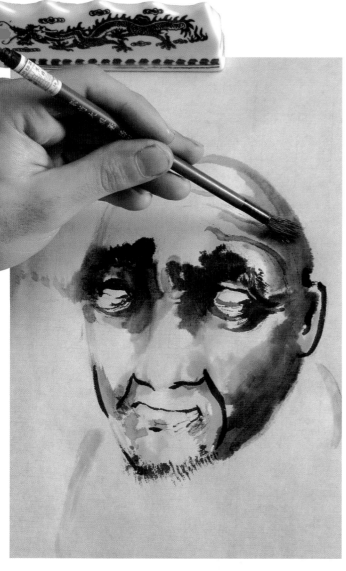

11. *Now the artist begins to fill in the tones. To do this, wide, diluted brushstrokes and very light ink are used. The work is done with a brush charged with a generous amount of paint to cover a large surface of the paper with the wash.*

12. *Again, dark, thin lines are used to emphasize the eyes because the gaze is very important.*

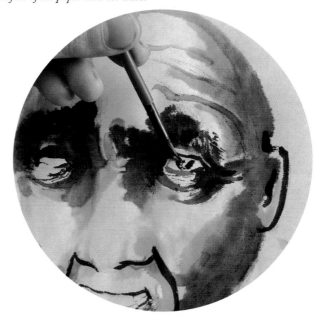

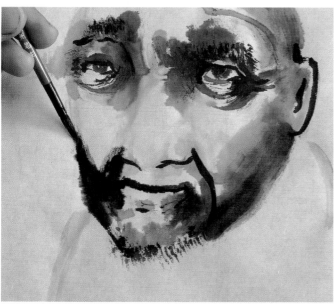

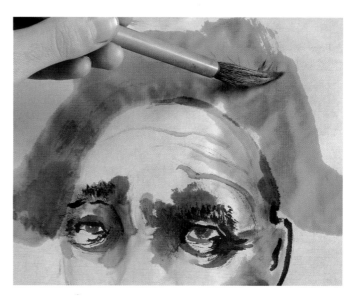

13. *Light washes continue to be applied, extending down to the lower outline of the mouth. To further highlight the volume of the cheek, the artist switches again to a darker tone of black ink.*

14. *Now a larger brush is used with light ink to paint the hat with very loose brushstrokes and a sweeping movement.*

逐步示範

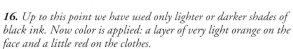

15. *To paint the man's clothes, the brushstrokes become quicker. The facial features are touched up with a few darker brushstrokes, to create a greater effect of depth on the features and the hat.*

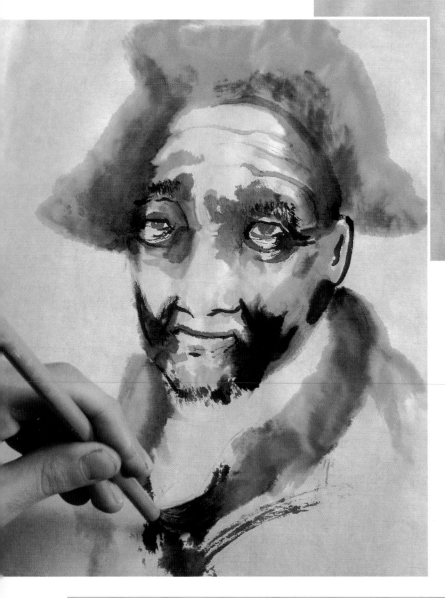

16. *Up to this point we have used only lighter or darker shades of black ink. Now color is applied: a layer of very light orange on the face and a little red on the clothes.*

VOLUME IN THE FIGURE

Traditionally, when a portrait is painted, the lines tend to be simplified since in Chinese painting the volume is not as important as the expression of the line, that is, of the brushstrokes created by a masterful use of the brush. There are usually no sudden changes in the application of color; instead colors are applied simply by superimposing a few very light layers of wash.

17. *Here, the artist, Manuel Díaz Sicilia, chose a technique different from those used in previous exercises. He has superimposed brushstrokes of light and dark ink. The work has some elements of Western painting (such as the simple areas of color on the face to define the volume) and of Eastern painting, such as the expressive power of the lines.*

逐步示範

Index

CHINESE BRUSH PAINTING

中國書畫

3/09
2/13-16
8/16-24